MASSACRE

— at —

DUFFY'S CUT

*Tragedy & Conspiracy
on the Pennsylvania Railroad*

WILLIAM E. WATSON AND J. FRANCIS WATSON

THE
History
PRESS

Published by The History Press
Charleston, SC
www.historypress.com

Copyright © 2018 by William E. Watson and J. Francis Watson
All rights reserved

Cover image: Painting depicting the burial of the first Duffy's Cut victims by those who were still alive, painted by Fred Danziger for Sam Katz's *Urban Trinity*.

First published 2018

Manufactured in the United States

ISBN 9781467139083

Library of Congress Control Number: 2018945791

CONTENTS

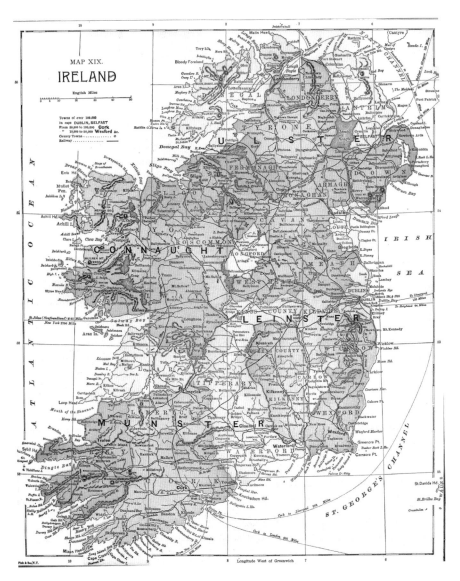

Map of Ireland's provinces and counties. Nineteenth-century engraving. *Watson Collection.*

INTRODUCTION

This book was fifteen years in coming. The Duffy's Cut Project began in 2002 as an effort to recover the remains of fifty-seven lost Irish immigrants to America and to recover and properly commemorate a forgotten episode of disease and bigotry in the shared histories of the Commonwealth of Pennsylvania and of the Province of Ulster. To date, no full accounting has been made of the efforts involved in the recovery of that lost history, although the project has attracted a great deal of attention in the United States and in Ireland. It is a story that has touched the Irish and Irish American communities because of lives cut short at such a young age and the fact that it is literally the tip of the iceberg of dozens, if not hundreds, of sites like it dotting the landscape of the Industrial Revolution across the United States.

Perhaps twenty thousand Irish immigrants died building the industrial infrastructure of the United States in the nineteenth century, and for most of those men and women, their identities and sacrifices will remain unknown due to intentional lacunae in the sources. For the fifty-seven who died at Duffy's Cut, a series of remarkable coincidences resulted in the recovery and reburial of at least some of them in proper graves in the United States and in Ireland. The Duffy's Cut Project team and Immaculata University student dig crew labored for more than a decade at the site to make sure that some of these common laborers would not remain anonymous.

This book is dedicated by the authors to Joseph F. Tripician, their maternal grandfather, who was a Sicilian immigrant railroader and who

started out as a stonemason and eventually became executive assistant to the president of the Pennsylvania Railroad and retired as that company's director of personnel. He instilled an interest in history in us and preserved the railroad's file on Duffy's Cut so that this history could be recovered.

IRELAND AND AMERICA

IMMIGRATION AND INDUSTRIALIZATION

Ireland's Tragedy and Exodus

By 1832, Ireland had been under British rule for more than half a millennium. The Norman invasion of 1169 fused Ireland together politically with England, an arrangement that lasted until 1921 for twenty-six counties and which still exists in the six counties that compose the United Kingdom's province of Northern Ireland. Despite the repressive Norman feudal policies that benefited a small elite of colonists in the "Pale of Settlement" in the eastern part of the island, Anglo-Norman elites gradually merged with Irish natives. The succeeding Plantagenet dynasty tried to maintain strict feudal overlordship on the island and keep the peoples apart in the Statute of Kilkenny (1365) by banning the "Old English" from intermarrying with the Irish or using the Celtic language, Irish dress and Brehon Law.

The Reformation added a sectarian dimension to preexisting tensions in Ireland in the mid-sixteenth century. The state-sponsored Anglican Church confiscated the native Catholic churches and required financial support from the Irish majority in the form of tithes. Racist, anti-Irish attitudes expressed by Edmund Spenser (1552–1599) in *A View of the Present State of Ireland* (1596) reflected contemporary English attitudes toward the Irish and justified exploitive colonial state policies of the Tudor and Stuart dynasties in Ireland. The colonial "civilizing" policy again suppressed the native Irish language, dress, Brehon Law and Catholic religion (derisively termed

"popery") and forbade intermarriages between the Irish and the old settler Anglo-Irish aristocracy.

The uprising of the native Ulster earls, supported by Spanish troops, in the Nine Years' War (1594–1603) resulted in their defeat by the Tudor army and their flight to the European continent. The conquerors began the Ulster Plantation, the British colony in the north of Ireland in which Scots Lowlander and English settlers (Presbyterians and Anglicans) were imported to take over the lands of dispossessed Irish Catholics who were opposed to the regime. The conquerors also enacted the Penal Laws to break the resistance of the native Catholic Irish. Catholics were barred from government and military posts in Ireland (as were Calvinists). Irish men and women deemed to be in rebellion were exiled to the Americas and the Caribbean. The Irish Confederates' uprising in the Eleven Years' War (1641–1652) led to their defeat by the army of Oliver Cromwell (1599–1658) and the loss of a quarter of the native Irish population due to war, massacre, disease and famine. Thereafter, Catholics were barred from parliament, and the Catholic priesthood was exiled. The Tudors, Stuarts and Cromwellians all sought to eradicate the lingering power of Catholicism to unite the Irish natives.

Irish Catholics were second-class citizens in their native country for the next two centuries of the Protestant Ascendancy period in Ireland. The Catholic majority was governed, persecuted and marginalized by the Protestant minority. Catholic hopes for independence were raised in the Irish campaign of the deposed Catholic Stuart King James II (1633–1701) against the Protestant King William III of Orange (1650–1702), who was married to James's daughter. Catholic troops were recruited from the disaffected and disenfranchised majority to join the army of James II in 1689–90. Protestant forces held out and stopped James's troops at the Siege of Derry in 1689, and William's army decisively defeated James about thirty miles north of Dublin at the Boyne River in 1690 in the largest and most important battle in Irish history.

Irish Protestants of various affiliations found common ground in the anti-Catholic Orange Order (named for William III's origins in Orange, the Netherlands), founded in 1795. Sectarian killings between Irish Catholics and Irish Protestants broke out in Counties Antrim, Down and Armagh in 1797, yet in 1798, Anglicans and Presbyterians joined with Catholics in the United Irishmen revolt that occurred under Anglican Theobald Wolfe Tone (1763–1798). The revolt failed despite French intervention, and in 1800, the Irish Parliament was dissolved in the Act of Union. Any pretense of Irish autonomy vanished.

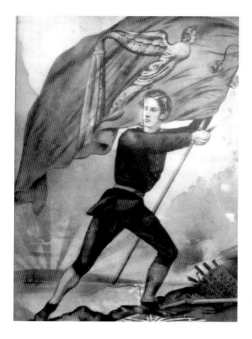

Theobald Wolfe Tone and the United Irishmen revolt against British rule, 1798. Nineteenth-century print. *Watson Collection.*

For the vast majority of the Irish, their lot was the exhausting and tedious life of agrarian labor for absentee British Protestant landlords. Catholic political emancipation, however, was achieved in 1829 by politician Daniel O'Connell (1775–1847), and Catholics and Protestants alike supported both the Young Ireland reform movement and the Repeal Association to end the union with Britain in the 1840s. In the mid-nineteenth century, the Great Hunger (1845–52) and all its horrors eventually cost Ireland a quarter of its population to a man-made famine, disease and exile. The Hunger, however, paved the path toward home rule. The Industrial Revolution that was beginning to emerge in Britain in the second half of the eighteenth century, and which would in time transform the wider British economy and society, offered scant hope for Irish Catholics, especially those in the rural areas of the country. The few industrial jobs that existed in Ireland, at Dublin and Belfast, were generally not open to Catholics.

By 1832, fully a decade and a half before the Great Hunger, the prospects for young Irishmen in their native land were so dismal that many chose immigration to Britain, Canada and the United States to seek out work in the emerging Industrial Revolution. Opportunities to work for a monetary wage existed abroad, where inexpensive Irish labor came to be the norm for railroad, canal and tunnel construction. Irish immigrant labor contractors, railroad and canal companies advertised employment opportunities where

Irishmen might earn a wage for the first time in their lives. These are the circumstances that lured fifty-seven young Ulster men and women to cross the ocean to work on mile 59 of the Philadelphia and Columbia Railroad in Chester County, Pennsylvania.

The population of Ireland in 1832 is estimated to have been about 5 million people and that of the United States almost 13 million. The Commonwealth of Pennsylvania was the second-most populous state (after New York), containing 1.35 million residents. Chester County was one of the original three counties in the commonwealth, founded in 1681 by William Penn (1644–1718). Penn had Irish roots on his maternal side and Irish holdings in County Cork dating to the Cromwellian conquest and the Stuart Restoration, when his father, Sir William Penn (1621–1670), was an admiral in the English navy. Penn himself provided supplies and logistical support to English forces in Ireland and was involved in the suppression of a mutiny in County Antrim. It was in Cork in 1667 that Penn converted to Quakerism.

In 1830, the population of Chester County was 50,908, 269 of whom were aliens and 5 of whom were slaves. The county was primarily rural, and agriculture was the primary factor in the county's economy. The population of the township of East Whiteland, where Duffy's Cut is located, was 994 in 1832. In Chester County's social hierarchy, the Quakers, who were one-third of the county's population in 1830, as well as Episcopalians, constituted the dominant groups in the county's political and economic life, followed by Presbyterians—many of whom were Scots-Irish Ulstermen—and, finally, Methodists and Mennonites. Those Irish who lived in Chester County before the 1830s were primarily Ulster Presbyterians. Very few Catholics of any ethnicity lived in the county before 1800, but by 1830, Irish Catholic laborers had begun to arrive in significant numbers to work on railroad and canal construction along the Main Line of Public Works. Whether they intended to remain only as long as the railroad or canal work lasted, or whether they eventually decided to settle in the county, their demographic impact on the county was substantial.

Scots-Irish Ulster Presbyterian immigration to Pennsylvania began in the early eighteenth century, when successive British regimes limited the volume of Scots-Irish activity in the cloth and cattle industries and also limited Scots-Irish involvement in the military and in government in Ireland to benefit English and Scottish merchants and politicians. A ban on English importation of Ulster cattle, beef and grain went into effect in 1667. In 1670 and again in 1691, a ban was placed on Scots-Irish merchant vessels from

William Penn, founder of Pennsylvania. Nineteenth-century print. *Watson Collection.*

visiting the American colonies, and in 1699, a ban on shipments of Ulster wool went into effect. In 1704, Presbyterians were barred from holding any office in the military or government, and the Presbyterian clergy were forbidden to preside at weddings.

Some 200,000 Ulster Scots thereafter fled to the British colonies in North America, seeking out backcountry settlements far from the prying eyes of the colonial government, where they became renowned game hunters,

trappers and Indian fighters. These backwoodsmen came to be called "Hillbillies" due to their adherence to the Protestant cause of "King Billy" (King William III) in the Battle of the Boyne against King James II and his Catholic allies. Irish Protestants accounted for a substantial portion of the population of Pennsylvania by the time of the American Revolution, and during the Revolutionary War (1775–83), there were so many Ulstermen in the Patriot forces that Pennsylvania units were collectively called "the line of Ireland." From a quarter to perhaps half of the troops from the various colonies who had fought for the British Crown in the French and Indian War (1754–63) were Ulstermen. Scots-Irish Ulstermen are estimated to have amounted to 15 percent of the overall population of Pennsylvania circa 1790. These Protestant Irish immigrants found it easy to assimilate with the Anglo-American majority due common religious sentiments.

Chester County contained 269 immigrant aliens in 1832, or 0.5 percent of the total population, a lower percentage than any other county in southeastern Pennsylvania. Ten of the county's non-naturalized aliens were living with Irish contractor Philip Duffy (1783–1871) in a rented house in Willistown Township, about one mile south of the rail line on Sugartown Road. Irish Catholic immigration to the United States increased in the 1820s with the beginnings of statewide public works projects. In the decade from 1820 to 1830, more than 50,000 mainly impoverished Irish Catholics came to the United States, and in the next decade, from 1830 to 1840, more than 200,000 did so, many arriving in the ports at Philadelphia, New York and Boston.

Within Philadelphia, the poorer Irish Catholic immigrants of the nineteenth century tended to settle in the working-class neighborhoods in the city and the communities then outside the city limits near the Delaware River extending northward, where both skilled and unskilled jobs were plentiful, on the docks and in the mills. Many of the new arrivals were assisted by the Friendly Sons of St. Patrick for the Relief of Immigrants, an organization established by well-to-do Irish Catholics and Protestants in 1771 at Miller's Tavern. Catholicism in Philadelphia had a venerable lineage stretching back to the establishment of Old St. Joseph's Church in 1733. At the time of the parish's foundation, it was the only legally established Catholic church operating within the British empire thanks to the Penal Laws, which had effectively outlawed Catholicism on British and Irish soil.

Several leading Irish Philadelphians in the Friendly Sons played prominent roles in the American Revolution, including naval hero John Barry (1745–1803); Stephen Moylan (1737–1811), who was George Washington's aide-de-

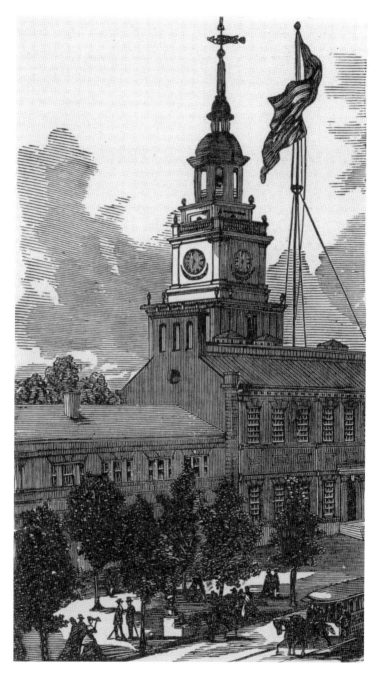

Independence Hall, Philadelphia. Nineteenth-century print. *Watson Collection.*

camp; and Thomas Fitzsimons (1741–1811), who was delegate to both the Continental Congress and Constitutional Convention and one of only two Catholic signers of the Constitution. Bishop John Carroll (1735–1815) estimated that there were one thousand Catholics living in Philadelphia in 1785. Eight hundred of them served in the Revolution.

Sectarian conflict followed the arrival of the Catholic newcomers, however, and in 1831, an Orange march like those commemorating the Boyne victory traditionally held in Derry and Belfast was held in Philadelphia. It was intended to be a show of force by the Protestant Irish, who had an easier time of assimilating into the Anglo-Protestant majority and who sought to dominate the newcomers economically and socially as they did in Ireland. The strategy backfired, however, when groups of Catholic Irish workingmen attacked the parade. This was something they would not have dared to do in Ulster given the tacit support for such Protestant shows of authority in the Ascendancy (and its aftermath). The case was adjudicated in the Philadelphia courts, with the judiciary and the press insisting that such old-world conflicts be put aside in the Commonwealth of Pennsylvania.

The rise of the Anti-Masonic Party was a reflection of increasing nativism in Pennsylvania and the nation as a whole throughout the 1830s. In many ways the precursors of the Know Nothings, the Anti-Masons were generally anti-immigrant and anti-Catholic, but they could not be opposed to public works after the state legislature created the Canal Commission in 1825 and began planning a combined canal and rail system out west that everyone knew would be dependent on inexpensive foreign-born labor.

THE INDUSTRIAL REVOLUTION AND THE RAILROAD

The Industrial Revolution of the eighteenth and nineteenth centuries created entirely new means by which nations measured their greatness in comparison to their rivals, such as miles of rail lines and canals and tonnage in mining of coal and in production of iron. The harnessing of steam power for production and transportation initiated new technologies and paved the way for social mobility, general participation in a money economy in place of barter and a consumer lifestyle unthinkable for most of humanity prior to the eighteenth century. It was regarded as a time of progress that was measurable by technological advances, but it was progress that was attended by a substantial rise in morbidity among the laboring classes because of

factory accidents and appalling conditions in coal mines and at industrial construction sites such as rail lines and canals.

The Industrial Revolution's start in Britain helped shape the events at Duffy's Cut in 1832, as American industrialists were dependent for many years on British models of production and labor. The Irish men and women who died at Duffy's Cut perished in one of the largest industrial endeavors of its day, the making of the Philadelphia and Columbia Railroad, an essential part of Pennsylvania's statewide "Main Line of Public Works." The essential natural resources of the Industrial Revolution were water and coal. The Industrial Revolution began in Britain for a variety of reasons, including the country's easy access to water for transportation, communication and power, as well as the abundance of accessible coal deposits. No part of Great Britain was more than twenty miles from some form of water, whether the coastline, rivers or man-made canals. By the eighteenth century, England, Scotland and Wales were essentially unified economically (for the benefit of England, but nonetheless more unified in that regard than most other European countries). Preexisting cottage industrial manufacturing was scattered throughout Britain, especially in textiles. The cotton and wool garment trade flourished in cities like Manchester. Additionally, the preexistence of an empire with holdings in strategic areas helped the British dominate the Industrial Revolution circa 1850–1900.

The decline of the tree population in Britain in the seventeenth century encouraged the search for alternative sources of fuel, and coal was found close enough to the surface to make coal mining a financially viable endeavor. By the height of the Industrial Revolution in the late nineteenth century, Britain was harvesting two-thirds of the world supply of coal. Burning coal to boil water to make steam for steam engines produced a byproduct of coke, used in manufacturing iron. Britain came to dominate the worldwide iron industry as it did coal, with about half the world supply coming out of its foundries. In 1850, it was producing 3.5 million metric tons per year and, by 1910, about 10.2 million metric tons. The steam engine was made originally to pump water out of mine shafts, and the first dated to Savory's engine in 1698 and Newcomen's in 1705. The device that served as a mobile power pack was invented by James Watt (1736–1819) in the 1760s for Matthew Boulton (1729–1809) in Birmingham, who famously said, "I sell here, sir, what all the world desires to have—power." This is the mobile device that revolutionized not only manufacturing but also transportation, in the form of the power sources for railroads and steamships.

The first steam-powered locomotive was invented by Richard Trevithick (1771–1833) in England in 1804, and world's first railroad company was the Stockton and Darlington Railroad, which began in England in 1825. The earliest American railroad survey was undertaken in 1814 by Colonel John Stevens (1749–1826), a former Continental army officer, in New Jersey between Trenton and Raritan. The objective in all railroad surveys was to locate the flattest ground possible to lay tracks to ensure the fastest route. Determining the most efficient source of motive power was problematic in the railroad's early days. Horses were used on the Granite Railroad of Quincy, Massachusetts, the oldest rail line incorporated in North America in 1826, to haul granite to docks. The South Carolina Railroad experimented with a sail-powered train car in Charleston in 1830. The first English-built steam locomotive in America, the Stourbridge Lion, arrived in New York in May 1829. It made a trial run at Honesdale, Pennsylvania, on August 8, 1829. Horses were commonly used in the earliest days of the railroad because locomotives were very costly, at about $20,000 for the locomotive and cars.

The earliest locomotives could typically travel about one hundred miles per day, and their lifespan was only about four years. The typical gauge of early tracks was four feet, eight and a half inches wide in the United States, as well as the United Kingdom, and the British model was said to be based on the width of typical Roman chariot. The original tracks were made of

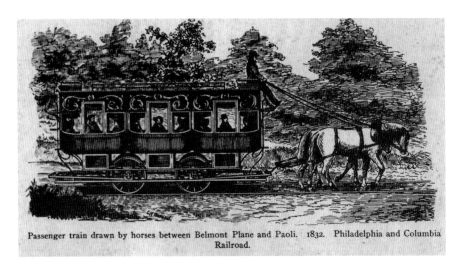

Passenger train drawn by horses between Belmont Plane and Paoli. 1832. Philadelphia and Columbia Railroad.

Philadelphia and Columbia horsecar near Duffy's Cut, 1832. From Watkins's *History of Pennsylvania Railroad Company*, unpublished galley proof. *Watson Collection.*

sections of cast-iron strap rail, and American railroads imported the rails from British manufacturers. The original strap rail sat on top of wood, affixed to locally quarried granite blocks called "sleepers" or "sills" that were driven into the ground. The stone sleepers were about two feet long by twenty-one inches wide, weighing about three to four hundred pounds each, and the track was affixed to them by means of spikes driven into holes cut into the blocks. The spikes were iron, but there were short-lived and experimental early variants made of stone, which frequently cracked and were quickly abandoned. By the mid-1830s, forty-pound T rail and crossties, resembling more modern railroad tracks had begun to replace the strap rail and stone sleepers.

The Louisiana Purchase (1803), in which the Jefferson administration purchased 828,000 square miles of French colonial North American territory west of the Mississippi from Napoleonic France, greatly enhanced the size of the United States. This territorial expansion encouraged economic competition between the states and in the mid-Atlantic region, between New York, Pennsylvania and Maryland. These states saw a proliferation of state-sponsored transportation public works projects during the Democratic administration of Andrew Jackson (1767–1845), who was president from 1829 to 1837. The Anti-Masons opposed Jackson and the Democrats at every turn and criticized the enormous debt that resulted from the rapid expansion of public works in the 1830s. The largest public works projects undertaken in the 1820s were the Erie Canal (opened in 1825) in New York and the Chesapeake and Ohio Canal (1831) and the Baltimore and Ohio Railroad (the B&O, completed in 1828), both in Maryland. The B&O was the first railroad in operation in the United States.

All these industrial endeavors utilized Irish immigrant labor extensively, based on British labor models in railroad and canal construction. From the War of 1812 and the Great Hunger, about 500,000 Irish Catholics immigrated to the United States, many of whom came as common laborers and most of whom had not had a prior opportunity to work in a money economy in Ireland. Jackson and the Democratic Party encouraged public works and courted the vote of the Irish and immigrants in general in the national and state elections of 1832. While the infrastructure of the country was being transformed by the public works projects being undertaken, the social fabric of the nation was also being transformed by demographic changes related to the influx of progressively larger numbers of immigrants each decade of the nineteenth century.

Pennsylvania's immigrant influx was tied to the need for internal improvements within the state in the face of economic competition with New York and Maryland. The state legislature created the Pennsylvania Canal Commission in 1825 to oversee construction of the "Main Line of Public Works," a new transportation system linking Philadelphia to Pittsburgh. The trip by Conestoga wagon from Philadelphia to Pittsburgh took three to four weeks. The new system was expected to shorten the trip down to three to four days. The Schuylkill, Susquehanna and Juniata were to be linked by an engineering feat called the Pennsylvania Canal, a series of interlocking canals. Part of the route, however, necessarily had to be connected via railroads, and a survey for such purposes was undertaken in 1827–28 by a father-and-son civil engineering duo, Major John A. Wilson (1789–1833) and William Hassell Wilson (1811–1902). The younger Wilson wrote a memoir of his career on the railroad entitled *The Columbia-Philadelphia Railroad and Its Successor* (1896). His career spanned from the beginning days of the P&C through the rise of the Pennsylvania Railroad.

Starting his narrative with the 1827 survey, Wilson described the decision to begin the Main Line of Public Works with a rail line rather than a canal due to "the scarcity of water and other good reasons." The survey began at the Schuylkill River at Valley Forge in June 1827 and followed the Great Valley of Chester County westward, with a seven- to eight-man crew consisting of the chief (Major Wilson), a surveyor, a leveler, a rodman, two chainmen (one of whom was future president of the Pennsylvania Railroad J. Edgar Thomson) and "one or two" axemen. William was originally a volunteer and gained critical experience working as an occasional replacement for one of the regular members when needed. In August, the survey examined a route for a canal between Columbia and Harrisburg and then a rail route between Columbia and Gap, at which time the survey party was "prostrated by fever." The locals informed the survey crew that the inhabitants of the region were regularly prone to "chills and fever in the fall of the year" and did not regard the unknown illness as "a matter of any importance."

The Pennsylvania legislature appropriated funds for the first of a series of "Canal Loans" intended to cover the costs of construction. The first of these was in April 1826 for $300,000 for the Pennsylvania Canal, and by March 1828, the loan amount had become $2 million for the combined canal and rail system. Politicians in Lancaster and Chester Counties were fearful that state funds would be exhausted in construction in the easternmost counties of Philadelphia, Montgomery and Delaware, so the commission decided

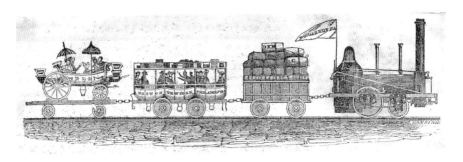

Early locomotive and cars, Philadelphia, 1834. From the *American Railroad Journal* 3, no. 35 (November 15, 1834). *Watson Collection.*

to parcel out contracts for individual miles of both rail line and canals in different areas simultaneously. The mayor and council members in Lancaster personally met with Major Wilson and the survey crew in May 1828 in the hopes of influencing the survey crew to lay the route in a manner that would be "advantageous to the citizens of Lancaster"; the leading citizens of Chester County did the same thing in West Chester in June 1828. The P&C line eventually fell north of the borough of West Chester, so a nine-mile branch line would be created called the West Chester Railroad, which linked Intersection—modern-day Malvern (near the location of P&C mile 59, where Duffy's Cut is located)—and West Chester. This branch line was funded by the gentry from the environs of West Chester.

The Canal Commission authorized two rail lines in 1828. The first was the P&C, which was to run for 82 miles and link the Schuylkill and the Susquehanna. The travel time on this first leg of the Main Line of Public Works, with horses as the motive power, was expected to be nine hours to complete, with fresh replacement horses provided every twelve miles. The second rail line was the Allegheny Portage, which was to run for 36 miles in the center of the state from Hollidaysburg to Johnstown and utilize a series of ten inclined planes. The inclined plane was a means to pull cars up an incline by means of a sixty-horsepower stationary steam engine and nine-inch hemp cables. It was devised in 1829 by Moncure Robinson (1802–1891). The P&C also used an inclined plane at its start from the Schuylkill in Philadelphia, called the Belmont Plane, which pulled cars 0.5 mile up a rise of 187 feet, a 6.6 percent gradient. Canals with locks and aqueducts connected the portions of the system linking Columbia and Hollidaysburg for a distance of 172 miles and the final portion of the system, linking Johnstown and Pittsburgh, for a distance of 104 miles.

When funds were appropriated for the construction of the system, it was anticipated that the whole Main Line of Public Works would be completed in two years' time. Construction of the P&C began in 1829 under Superintendent and Lancaster County native John Barber (1782–1868), in mile-long contracts for grading and bridging all along the line. Laborers hired heavily from Ireland and other immigrants arrived at the Philadelphia docks and from local populations along the route. Work proceeded at varying rates all along the line but fell behind schedule. The slow progress of the work in general was due to the difficult physical environment, the relative inexperience of the contractors and laborers in such work, logistical and financial problems and weather conditions. Wilson wrote that proponents of the Main Line of Public Works struggled to keep the legislature interested in the endeavor in the face of mounting debt and incomplete public works:

> So great was the apathy, and even opposition, to the railroad, that at the session of the Legislature commencing December, 1829, no appropriation was made, and great exertion was necessary on the part of its friends to prevent the abandonment of the enterprise at the sacrifice of what had been already extended.

The proponents of public works won out, however, and Wilson reported that by the spring of 1830, the work on the eastern and western divisions was "well advanced." Local Chester County historian Julius F. Sachse (1842–1919) wrote in an 1889 account of the construction of the P&C at mile 59:

> When the road was first projected and built the rails were of wood plaited with flat iron bars or tire irons expressly imported from England. These cars both passenger and burden, were small four wheeled affairs drawn by single horse or two driven tandem.

Horsecars were originally used on the various segments of the line until locomotives were proven to be more efficient. According to Wilson, both the passenger and freight cars were originally owned by private individuals and competing companies, and the various owners provided their own horses. The trucks below the cars, as noted by Sachse, had four wheels, and the carrying capacity of the freight cars was limited to three or four tons.

The steam engines at first used wood and then eventually converted to coal. Steam power matched and then surpassed horsepower. For a brief period, both locomotives and horses operated on the same tracks,

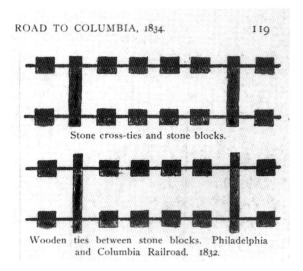

ROAD TO COLUMBIA, 1834. 119

Stone cross-ties and stone blocks.

Wooden ties between stone blocks. Philadelphia and Columbia Railroad. 1832.

Diagram of 1832 track construction, Philadelphia and Columbia Railroad. From Watkins's *History of Pennsylvania Railroad Company.* *Watson Collection.*

and occasionally, collisions occurred that resulted in fatalities. The brittle nature of the strap rails also sometimes caused the rails to snap while a car was passing on it, and the broken rail (called a "snake head") would crash through the car, injuring or killing passengers. The strap rail had been replaced in the mid-1830s by edge rails and then by the first generation of T rail, which resembled the modern track design but was originally smaller; each track piece weighed only forty pounds per yard. By the mid-1830s, the state was providing the locomotives used on the line. Wooden crossties (which provided more elasticity than the stone sleepers) then replaced the sleepers, with cast-iron chairs and spikes to hold the tracks in place. Men with hammers had to patrol the tracks regularly to make sure that the spikes did not come loose.

Mile 59 was the most difficult mile because the Canal Commission decided to make a three-hundred-foot-long earthen fill at the site in lieu of a costlier stone bridge. The fill consisted of the rocks and soil that had been grubbed from the "cut" and taken by cart and dumped where the earthen bridge was to be located. It was an arduous, backbreaking effort undertaken by men and horses in a manner that would not have differed much from the way such work was done in antiquity. The contract issued by P&C superintendent John Barber to Philip Duffy for mile 59 (from Canal Commission records, Pennsylvania Archives) itemized the tasks as follows: $300 for grubbing and clearing the whole section; $0.08 per cubic yard for removal of sand, earth, clay, loam, gravel or loose stones; $0.14 per cubic yard for removal of cemented gravel or hard pan; $0.10 per cubic yard for removal of embankment more than one

hundred feet; $0.25 per cubic foot for removal of detached rock; $0.25 per cubic yard for removal of slate rock; $0.50 per cubic yard for removal of solid or blast rock; and $0.50 per foot "for all necessary cross drains on the section [to be built of flagstones]."

The cost of P&C construction, according to Wilson, "was about thirteen thousand dollars per square mile," although the contract amount for grubbing, clearing and making the ground suitable for tracks was on average $5,000. The exception to this was mile 59—Duffy's Cut—which required that a fill also be created in lieu of a costlier stone bridge, and the contract for that mile was $23,500; the total costs, when it was completed, were $32,000. Mile 59 was also reportedly the mile of track with the most experimental technology in track design on the P&C. There was a great deal of corruption and padding of costs in P&C construction reported by Egbert Hedge in *Sketch of a Railway, Judiciously Constructed Between Desirable Points* (1841). Hedge pointed out, for example, that the cost of manufacturing each stone sleeper was $0.53, yet the state was charged $100 each.

In 1832, the line was partially completed near Philadelphia up to mile 60, just east of Duffy's Cut. Wilson wrote about the trial run of the first P&C locomotive, the Green Hawk, in the late summer of 1832 along the route from Philadelphia to the Green Tree Inn in Intersection, not far from Duffy's Cut. It left the Belmont Plane at 10:00 a.m. and proceeded westward. When the train ran out of wood to fuel the steam engine, passengers were enlisted to pillage wood from local fences. When it ran out of water at the Green Tree Inn at Intersection (Malvern), near the farthest west it had intended to go, the passengers were enlisted to form a bucket brigade from a local well. The train finally returned to the Belmont Plane at 9:00 p.m. The trip had taken eleven hours to travel twenty miles west to Intersection and then twenty miles east back into Philadelphia.

The original toll rates set by the Pennsylvania legislature for travel on the system were $0.04 per ton of freight, plus a "wheel toll" of $0.01 per mile of each freight car, and $0.02 per mile for passenger and baggage cars. An additional toll for motive power was charged after the state introduced locomotives on the line. The early locomotives typically covered one hundred miles per day, and their life span was usually about four years. By the mid-1830s, the P&C had forty locomotives, most of which were made in Philadelphia by the firms of Matthias Baldwin, Richard Norris or Garrett and Eastwick. According to Hedge, the P&C in 1837–38 carried 75,612 passengers and 97,180 tons of merchandise. The charge per passenger was $3.25, with a total revenue in that period of $243,500 for passenger service.

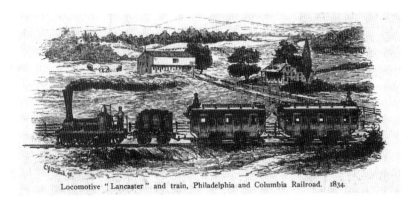

Locomotive "Lancaster" and train, Philadelphia and Columbia Railroad. 1834

Philadelphia and Columbia locomotive Lancaster and cars, 1834. From Watkins's *History of Pennsylvania Railroad Company*. *Watson Collection.*

It charged $7.40 per ton of merchandise in that period, for revenues of $675,000 for freight. An additional $24,000 revenue was generated for the mail transported on the system.

With so much potential economic activity depending on the success of the P&C, railroaders sought answers for the delay in the opening of the line in 1834 instead of 1833. Traditional railroad lore would identify balky contractors and poor weather conditions as the causes of the delay, but the most substantial obstacle preventing the completion of the eighty-two-mile system was the loss of an entire Irish immigrant work crew in the late summer of 1832 at mile 59, the railroad's costliest mile. On April 16, 1834, the locomotive Black Hawk conveyed the canal commissioners and members of the state legislature from Columbia to Philadelphia. The system's opening was celebrated on October 7, 1834, when two locomotives, the Lancaster and the Columbia, carried Governor George Wolf (1777–1840) and other politicians from Columbia to Philadelphia. The P&C was America's second railroad, and Pennsylvania's first, and it lasted until 1857, when the system was bought out by the private firm of the Pennsylvania Railroad.

PHILIP DUFFY AND DUFFY'S CUT

AN IMMIGRANT LABORER BECOMES A GENTLEMAN

Irish-born railroad contractor Philip Duffy, whose name has inextricably been linked with the deaths of fifty-seven fellow Irish immigrant laborers in August 1832 at the place known as Duffy's Cut, has been styled an "immigrant who succeeded against the odds." Over the years, Duffy worked his way up the business and social ladder from an immigrant laborer to a respected railroad contractor. Before his death, his occupation was listed as a "gentleman" within the city of Philadelphia. This chapter will document Duffy's transformation from Irish laborer to gentleman.

Philip Duffy was born in Ireland in 1783, the year the Treaty of Paris ended the American Revolution. Fifteen years later, in 1798, as Ireland witnessed the United Irishmen Rebellion, the fifteen-year-old Duffy joined many of his compatriots and fled Ireland for a new life in America. Duffy settled in Philadelphia County, where he and his family spent most of their lives, outside of his sojourns as a railroad contractor in different parts of the state of Pennsylvania. In 1813, with Great Britain at war with his adopted country, Duffy filed his petition for naturalization.

When Duffy became a citizen of the United States, he was thirty years old. Between his arrival in 1798 and the later 1820s, Duffy moved up from working as a laborer to become a contractor who hired and supervised other laborers on public works projects. Duffy's rise to the position of contractor coincided with the dawn of the railroad age in the United States. The first known railroad contract on which Duffy is named as a contractor dates from February 1829, where he is listed as "partner" with his brother-in-law, and

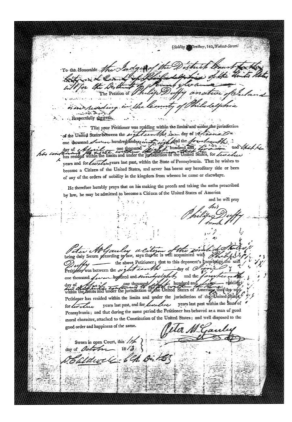

Left: Philip Duffy's naturalization papers. *National Archives and Records Administration.*

Below: Philadelphia docks. Nineteenth-century print. *Watson Collection.*

STEAMSHIP DOCKS ON THE DELAWARE.

fellow Irish immigrant, James Smith on "section 16" of the Philadelphia and Columbia Railroad (P&C). Duffy was successful enough on that mile of the P&C that in June 1829, he received his own contract to work on mile 60 of the rail line. Newspaper accounts reported that Duffy used Irish immigrant laborers for that work, which was a practice that he would continue throughout his career on the railroad. The work crew that Duffy used at mile 60 was described as "a sturdy looking band of the sons of Erin." Some of Duffy's Irish immigrant laborers even lived with him at times. The work along mile 60 was described as "Herculean," as Duffy's laborers built a very difficult roadbed for the railroad. With mile 60 of the P&C, Duffy made a name for himself as a hardworking contractor who was able to prosecute difficult work in a relatively short period of time. This became the pattern for the rest of Duffy's life as he worked for the railroad and, later, for the City of Philadelphia. Eleven months after he began work on mile 60, Duffy was given a contract for what became the most expensive, the most difficult and the most dangerous mile of railroad on the whole line of the P&C, the mile that would come to be known as Duffy's Cut.

DUFFY'S CUT:
THE IMMIGRANT MAKES A NAME FOR HIMSELF

Duffy was presented with the contract for mile 59 of the P&C on May 18, 1831. That mile of the railroad was to be completed in less than eleven months. According to his railroad contract, Duffy was expected to complete the work on mile 59 by April 1, 1832. Because of the difficult nature of the work at Duffy's Cut, April 1, 1832, came and went, and the work was nowhere near completion. Duffy's original work crew was unable to complete the work of ripping apart the earth along the railroad cutting that was eventually called Duffy's Cut, as well as the bridging of the large valley between miles 60 and 59 with the materials from the cut (which became known as Duffy's Fill or Duffy's Bank). Duffy was so far behind in his work by the summer of 1832 that he needed to hire a whole new work crew to finish the job. What Duffy did at Duffy's Cut was what he did throughout his career: in June 1832, he hired a group of recently arrived Irish immigrant laborers.

Less than eight weeks after Duffy hired the fifty-seven Irish laborers, all were dead and buried in the railroad fill. In August, cholera made its way

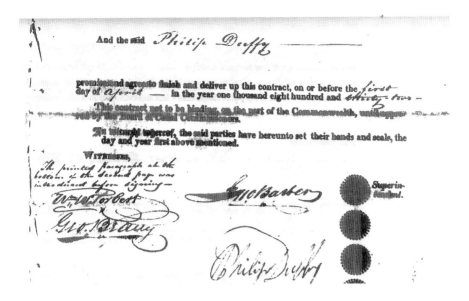

Philip Duffy's signature on Philadelphia and Columbia Railroad contract. *Pennsylvania Archives.*

into the shanty where the Irish laborers lived, located just several yards south from their worksite. Cholera came from drinking contaminated water, but no one in 1832 knew how it was transmitted. Immigrants in 1832 were often suspected of being carriers of cholera, while it is clear from the evidence that the laborers at Duffy's Cut actually caught the disease from a source in Chester County. The railroad records indicate that when the laborers realized that cholera had broken out in their shanty, some tried to flee to neighboring farms but were turned away by people afraid of the disease. By the end of August, all fifty-seven Irish laborers were dead.

The railroad reported that the laborers had died of cholera, and the newspapers downplayed the number of the dead throughout the nineteenth century. The archaeological dig and the anthropological examination of the remains revealed that the men and the woman recovered at the site were all murdered. Nativism along with a fear of cholera and fear of foreigners as supposed harbingers of the disease were likely responsible for vigilante violence that occurred at mile 59.

No record has been found to indicate Duffy's frame of mind during and after the events at mile 59. Where was Duffy when his men were murdered and others died of cholera in August 1832? We may never know. What we do know is that when his fellow Irishmen were dying at Duffy's Cut, Duffy

himself was living elsewhere. He did not live in the shanty along with his newly arrived laborers; he lived in a rented home several miles away in Willistown Township, and with a separate (and safe) water source. Secondly, while he was building mile 59 of the P&C, Duffy was moonlighting on another mile of railroad. On May 26, 1831, a little more than a week after he signed his contract to work at Duffy's Cut, Philip Duffy signed another contract with another railroad, to work on Section 9 of the West Chester Railroad. Duffy was moonlighting for at least part of the time he was supposed to be supervising his men at Duffy's Cut.

It seems impossible to imagine that Duffy did not know what happened to his men at mile 59 in August 1832. Even if he did know the full extent of what happened there, he never seems to have spoken about it to anyone. At minimum, he turned a blind eye on what went on in and around his shanty at Duffy's Cut. While Philip Duffy was alive, no one within the railroad spoke publicly about what really happened to his Irish laborers at mile 59. It was only to be after Duffy's death in 1871 that the Irish American railroading community spoke out about the deaths at Duffy's Cut. In fact, it seems that Duffy's death provided the impetus for the first memorial at the site, as the first memorial fence was erected by local Irish railroaders in 1873.

There was certainly no effort on Duffy's part to communicate with the families of those who died under his charge in Chester County. No contemporary source has been located that indicates Duffy's feelings or thoughts at the deaths of fifty-seven of his Irish compatriots. What mattered most to Duffy after his laborers were murdered in August 1832 was the

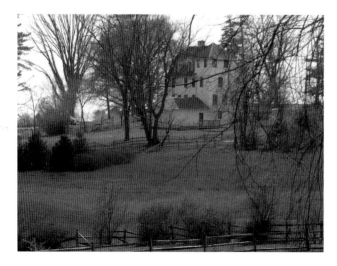

Philip Duffy's rental house in Willistown Township, circa 1832. *Watson Collection.*

completion of his contract, which he was able to accomplish with a new work crew in 1833.

Duffy did communicate with his superiors at the P&C about why the work had stopped at Duffy's Cut in August 1832. It seems that Duffy simply reported that fifty-seven of his men had died of cholera. In the spring of 1833, Duffy's superior on the P&C, William B. Mitchell (died in 1844), reported to the Pennsylvania Canal Commission on the events at mile 59 in what is referred to as the "Mitchell Letter." In that letter, Mitchell stated the bare facts of what Duffy experienced—that by the spring of 1833, Duffy had "progressed with his contract nearly to completion," but half of his men (up to sixty laborers) died at mile 59. Mitchell further stated that Duffy "complains that he is in great difficulty and distress" as he dealt with that crisis. According to Mitchell:

> *This man* [Duffy] *has been rather unfortunate during the last fall. Nearly one half of his men died of cholera—but it must also be admitted that he is perfect master of the art of complaining, with or without cause.*

Duffy had argued that due to the deaths of his laborers at mile 59, he was experiencing a financial loss. He claimed that he was over his expenses by $3,382.42. After the deaths of his fifty-seven immigrant laborers, Duffy apparently sought more financial support from the Pennsylvania Canal Commission to hire a new work crew to finish the project. Even though Mitchell supported a partial payment of $500 to Duffy to help with his expenses, the Canal Commission denied both Duffy's request and Mitchell's suggestion. Nonetheless, Duffy eventually did hire another work crew that completed the job at mile 59 in the spring of 1833.

The Irish immigrants who had come to Duffy's Cut in June 1832 arrived in Philadelphia as Duffy himself had in 1798, hoping to find a share of the American dream. Their immigrant dreams had died with them, as they succumbed to cholera and murder at mile 59. Nonetheless, Philip Duffy had made a name for himself at Duffy's Cut on the backs of fifty-seven dead Irish laborers. Even though the work at Duffy's Cut had taken a year longer than estimated by the railroad, and even though the delays at Duffy's Cut had slowed down the completion of the entire line of the P&C, Duffy had gained the reputation as a hardworking contractor who completed his work, no matter the obstacles that came in his path. His ability to complete his contract at mile 59 ensured his future career with the railroad.

DUFFY AFTER DUFFY'S CUT

Despite being called the "perfect master of the art of complaining," Duffy had proven himself to his railroad superiors at mile 59. Very shortly after he finished the work at Duffy's Cut, William Mitchell gave Duffy another contract, at section 29, which was located in Lancaster County (west of Duffy's Cut). This contract consisted of laying two tracks, the first was to be completed by December 1, 1833, and the second to be finished by July 1, 1834.

As Duffy worked at section 29, he joined twenty-three other P&C contractors in signing an interesting document called "Columbia Contractors for Relief." This document was a petition to the canal commissioners in support of promised funding to complete the laying of a second track along the P&C after the Pennsylvania legislature had withdrawn that funding due to budgetary wrangling in Harrisburg. Duffy was the second signatory on this document, and he, along with the contractors along sections 30 to 9 (except section 13), claimed that they were "subjected to great inconvenience and embarrassment" by the lack of funding and the resultant "stoppage of the work." The contractors lamented that their inability to pay their workers caused "troubles" for their employees (the "poorer and laboring classes"). As the state had not allocated the proper funds to complete their contracted work, the contractors claimed that they incurred "heavy responsibilities," "expended money, and made arrangements which will involve them in loss and in some cases perhaps utter ruin." The contractors hoped that the commissioners would use their "power" to enable the completion of "this great work." The conclusion of the document stated that "[y]our petitioners therefore pray your honors to take this measure into serious consideration and use your influence to promote the interest of your petitioners."

This document is an intriguing glimpse into the relationship between the railroad contractors and the railroad leadership in the early period of railroad development in America. The "Columbia Contractors for Relief" is certainly one of the earliest documented cases of organized labor protest in early industrial America. By claiming to speak for the concerns of their laborers, Duffy and his fellow contractors had tried to humanize the plight of the laborers under them. What role this document played in the resolution of the state budgetary battles in 1834 is unknown. Nonetheless, the fact that Duffy and twenty-three of his fellow railroad contractors came together to try to exercise corporate pressure on the structure of the Main Line of Public Works is significant. Also significant is the fact

that Duffy's career with the railroad was not harmed by his signing of this document. In time, the Pennsylvania legislature approved this funding for a second track, and Duffy was able to fulfill his contract at section 29. Duffy continued to have a long and distinguished career with the railroad for many years.

On July 16, 1834, in the same year that he signed the "Columbia Contractors for Relief" and a little less than two years after the deaths of his laborers at mile 59, Duffy signed "Letters of Administration" as administrator for the estate of deceased railroad laborer Paul Maguire, "a laborer on the Penn. R. Road," "late of Chester County." Duffy himself was listed as living in Chester County when he served as the administrator of Maguire's estate. That Duffy was willing to serve as administrator for the estate of one of his railroad laborers provides a very fascinating glimpse into the interpersonal dynamics between the working railroad contractor and his laborers in the early years of steam power in America.

By the 1840s, railroads were being built throughout the state of Pennsylvania. In 1842, Duffy found himself working along the railroad in Schuylkill County, situated about eighty miles northwest of Duffy's Cut. He and his family resided in Schuylkill County during this period, as Duffy's twin sons, Francis and Edward, were born there on July 17, 1842, and were baptized at St. Patrick's Church in Pottsville.

Philip Duffy in Philadelphia: The Immigrant Becomes a Power Broker

With his move to the city of Philadelphia sometime before 1846, Philip Duffy the railroad contractor branched out into other areas. His successful career on the railroad carried him up the business, social and even political ladders. When he moved to the Greater Philadelphia area, Duffy and his family settled in the then unincorporated District of Richmond, which was located within the larger county of Philadelphia. They all lived in Duffy's home at the corner of William and Richmond Streets, and Duffy would spend the rest of his life at that address. This neighborhood later became part of the Twenty-Fifth Ward of the city of Philadelphia. As he settled into the Greater Philadelphia community, Philip Duffy appears as a larger-than-life figure who was involved in a great number of community and public works projects.

Duffy had worked for nearly two decades as a railroad contractor, but by 1846—two years after the infamous 1844 "Bible Riots" in the city of Philadelphia—Duffy was in a position to help shape the policies of the railroad industry that employed him. In early March 1846, Philip Duffy was one of three elected delegates from Philadelphia County sent to the Democratic Party Convention in Harrisburg, Pennsylvania, which met to elect a Democratic candidate for canal commissioner. Duffy is recorded as voting for the winning Democratic candidate, fellow railroader William B. Foster Jr. While Foster lost in the statewide election for canal commissioner to the Whig candidate, the fact that Duffy was one of three delegates selected to represent Philadelphia County in this important election is significant. In 1846, Duffy was clearly a man on the rise within the Greater Philadelphia community.

Another event was to shape Duffy's life in 1846. Duffy was an Irish immigrant who came to America at a time when his home country fought an ill-fated battle for freedom against Great Britain and who became an American citizen in a year when his adopted country was once again at war with England. Just so, it should not be surprising that Duffy appears to have had a continued interest in the affairs of his homeland. It is clear that Philip Duffy was very much aware of the failure of the Irish potato crop in 1845 that devastated Ireland and soon sent millions of his countrymen and women to America for a chance at a new life. It is also clear that Duffy was aware of how the British Corn Laws of 1815 exacerbated the famine in Ireland.

After the defeat of Napoleon at Waterloo and the end of the Napoleonic Wars, the price of British grain, which had been artificially inflated during the French Wars, fell by nearly 50 percent. British farmers panicked, and as a result, the Corn Laws were established in 1815 to help protect a higher price for British grain. As the potato famine struck Ireland, the Irish in America were well aware of how the Corn Laws caused more harm to their countrymen and women who were already suffering in the Great Hunger. Philip Duffy was a member of the Repeal Association in Philadelphia, an organization that publicly supported the repeal of the Corn Laws. When the Corn Laws were finally repealed in 1846, the Philadelphia Irish American community celebrated with a Repeal Association Repeal Ball, held in the old Philadelphia Museum, which had been founded by Charles Willson Peale in 1786. Philip Duffy was one of the more than ninety "managers" of the April 20, 1846 Repeal Ball. Duffy's active support of this event was a public display of solidarity with the suffering of his countrymen and countrywomen in his homeland.

NEW PUBLIC BUILDINGS, FROM BROAD AND ARCH STREETS.

Broad Street and Arch Street, Philadelphia, 1800s. Nineteenth-century print. *Watson Collection.*

While he continued to work for the railroad in the 1840s and 1850s, during the latter half of the 1840s, Duffy further involved himself in local politics and in other Philadelphia area "improvements." On February 27, 1847, Duffy was appointed as one of the first nine commissioners of the District of Richmond in Philadelphia County. In October 1847, he was

elected as a commissioner of the district in the first-ever election held there. He held that position until October 1850, when he retired from the board. Among the early acts of the Board of Commissioners was to support three of the principal railroads that ran through the District of Richmond: the Sunbury and Erie Railroad, the North Pennsylvania Railroad and the Reading Railroad. That a successful railroad contractor such as Philip Duffy sat on the first Board of Commissioners surely assisted the negotiators in the discussions and marshalled public support of these various railroads throughout the Richmond community.

In March 1847, Duffy was appointed a commissioner for the Gunnar's Run Improvement Company (incorporated on March 15, 1847), which built the ill-fated Aramingo Canal. The canal was intended to facilitate commerce and industry in Richmond, and Duffy would have had an eye to a potential rail link between this canal and the larger Port of Philadelphia. That same year, Duffy was appointed as one of two elections inspectors for the District of Richmond in Philadelphia County. Duffy and his fellow inspector, Henry Funk, were charged with ensuring fair elections within the District of Richmond for the election of a new judge, as well as new district inspectors and "other district officers" in an election that was to be held on the third Friday of March 1847. Both of Duffy's appointments were noted by the Commonwealth of Pennsylvania in the official record of the Acts of the General Assembly, and they bear witness to his rise in power and influence within Philadelphia County. As he assumed these leadership roles in 1847, Duffy was sixty-four years old. The fifteen-year-old immigrant laborer who had arrived in America in 1798 had made it in his adopted country. Duffy had become a man of influence whose experience was valued by his community.

PHILIP DUFFY THE "GENTLEMAN"

When Duffy arrived in Philadelphia, he brought his entire family with him. Prior to the events at Duffy's Cut, Philip Duffy had married his business partner's sister, Margaret Smith. Margaret was also a native of Ireland. She and Duffy had a least seven children together, including two sets of twins: fraternal twins Philip and Maria (born in 1832), William (born in 1834), Catherine (or Kate, born in 1837) and likely identical twins Francis X. and Edward (born in 1842). The Duffys had another daughter, a baby

named Margaret, who died after only two months on November 16, 1850. Duffy's wife, Margaret, died on September 21, 1853. Duffy's remaining children lived with him until he died. None of the children ever married or had any progeny.

The younger Philip Duffy died fighting for the Union in the Battle of Chaffin's Farm, Virginia, on September 29, 1864. Duffy's younger twins were also veterans of the Civil War, and they claimed to have seen their older brother die in battle (later in life, inexplicably, the younger twin brothers reported that their older brother had died at Antietam). Francis and Edward Duffy were variously employed as "hostel keepers" (1870 census), "carpenters" (1890 Philadelphia City Directory and the 1900 census) and "musicians" (Francis's 1907 death certificate). In the 1880 census, the brothers were listed as being unemployed for twelve months. According to Edward's obituary in the *Philadelphia Inquirer*, he was called a "unique figure" as well as "Lincoln's Counterpart," as both Edward and his brother Francis "wore the style of dress in vogue at the time of the Civil War," including "the old fashioned long coat, trousers with long straps running under the feet and Congress gaiters." The brothers were said to have taken pride in their "facial resemblances to Lincoln before he grew a beard." Edward, it was noted, was "a follower of boxing and racing," while he "never rode in a trolley car or horse car, and he never touched a drop of liquor." Along with his brother Francis, Edward furthermore "frequently performed on the violin "at weddings, dances and other social affairs among the Irish residents."

When Philip Duffy was sixty-six years old, he was given yet another contract by the railroad; he signed his "Article of Agreement" on October 8, 1849. His job was to redo the track layout so as to "avoid" the old Inclined Plane at the Belmont Plateau in Philadelphia that dated to the early days of the railroad, when Duffy was starting out as a contractor. Duffy was to "execute the Grading and Road formation of that portion of the Railway." His work was to be completed by May 1, 1850. While the payments for the various portions of this work within Duffy's contract were not very different from the payments he received when he worked on mile 59 in 1832, this contract would have been seen as having a particular prestige and significance, as the Belmont Plane had served as the original eastern terminus of the P&C. Ten years earlier, the P&C had eliminated the inclined plane at the beginning of the rail line in Columbia. Duffy was one of the longest-serving P&C contractors, and it would likely have been seen by Duffy as a great honor to execute this significant contract.

As a naturalized American citizen himself, Duffy was in the habit of supporting the naturalization of his fellow Irish immigrants. One such immigrant was the Irish-born stonemason Thomas Lappan, who settled in Duffy's Port Richmond neighborhood and, with the Duffy family, attended St. Anne's Catholic Church at Memphis and Lehigh Avenues. Philip Duffy signed as a witness to Lappan's petition for naturalization on October 2, 1852. When Lappan died in 1888, Philip Duffy's son Francis signed as a witness to Lappan's will, along with Reverend D.P. Egan, pastor of St. Anne's Church (on May 23, 1888). Duffy also seems to have supported the practice of indenturing of Irish immigrants. He owned a dwelling that was used to house Irish indentured servants.

During his time in Philadelphia, Duffy not only worked as a railroad contractor but also was hired to work on other projects in the City of Brotherly Love. For example, in 1855, Duffy was hired by the City of Philadelphia to widen Richmond Street, in his Richmond neighborhood. Duffy was to be paid $600 "for widening Richmond Street, in the Nineteenth Ward." While Duffy continued to work in Philadelphia, his status rose as well. In the 1861 Philadelphia City Directory, the seventy-eight-year-old Philip Duffy was still listed as "Contractor," while his son Philip Jr. was listed as his "clerk" for his father's contracting business. By the 1863 Philadelphia census, Philip Duffy the immigrant contractor was listed with the occupation of "gentleman."

By his eightieth year, Philip Duffy had truly made it. The immigrant who worked his way up from laborer to contractor had indeed succeeded in the face of a variety of odds—this despite the nativism that had contributed to the deaths of his own laborers at Duffy's Cut. He was a tough taskmaster who successfully prosecuted extremely difficult jobs, sometimes at the expense of his fellow immigrant workers. Nonetheless, as he worked his way up the occupational and societal ladder, he had helped to shape the very railroad industry that had employed him throughout his career. He had contributed to the growth of his community and had paid homage to the concerns of his fellow suffering Irish men and women back in his homeland during the Great Hunger. Duffy's success was, nonetheless, built on the backs of fifty-seven Irishmen who were murdered at Duffy's Cut in 1832, and it was only after his death that the Irish American railroading community was free to speak of the horrific events that transpired at mile 59 of the old P&C.

Philip Duffy lived another eight years, dying on April 22, 1871, at his home on William and Richmond Streets, in Philadelphia. Survived by his daughters Catherine (or Kate), who served as her father's executrix in his Last Will and Testament (dated April 12, 1871), and Maria, as well as his younger twin sons

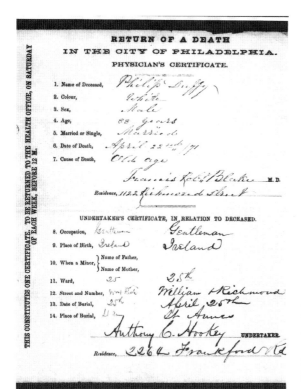

Left: Philip Duffy's death certificate. *City of Philadelphia Department of Records.*

Below: St. Anne's Cemetery, Port Richmond, Philadelphia, burial place of Philip Duffy, 1871. *Watson Collection.*

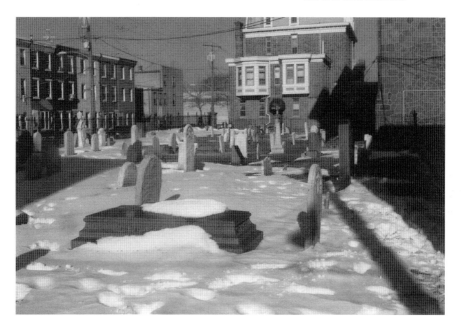

Francis and Edward, Duffy was eighty-eight years old when he died of "old age" at his home. His death certificate recorded him as being born in Ireland, and his occupation was listed simply as "gentleman." The teenage laborer who had immigrated to America during the United Irishmen Rebellion and become a U.S. citizen during the War of 1812 had three sons who fought for his adopted country in the American Civil War, including one son who lost his life fighting for the Union. Duffy and Margaret also had another son, William.

Duffy directed that upon his death, his home at the northeast corner of William and Richmond Street was to be sold, along with all its contents. The residue, after the payment of his "just debts and funeral expenses," was to be converted into cash and equally distributed between his surviving children. Twin brothers Francis and Edward Duffy lived together until Francis died on April 1, 1907. They never married and had no heirs. Duffy's home no longer exists.

A number of the Duffy family (including Philip Duffy himself, his wife, their infant daughter Margaret and Francis and Edward) were buried at St. Anne's Catholic Church, not far from Duffy's home in the Port Richmond section of Philadelphia. A memorial stone for Philip Duffy was finally erected at the St. Anne's cemetery in 2018 thanks to the work of the St. Anne's Historical Commission, enabling visitors to remember the man whose name is irrevocably linked to mile 59 of the P&C, as well as to the deaths of fifty-seven of his fellow Irish laborers who were buried in unmarked graves there in August 1832.

WHAT HAPPENED AT DUFFY'S CUT

I n the Wally Page song "Duffy's Cut," sung by Christy Moore on his album *Listen*, the singer asks some pointed questions about what happened at Duffy's Cut: "Were they taken by the sickness/were they hunted down like scum; was there poison in the water/was it cholera or murder; the smoke, that hid the bullets from the barrel of the boss's gun."

The Duffy's Cut story began with the arrival of 57 Irish immigrant laborers on the docks of Philadelphia who were hired to work at mile 59 of the Philadelphia and Columbia. Given the time frame of the arrival of the laborers in the sources, which is the summer of 1832, there was only one ship that could have carried the work crew employed by Philip Duffy at mile 59: the *John Stamp*, which sailed from the port of Derry in April 1832 and arrived in Philadelphia on June 23. Of the 160 passengers, there were 100 men and 60 women, and among them were 47 of the right age and occupation who were added to a small crew of 10 already with Duffy from a previous contract.

Throughout the nineteenth and twentieth centuries, the question of what happened at Duffy's Cut was answered in different ways by a variety of different sources. As articulated in the song "Duffy's Cut," there were two main suggestions about the cause of death of the fifty-seven Irish laborers at mile 59: cholera or murder. Between these two possibilities, there were other suggestions and ideas about what happened to the laborers. By bringing together the various sources that treated the deaths at Duffy's Cut, the story of both what really happened there, as well as the railroad coverup, starts to become clear.

Left: Early railroad spike found at Duffy's Cut. *Watson Collection.*

Bark *Jeanie Johnston* docked in Dublin, Ireland. *Watson Collection.*

ARTICLE OF AGREEMENT, entered into this *Eighteenth* day of *May* —— eighteen hundred and thirty *one* by and between the Commonwealth of Pennsylvania, by *John Barber* —— Superintendent of the Columbia and Philadelphia Railway, of the one part, and ——

Philip Duffy ————————————

of the other part;

Witnesseth, That the said *Philip Duffy* ————

do *½* promise and agree, to execute the Grading and Road formation of that portion of the said Railway, known and designated upon the plan of the said railway, as the —— *Fifty-ninth (59 th)* ———— section, and to conform to such directions as shall from time to time be given by the Engineer, or assistant Engineer, having charge thereof, at the following prices, to wit:

For Grubbing and clearing the whole section, the sum of *Three hundred dollars.*

For all necessary excavation of sand, earth, clay, loam, gravel or loose stones, which may occur on the section, per cubic yard, *Eight cents* ——

For cemented gravel, or hard pan, strictly such, per cubic yard *Fourteen cent*

For embankment, when removed more than one hundred feet, to be measured in the banks, per cubic yard, *Ten cents* ——

For excavation of detached rock, measuring more than one cubic foot, and for slate rock, per cubic yard, *Twenty five cents*

For excavation of solid or blast rock, per cubic yard, *Fifty cents* ——

For all necessary cross drains on the section, (to be built of dry flag stone,) per foot lineal, *Fifty cents* ——

It is understood by the parties, that all embankment, the earth for which is not removed more than one hundred feet, shall be estimated and paid for as excavation; and that in all cases the earth for embankment shall be taken from such places as may be directed by the Engineer or his Assistant. It is also understood that no allowance shall be made for bailing or pumping of water.

It is further agreed, that any items of work, that may necessarily occur on this section, not already specified in this contract, shall be estimated by the engineer, and paid for accordingly. And it is further understood by the parties, that all the stone quarried, and other material removed from the bed of the Railway, is the property of the Commonwealth of Pennsylvania and not of the contractor , and may be disposed of by the Superintendent as he may think proper; and that all timber, buildings or fences, on the track of the Railway are the property of the landholder, and that the contractor ha*s* no right to convert them to *his* individual use or benefit; and the said contractor shall be responsible for the safe keeping of the same from the depredations of *his* hands and labourers.

Jan 29 2004 13:53 d"

Duffy's Philadelphia and Columbia contract for mile 59, 1832, page 1. *Pennsylvania Archives, Pennsylvania Historical and Museum Commission.*

EARLIEST NEWSPAPERS

Among the sources that discuss what happened at Duffy's Cut, there was a variety of newspapers that treated the deaths of the men at mile 59, as well as the PRR file itself, which offered reflections from a variety of railroaders and others about what actually happened. Within the 1832 newspaper articles that reported the events in August 1832 at Duffy's Cut, the earliest record that has been discovered that speaks of cholera among the railroaders comes from the September 6, 1832 edition of the Philadelphia paper the *National Gazette and Literary Register*. This record is contained in the section entitled "Cholera Intelligence," which, as was found in many newspapers throughout the eastern seaboard, reports on the spread of cholera in the Delaware Valley. The account reads:

> *The Cholera has appeared in a very malignant form, in the vicinity of the White Horse, and Kungle's Mills, in the Great Valley....It is reported that several cases have occurred lower down the Valley, among the laborers on the Pennsylvania rail road.*

This account was repeated, nearly word for word, in the September 8 edition of the same newspaper and in the September 7 edition of the *Philadelphia Daily Chronicle*. These earliest newspaper accounts unanimously state that cholera was discovered among the railroaders living and working at Duffy's Cut. What is significant about these three early newspaper accounts is that they are contemporary confirmations of what was reported later in the nineteenth century and within the PRR Duffy's Cut file—the fact that cholera broke out within the workers' shanty.

Another fascinating 1832 newspaper account of the events comes from the November 7 edition of the Chester County *Village Record*. This newspaper account, entitled "The Cholera," retracted an earlier version of the Duffy's Cut narrative from a previous edition of the paper and sought to "prevent exaggeration." This version of the story claimed that only eight railroaders died there and that they died of cholera. This article also detailed the burial of the cholera victims by the "humane" camp blacksmith. While claiming to prevent "exaggeration," this newspaper article is one of the earliest examples of a coverup of the Duffy's Cut story that was widely repeated by the railroad throughout the nineteenth century. This deliberate misrepresentation of what happened at Duffy's Cut was likely offered so as to prevent worries on the part of investors, who feared that if the real extent of the tragedy got out into

Top: The fill at Duffy's Cut, north side. *Watson Collection.*

Bottom: Duffy's Cut view looking east. *Watson Collection.*

the public, no one would want to ride on a railroad where cholera had killed scores of workers.

These various public newspaper accounts of what happened at Duffy's Cut were printed with the approval of the railroad and at its direction. These accounts all downplayed the reality of the sheer volume of workers who died. According to the various newspaper pieces written throughout the nineteenth century and into the early twentieth century, the railroad reported to the public that the deaths at Duffy's Cut were all from cholera and that a number as low as eight men died there. Nonetheless, internally the railroad admitted that something quite different happened at Duffy's Cut—that fifty-seven men died there.

THE MITCHELL LETTER

An important internal record of what happened to the laborers at Duffy's Cut is found within the records of the Philadelphia and Columbia Railroad (P&C) in the Pennsylvania State Archives. This particular record states that many more men died at Duffy's Cut than the number of dead admitted to publicly in the newspapers. The spring 1833 letter of P&C Eastern Division superintendent William B. Mitchell, known as the "Mitchell Letter," detailed what Duffy's immediate supervisor knew of the deaths at Duffy's Cut from Philip Duffy himself. This letter is significant in that it offered a frank assessment explaining the delay of the completion of the railroad that was caused by the deaths of Duffy's workers.

In his letter to the Pennsylvania Canal Commission, Mitchell stated that according to Duffy, "nearly one half of his men died of cholera," indicating that a number as high as sixty men died at Duffy's Cut. Again, though, here the railroad simply asserted that it was cholera that killed the men at mile 59. In his letter, Mitchell presented Duffy in "great difficulty and distress" and facing a financial crisis. By the time he wrote his letter, Mitchell claimed that Duffy had "progressed with his contract nearly to completion." Yet Duffy "complains that…his estimates are altogether inadequate to pay his expenses and enable him to proceed with his works." According to Mitchell, "I think it very probable that his statements are true…as the work he is now employed at…is very unprofitable." The work of building mile 59 was costing Duffy $22,611.95, and he was promised only $19,229.44. Duffy was, according to his claims to Mitchell, over his expenses to the tune of $3,382.40. Mitchell supported Duffy's claims for increased funding, suggesting that the commonwealth pay Duffy $500. Nonetheless, despite Mitchell's suggestion, the Canal Commission denied Duffy's claims. "File this away," the commissioners wrote. "No action taken." Somehow, despite the deaths of fifty-seven of his men, Duffy was able to complete his work at mile 59 in the spring of 1833.

The author of the Mitchell Letter, William B. Mitchell, was born in Northern Ireland of Scots-Irish origin. According to a 1908 *Commemorative Biographical Record of Prominent and Representative Men of Indianapolis and Vicinity*, Mitchell "came to America as a young man, as a teacher, and he married Miss Rebecca Lyman, of Pennsylvania, born in Lancaster, of an old family there." Mitchell was heavily involved in the survey and construction of the Main Line of Public Works. Trained as a civil engineer, prior to his appointment as superintendent of the Eastern Division of the P&C, Mitchell

The Mitchell Letter, 1833. *Pennsylvania Archives, Pennsylvania Historical and Museum Commission.*

served as superintendent of the Juniata Division of the Pennsylvania Canal. In addition to his work of supervising the contractors who built the Eastern Division of the P&C and issuing certificates to pay their contracts, Mitchell furthermore designed his own version of the popular "T Rail" that was eventually used by the railroad. As a result of the 1832 cholera epidemic, Mitchell claimed to have established "cholera hospitals" to assist ailing railroaders. An April 9, 1833 State of Pennsylvania resolution, "For the Relief of William B. Mitchell," authorized repayment of $1,030 to Mitchell, which he claimed to have expended in procuring "physicians, medicine, and a temporary hospital." This is a direct reference to the outbreak of cholera within the workers' shanty that led to the deaths of at least some of the laborers at Duffy's Cut.

On May 11, 1835, Mitchell resigned as superintendent of the P&C, and he went west to Indiana and led the survey for the Erie and Michigan Canal. In the December 1836 report of the General Assembly of the State of Indiana, it was reported that the state was "fortunate as to obtain the services of William B. Mitchell, Esq., Civil Engineer, whose long experience on both canals and rail-roads in Pennsylvania, rendered his services

peculiarly valuable on this line." Mitchell also surveyed the first railroad. In 1841 Mitchell, a Democrat, became a state senator from Elkhart County, Indiana. He died in 1844, and upon his death, unanimous resolutions in both the Senate and House of Indiana expressed sorrow. He was buried at Middlebury Street Cemetery in Elkhart, and in 1895, his remains were transferred to Grace Lawn Cemetery.

While Mitchell presented Duffy's tale of woe, that half of his work crew died from cholera, Mitchell also noted that Duffy was a "perfect master of the art of complaining, with or without cause." Nevertheless, after Duffy finally completed his work, Mitchell immediately hired Duffy again to work on another section of the P&C. The Mitchell Letter was not the only railroad assessment of what happened at Duffy's Cut. Within the PRR Duffy's Cut file, there are several documents that speak to what happened there in August 1832.

THE PRR FILE

As the guiding force behind the compilation and the preservation of the PRR file, PRR president Martin Clement (1881–1966) summarized what he had learned from those he had interviewed and from several other sources. Clement asserted that fifty-seven men died at Duffy's Cut in August 1832. He furthermore believed that all the workers died of cholera. That information is found summarized on the cover of the file, and that is what Clement believed actually happened at Duffy's Cut.

Clement also collected reflections from railroaders who worked in the area of Duffy's Cut in the nineteenth century, and within those remembrances there are a number of different sources suggested for the deaths of the laborers at mile 59. In the letters from local railroaders, Clement had heard from men who both worked at the site and who either heard the story of from other locals or had a relative who lived through the events of August 1832.

In his letter to Clement, James Dixon stated that he had learned that fifty-seven men had "contracted yellow fever from some person who came in from the south." While Dixon correctly listed the number of the dead at Duffy's Cut at 57, the claim that the men who died there died of "yellow fever" has no basis in the known facts. Cholera, not yellow fever, was present in the Delaware Valley in the summer of 1832. In railroader George Dougherty's

letter to Clement's PRR colleague George Sinnickson (1874–1934), he repeated both what he had learned from fellow railroaders in the Malvern and Frazer areas and what he learned from his father—that the men who died at Duffy's Cut "died with the cholera." In his reflections to Sinnickson, Thomas Furlong stated that the men "died with collery [*sic*]." James Kerns (1841–1929), in his letter to Sinnickson, stated that he learned that "there were 50 or 60 men buried there who died of the cholera." In his letter to George H. Brown, Supervisor J.K. Johnston (1860–1942) stated that he had learned that the workers at Duffy's Cut died of what he called the "Bourbonic plague [*sic*]." Clement accepted what had been reported in the 1832 newspapers, that cholera was present in the workers' shanty in August 1832.

Clement also collected several newspaper pieces that reported on the deaths of the laborers at the site. In his November 30, 1909 article in the *Daily Local*, Reverend Alden Quimby (1854–1922) repeated what he had learned from a local resident several years before, that sixteen track laborers died of cholera at Duffy's Cut. Clement furthermore accepted much in Julius Sachse's 1889 piece, "The Legend about Duffy's Cut," which Clement had transcribed onto PRR letterhead. Sachse's piece corroborated several important pieces of information that are contained in other sources, and he also offered some unique details that have been borne out by modern research and archaeology.

Sachse based his article on the recollections of an "old resident" who was a contemporary of the events of August 1832. Sachse described the area known as Duffy's Fill, which he described as "the bank made over the deep gully just above Malvern…while on each side where the hill was grubbed away was called Duffy's Cut." Writing of the wooden enclosure that had been erected at Duffy's Cut, Sachse stated:

> [T]*here is a sad bit of history connected with this small enclosure. The contractor for this section of the Philadelphia and Columbia Railway was one Duffy, from him the cut took its name, even to the present day. The work here was heavy, and the Contractor in the early summer of 1832, employed a large number of Irishmen, who had but lately arrived on these shores. They were mostly single men, and without friends in this Country; they lived in a large shanty built on the west side of the ravine….In the month of August the much dreaded cholera suddenly made its appearance among the laborers, many were stricken causing great consternation, and with the improper attention and the lack of proper remedies, the scourge could not but rage with terrible effect.*

Julius F. Sachse account of the Duffy's Cut incident, pages 1–3 (June 1889). From Pennsylvania Railroad File 004.01C, "History of Duffy's Cut Stone enclosure." *Watson Collection*

Sachse reported many of the known facts of the Duffy's Cut story, as corroborated by local 1832 newspapers and the Mitchell Letter. From his sources, Sachse had learned about Philip Duffy and his work on the P&C, as well as the cholera outbreak among the railroaders at Duffy's Cut. Archaeological work by the Duffy's Cut Project has excavated the shanty that Sachse mentioned in his article.

Sachse's account seems to indicate an enforced quarantine of the cholera victims in the valley at Duffy's Cut. Enforced quarantines were indeed put into place throughout Europe and in parts of America during the 1832 pandemic. Sachse's account raises questions: How could a work crew of fifty-seven laborers—the "fugitives" from Duffy's Cut, as Sachse described them—be forced back into their shanty, which was located in the valley? Could a simple denial of care force the Irish work crew to go back to a shanty where they knew there was a fatal outbreak of cholera?

A final piece of Sachse's narrative that offers a unique perspective on the event is his description of the nursing work of the Sisters of Charity, who were nursing cholera victims in Philadelphia. While the majority of the sources assert that cholera was present in the shanty at Duffy's Cut in the summer of 1832, Sachse suggests the possibility of the establishment of a quarantine around the valley.

WAS IT CHOLERA OR MURDER THAT KILLED THE RAILROADERS AT DUFFY'S CUT?

What is beyond dispute is that on June 23, 1832, the *John Stamp* landed in the Port of Philadelphia, and Philip Duffy hired the laborers from this ship to help finish the work twenty miles west of Philadelphia at Duffy's Cut. Furthermore, it is beyond dispute that in less than eight weeks, the laborers hired by Philip Duffy to work at mile 59 were all dead. The official public railroad account of those deaths asserts that the Irishmen died of cholera. Nonetheless, within the official railroad records of the deaths of those workers, there are different, and to a degree conflicting, accounts of their demise.

Within the official railroad records of what happened at mile 59, there are accounts from contemporaries as well as other locals who remembered bits and pieces about the event. Still others within the railroad community answered the question of what happened at Duffy's Cut with deliberate obfuscation and considered disinformation. The question remains: how could fifty-seven tough Irish laborers be forced back to a shanty where they knew there was a fatal outbreak of cholera?

CHOLERA AND MURDER

GLOBAL PANDEMIC

The *John Stamp*, the ship that brought the laborers to Duffy's Cut, was a 401-ton Newcastle barque (a three-masted sailing ship that carried passengers and cargo). Passengers bound for Philadelphia boarded the *John Stamp*, which was docked on the River Foyle in the port of Derry, setting sail in late April 1832. After a safe voyage, the ship landed in the Port of Philadelphia on June 23. It had stopped first at the Lazaretto quarantine station, where a physician found all on board to be healthy. On the ship were 160 passengers, 100 men and 60 women, hailing from the counties of Tyrone (70 passengers), Donegal (51), Derry (27), Fermanagh (6), Leitrim (5) and Monaghan (1). There were 18 children among the passengers, and all boys fifteen years of age and over had a profession listed in the ship register; 39 men were listed as laborers, aged between fifteen and seventy years old; twenty-one were in their twenties; and fifteen were in their teens. The laborers came from Counties Donegal, Derry, Tyrone and Leitrim.

The July 21, 1832 *Londonderry Sentinel* newspaper announced the arrival of the *John Stamp* under the section "Londonderry Ship News": "The John Stamp, Captain Young, from this port to Philadelphia, arrived safe after a pleasant passage—all well." The ship captain, John Young, sailed mainly from the port of Cork, Ireland, but in his career, he captained ships from Derry as well as London and carried Irish passengers and cargo

throughout the world, including prisoners to Australia. Captain Young was known for being a safe shipmaster and was a meticulous record keeper. For the ship register of the *John Stamp*, Captain Young listed the names of his passengers, as well as their counties of origin in Ireland, their ages in April 1832, occupations and belongings; he noted if they traveled together. The passengers brought a variety of belongings with them to the New World, including bundles, sacks, chests, boxes, casks, trunks and packages. One passenger even brought a bed.

The *John Stamp* was later lost off the Irish coast on February 17, 1839. The ship was "fully rigged" and was carrying a cargo of raw cotton from Bombay, India, to Liverpool, England, when it sank off Leestone Point, Rossglass, South County Down. Seven of its crew perished.

Duffy's mile 59 work crew arrived in the Delaware Valley at the time of the arrival of a cholera epidemic that had started in 1829 in the Bay of Bengal and moved westward across Central Asia into Russia in 1830 and then into western Europe and Great Britain in 1831. It jumped across the Atlantic in 1832, arriving first in Canada and making its way south following the Hudson Valley into New York City in June. From there, it came to Philadelphia in early July.

The parasitic microorganism *Vibrio cholerae* passes into the body orally, and the source is most often contaminated drinking water. Human excretion into streams was fairly common in the nineteenth century, and in European and North American communities, outhouses were often placed in proximity to wells so that seepage occurred. When ingested, *Vibrio cholerae* attaches to intestinal walls and releases toxins that cause stomach cramps, vomiting and diarrhea. Portions of the intestines flake off in the effort to expel the bacterium, giving the appearance of "rice water" in both stool and vomit. Until modern treatments were available, death resulted from electrolyte loss, dehydration and shock in about 50 percent of cases.

A minimum of 150,000 lives were lost during the global cholera pandemic of 1832, 10,000 of whom were in North America, and 900 of whom were in the Delaware Valley. But a good many victims never got counted in these totals, including victims in three Irish immigrant laborer mass graves in Chester County, Pennsylvania. North American newspapers reported on its path of destruction in Europe prior to its arrival in the Western Hemisphere, and many municipalities tried to prepare for the arrival of a then largely unknown illness. Sanitary commissions were established in a number of cities, including Philadelphia, whose purpose was to attempt to stop the disease at its first appearance by whatever means were possible.

John Stamp passenger list, pages 1–8. *National Archives and Records Administration.*

No.	Names	Residence	Age	Occupation
152	George Quigly	Donegal	22	Labourer 3 Trunks
153	Michael Farran	do	26	Farmer 2 Chests
154	John McClanon	Cy Derry	34	Labourer
155	Mudge do	Tyrone	50	Widow
156	Frank do	do	11	Son of do 1 Chest
157	Jane do	Cy Derry	23	Unmarried
158	Ony Reilly	Farningen	24	Married 1 Bundle
159	Arthurine do	do	3	Daughter of do
160	Edward do	do	1	Son of do 1 Chest

Cholera treatise, 1831. *Watson Collection.*

The problem was that not much was known about the disease, and treatments varied widely, from bleedings to enemas; ingesting calomel, camphor, morphine or quinine; wearing flannel; and establishing quarantines of certain foods considered dangerous as well as infected people. The dominant etiology for the disease in the 1830s was the miasma theory, in which it was said to spread via vapors in the air. An 1831 case in Britain appeared in American newspapers detailing how frightened residents of an English town fired cannonballs into the sky in a futile effort to ward off an ominous cloud during the epidemic there. Most British and American physicians did not believe that it was contagious from person to person, instead believing that a variety of factors made one more susceptible to the disease.

The symptoms of predisposition included indigestion, overheating, exhaustion, a "furred and pasty tongue" and muscle cramps in the arms and legs. The onset of the disease was thought to begin with one of the "exciting causes," including "moral excitements" of fear or anger, overeating and drinking unsafe beverages. Individuals were cautioned to not drink alcohol, not to eat "crude indigestible food" (especially raw vegetables), not to eat shellfish or fresh fruit, not to exert themselves in the heat or expose themselves to drafts of cool air, especially at night, as the onset of most cases was thought to be between 11:00 p.m. and 4:00 a.m. In the early "forming stage," the patient was thought to be treatable, at the onset of camping, diarrhea and vomiting. Physicians urged the public to wear flannel, not to eat or drink immoderately and maintain a "tranquility of mind and body." Quarantines of humans and food were common public health procedures in all of the nineteenth-century cholera outbreaks, despite official skepticism as to whether the disease might be communicable between humans. It was observed that cholera seemed more prevalent in poorer neighborhoods, where the unpleasant odors caused by open raw sewage and dung heaps was thought to provide evidence of the miasmic origin of the disease.

Because the dangerous "cold cholera" stage of the disease manifested a slow pulse in patients, some cholera patients were sometimes diagnosed as being clinically dead when, in fact, they were still alive. Newspapers reported on such cases and of premature burial. It has been suggested that some burials during the cholera epidemics of the nineteenth century in Europe show signs of premature burial. Some American newspapers mockingly reported that intoxicated Irish immigrants (invariably called "Hibernians") were occasionally coffined before the realization set in that the victims were not dead but rather inebriated, and they were rescued at the last possible minute. Some newspapers reported on a woman awakened from cold cholera condition when her husband cut off her finger to retrieve her wedding ring (perhaps a folkloric tale told in previous epidemics and repeated in the 1832 epidemic). Some graves in the nineteenth century were fitted with exterior bells that could be rung from cords inside the coffin to prevent premature burial, believed by some to have given rise to the term "dead ringer."

Cold cholera gave the appearance of catalepsy, a then poorly understood psychological condition (now known to be brought on as well by epilepsy) in which patients experience a trance-like rigidity, slowed and shallow breathing and an inability to respond to external stimuli. American Gothic

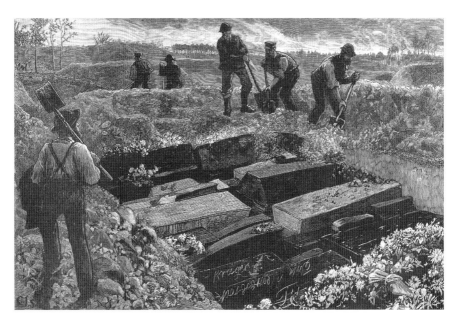

Cholera mass grave in Hamburg, Germany. Nineteenth-century print. *Watson Collection.*

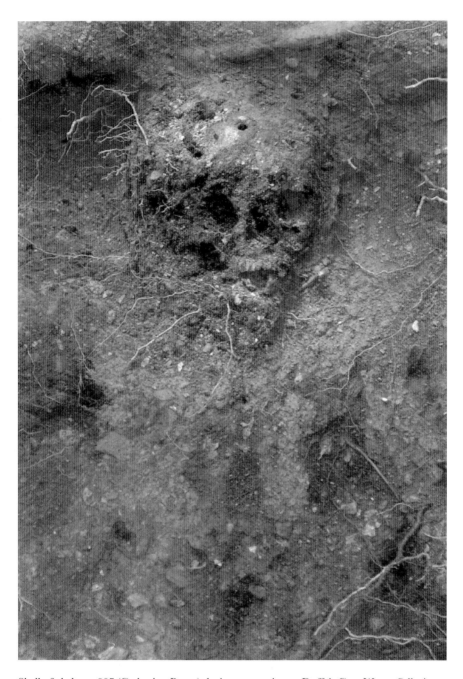

Skull of skeleton 007 (Catherine Burns) during excavation at Duffy's Cut. *Watson Collection.*

author Edgar Allan Poe (1809–1841) wrote several stories based in part on the pervasive fear of live burial due to catalepsy, including "The Premature Burial" (1850), "The Fall of the House of Usher" (1839) and "The Cask of Amontillado" (1846). An American newspaper report of French onlookers falling ill during a street performer's parody of death during the cholera epidemic in Paris in 1831 may have influenced Poe's depiction of death in "The Mask of the Red Death" (1842).

Cholera epidemics recurred in the 1840s and the 1850s, and it was not until 1854 that British physician John Snow (1813–1858) properly diagnosed unclean drinking water as the source of the disease during an outbreak in London. The 1854 epidemic in Italy enabled physician Filippo Pacini (1812–1883) to isolate *Vibrio cholerae* for the first time, but it was not until 1883–84 that German physician Robert Koch (1843–1910), a future Nobel laureate for his work on tuberculosis, was able to fully understand the microorganism.

Cholera in the Delaware Valley

The advance of cholera across the Eurasian landmass was reported in North American newspapers with increasing dread as it arrived in the British Isles in 1831. When it jumped across the Atlantic in 1832 and caused numerous deaths in Canada, American cities began to prepare for the epidemic. The chronology of its passage down the Atlantic seaboard was reported daily in the summer of 1832, with New York City being affected in June-July and Philadelphia in July-August. Various Philadelphia newspapers such as the *National Gazette and Literary Register* and *The Friend* (a Quaker publication) included both daily and weekly reports on cases and deaths by neighborhood in Philadelphia and the surrounding municipalities. Philadelphia was the location of the prestigious College of Physicians, and its medical personnel had extensive experience with epidemics of yellow fever in the 1790s, which had killed one-tenth of the city's population. A Board of Health was created in 1798 to try to oversee efforts at preventing or containing the spread of epidemic diseases.

In 1799, a quarantine station called the Lazaretto was established outside the Port of Philadelphia at Tinicum in Delaware County whose purpose was to prevent the arrival of illness by removing ill immigrant passengers from arriving ships before they got to the port. Henceforth, arriving ships

would be boarded by a physician, who inspected the passengers for signs of illness. Any ill passengers would be taken to the facility's hospital, and the ship would then be cleared to continue on to the port.

In 1832, the city's leading physicians and officials instituted a variety of public safety measures after cholera arrived in Canada, including the establishment of a sanitary committee to oversee the various efforts to prevent or contain the disease. The committee established a medical commission to study the measures being taken in Canada, comprising some of the city's most experienced physicians: Samuel Jackson (1787–1872), Charles D. Meigs (1792–1869) and Richard Harlan (1796–1843). The commission visited Montreal and Quebec City and studied the measures being taken there for the purposes of formulating a plan to deal with the epidemic when it reached Philadelphia. The commission's findings were published in *The Friend* on July 14. The commissioners explained that the different names by which the disease was known—"Malignant," "Asiatic" and "Spasmodic" cholera—were all the same. They suggested that cholera was not contagious; that both the physical predispositions and exciting causes must be present for a person to become ill; and that the onset of illness is almost always at night. The commission's advice to prevent the disease consisted of "the wearing of flannel particularly on the body, keeping the feet warm and dry, the avoidance of improper food and drinks, tranquility of mind and body." When the epidemic arrived, the commission and the Board of Health supervised the creation of cholera hospitals to treat patients with the primarily palliative treatments that existed at the time.

The first case appeared in Philadelphia on July 7, and city officials began pumping water from the Schuylkill River into neighborhoods to flush out accumulated "night soil," which was thought to be connected to poor air and hence the miasma in which cholera was thought to thrive. The odor of excrement seemed more apparent in poorer neighborhoods, crowded with immigrant tenements. During the course of the summer, the majority of cholera cases and deaths occurred in the working-class neighborhoods of the city, However, only a few cases appeared in the city during the month of July, and it was thought that the flushing out of night soil and whitewashing of curbs were sufficient acts of "purification" to prevent the disease from becoming an epidemic. Clergy of many denominations in the city participated in a day of "fasting, humiliation and prayer" on July 19, and Irish-born Catholic bishop Francis Kenrick (1796–1863) issued the following proclamation regarding diet that lasted until the third week of September:

The excess too frequently committed in eating, and still more frequently in drinking, must be abandoned by all who wish to flee the wrath to come and escape the overflowing scourge. As the use of vegetables and fish is considered by eminent gentlemen of the faculty to predispose the system to disease, the obligation of abstinence from the use of flesh meat during the continuance of the alarm or prevalence of the malady will be dispensed with.

In early August, despite the "purification" policies, cholera began to reach epidemic proportions in the city proper and nearby municipalities. Newspapers began reporting the daily and weekly cases and deaths marking the progress of the disease. Knowing from newspaper stories that cholera had ravaged New York City in June and July, many Philadelphia residents began fleeing the city to outlying areas to the west. *The Friend* described the ensuing panic "like an electric fluid [which] seemed to have been suspended in the atmosphere." The panic is also described in the diary of a local Quaker gentleman dated August 8–18, preserved by Priscilla Walker Sheets, entitled "Account of the Cholera the Day It Broke Out at Arch Street Prison in 1832 Written by My Dear Father Lewis Walker." After describing the outbreak among prisoners in Arch Street Prison and the Blockley Almshouse, and the city's cleansing policies to remove "every foul filth whatsoever deposited," he remarked that a substantial part of the population was preparing to flee, "yet, very many are on the wing and are just waiting to take their flight. Wither to they know not." He continued:

None of the small towns within a few days ride of this may be exempt. The only chance of escaping the disorder—some consider the farm House the most probable. I saw this day several families removing out with much avidity. Wither to I know not. Its not unlikely very many more will follow the example in a few Days if the[y] *can possible* [sic] *make the necessary arrangements. I do not consider it a light matter for people to abandon their Business and homes for weeks or months. Having no certain knowledge when they may return. We all have our fears and apprehensions of some sort or other. Its true we know not where we are safe, whether at home or in the bustle of Business, or in the pursuit of Safety by flight to an adjoining neighborhood.*

Walker described a barber discharged from prison, apparently showing no signs of illness, who then shaved his customers as usual and yet was

dead by nightfall. Referring to the prevalent idea that alcohol consumption predisposed individuals to the illness, Walker stated, "It is not unusual for some of the intemperate class to be swept off in but a few hours sickness." Continuing with this theme, Walker referred to the alcohol-consuming population of the city as "the refuse of Human Nature" and "outcast Sons and Daughters of Baccus." He believed that "were the disorder to continue a few months longer their number would be almost extinct."

Walker, however, noted that "[i]t is not altogether confined to that class—here and there we see a respectable Citizen, who had been uniform in life and habits falling before the destroying angel." Walker was not alone in viewing the epidemic as a "Righteous Judgment from the Almighty." Cholera as divine chastisement for sin was a recurring theme in a good many newspapers and in sermons preached from pulpits in Philadelphia and across North America.

In 1832, the city of Philadelphia proper had a population of 80,462, and the nearby contiguous townships and boroughs that radiated out to the north, west and south, which would later be consolidated with the city (in 1854), contained populations of tens of thousands more, many of whom were industrial immigrant laborers. Moyamensing had a population in 1832 of 6,822, Southwark had a population of 10,202, Kensington had a population of 13,394 and Northern Liberties had a population of 28,872. These communities, like the city proper, contained crowded neighborhoods with outhouses close to wells, human waste dumped in the streets and inadequate public safety resources. The number of cases in August in these areas was cumulatively as large as the number of cases and deaths in New York City in the preceding month.

In a four-day period at the end of July, there was a major spike in cases in the city and Northern Liberties: 46 new cases and 22 deaths. On August 1, 21 new cases and 8 deaths occurred on a single day. On August 2, there were 40 new cases and 15 deaths, 13 of which cases were among the inmates of the Arch Street Prison, as was 1 death. The prison's 210 petty criminals and 21 debtors were especially susceptible to the illness given the cramped conditions in which they lived, and within a few days, the number of cases at the prison rose to 80. Both the inmates and the guards were in a state of panic when, at last, some charitable, civic-minded citizens intervened on August 5 to pay their fines and obtain the release of the healthy prisoners. The epidemic continued to spread rapidly, however, and from August 4 to 10, there were 830 new cases and 326 deaths in the city and Northern Liberties.

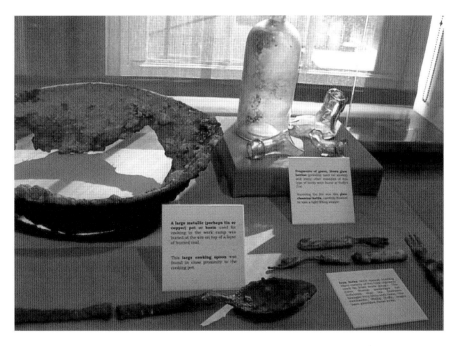

Duffy's Cut artifacts on display, including medicine bottles. *Watson Collection.*

August 6 and 7 proved to be the worst days of the epidemic in the Philadelphia region. The cases and casualties during this one week matched or even exceeded those in other hard-hit municipalities in North America, such as New York City (generally considered to be where the worst casualties occurred). On August 6, the city and Northern Liberties had 176 new cases and 71 deaths, and on August 7, there were 136 new cases and 73 deaths, exceeding the number of deaths in New York City on those days (68 on each day).

Treatment was provided in private practices and hospitals and in the Blockley Almshouse (located on Spruce Street, between Tenth and Eleventh Streets), and there seem to have been more cases and more deaths in the city's busy cholera hospitals. As the epidemic became worse at the end of the second week of August, medical professionals in the hospitals became more fearful of contracting the disease and discipline collapsed. Many abandoned their posts.

The Committee of the Almshouse reported:

> *When cholera made its appearance in the different wards of the Almshouse, and led to the belief that the atmosphere of the whole institution was infected, the nurses and attendants became clamorous for an increase in wages, and*

after their demands were gratified, such was the appalling nature and extent of the disease, that fear overcame every other consideration, and it was found impracticable to keep the nurses to their duty or to obtain, at a reasonable price, proper persons to attend to the sick....In one ward where the disease raged in all its horrors, where one would suppose that the heart would be humbled and the feelings softened at the sight of distress, the nurse and her attendants were in a state of intoxication, heedless of the groans of patients and fighting over the bodies of the dying and the dead...the few good nurses were broken down by loss of rest and by fatigue, and the remainder abandoned the sick from fear of disease or resorted to intoxication....Under these circumstances the committee came to the determination of soliciting the Sisters of Charity at Emmitsburg to take charge of the wards, and for this purpose they applied to Bishop Kenrick.

One of the almshouse directors, Dr. Jesse Burden (1796–1875), asked Bishop Kenrick to bring several members of the Sisters of Charity to assist in the epidemic as nurses. Five members of the order had already been working in Philadelphia in the St. Joseph's and St. John's orphans' asylums. They were soon joined by eight others of the order who left their headquarters in Emmitsburg, Maryland, to come to the disease-ravaged city. Most of the sisters were Irish Americans. Eight of the sisters worked in the almshouse, and the remainder worked in the city's other cholera hospitals.

St. Augustine's Catholic Church (Fourth Street, between Race and Vine) was turned into a cholera hospital by its pastor, Father Michael Hurley, OSA (1780–1837), and two sisters served as nurses there under Dr. Oliver H. Taylor. Only 63 of the 370 patients treated at St. Augustine's were Catholic; the remainder were Protestant, a fact that anti-Catholic nativists forgot in the 1844 riot that destroyed the church. Kenrick later said that during the epidemic, the sisters "displayed an example of heroic fortitude," priests "proved their strong virtues" and "non-Catholic ministers generally fled from the city."

The almshouse committee reported that the sisters "left a healthy home to visit an infected city, to encounter a dreadful disease, to live in an atmosphere dangerous in the extreme, to watch by the bedside of the friendless." None of the sisters perished in Philadelphia due to the disease in 1832.

The epidemic reached its greatest extent in Philadelphia in mid-August, when all sanitary measures undertaken by the Board of Health failed to prevent a general outbreak. On August 18, an astounding 535 cases were reported by *The Friend* in the city, Northern Liberties, Kensington, Southwark

and Moyamensing. By then, cholera also had spread to surrounding suburban counties. The September 8, 1832 *National Gazette and Literary Register* included a front-page notice on the arrival of cholera in Chester County, with cases reported at White Horse Tavern, Gunkle's Mill and the Great Valley, as well as along the rail line at mile 59. The report noted 11 cases and 9 deaths from September 17 to September 25, including the names of a few of the victims: Davis, Speer, Hall and Ogden. Disparaging remarks were made about some of the victims, presumably the more economically disadvantaged ones. Three members of the Speer family and an unnamed man living with them, all of whom died, were described thus: "All were intemperate, and ALL ARE DEAD! The house, or rather hovel, in which they lived, with all its contents, was burned immediately after the bodies were buried." On the other hand, a Mr. George Hall, who also died, "was, we believe, a respectable citizen."

Then, on Saturday, September 25, William Ogden died. The *Gazette* stated that "he was at the appraisement of sundry cows, pigs, &c. of Speer's, and was attacked shortly afterwards." The death of William Ogden was another kind of death. A member of the local gentry, he was a lieutenant in the local militia, and his family lived along King Road near the Green Tree in Intersection, which later became known as Malvern. An undated notice in the 1909 PRR file on Duffy's Cut states that the youngest of Ogden's three daughters, Sarah Wayne Ogden, had possession of a diary written by her older sister in 1832 that referenced the deaths of the Irish work crew, but the diary was not included in the railroad file and it subsequently disappeared.

The evolution of the narrative of the death of the immigrant work crew at mile 59 is an example of the development of railroad "spin." The number of workers who were victims of the epidemic differs substantially between what the railroad maintained internally in documents dating between 1833 and 1909 and what was released to the public at the time in newspapers. In the spring of 1833, the railroad's Eastern Division superintendent, William Mitchell, maintained that Duffy lost half of his crew to cholera (i.e., half of 100 to 120) in the previous summer of 1832. The Pennsylvania Railroad file on the incident created in 1909, containing accounts by railroaders and other sources circa 1832 to 1909, stated specifically on the cover and throughout the documents that fifty-seven Irish workers died of cholera at the site. The public retelling of the story was done in such as a way as to minimize the number of victims, from six to seven and then from eight to nine, undoubtedly in order to maintain the payment of shares by the railroad's investors and maintain the influx of inexpensive Irish labor for rail construction.

What kind of detail the diary contained is unknown, but its absence in relation to other kinds of subsequent obfuscation and misinformation provided by the railroad and by locals makes the 1909 notice of its existence quite curious. Regarding the work crew at mile 59, the *Gazette* states:

> *It is reported that several cases have occurred lower down the Valley, among the labourers of the Pennsylvania rail road. Mr. Mitchell, the general superintendent of the rail road, is about establishing Cholera Hospitals along the line of the road. The charge of Hospital No. 2 is committed to Dr. J.M. Pugh.*

There is no evidence that a "hospital" was ever established at the site of the Irish workers' camp, but there is a record in the Pennsylvania Archives of a sum of $1,030 approved on April 9, 1833, to pay for "doctors, medicines, and a temporary hospital for laborers" at the site. There is no other surviving source that refers to the existence of a hospital at the site, and in fact, it may be evidence of payment for a subsequent coverup. Duffy and his blacksmith both went westward in 1833 to work on other P&C contracts. The blacksmith also appears in a subsequent report of the incident regarding the care of the sick and dying. Two men named John Pugh owned land along the rail line, east of Duffy's Cut, and signed contracts with the railroad to agree to put up a fence to separate the properties: John Pugh Sr. at mile 68 and John Pugh Jr. at mile 64. John Pugh Jr. also signed a contract for work on mile 64:

> *The said John Pugh doth promise to construct according to the directions of the Principal Engineers or assistant Engineer, all the necessary pavement on a piece of the turnpike road on the Sixty fourth section of the Pennsylvania Railway, to be made in lieu of a part of the Philadelphia and Lancaster turnpike road.*

The next extant contemporary news source for the event, after the *Gazette* of September, is a "correction" in the *Village Record* of West Chester from November 7 that purportedly was published to update the public on a story from a previous issue from October 3, whose earlier article appears to not have survived in any form, suggesting it may have been pulled from the record at or close to its publication date.

The November 7 newspaper piece is simply entitled "The Cholera":

> *As faithful chroniclers, and to prevent exaggeration, we deem it proper to state, that on the Railway, in East Whiteland Township, a fortnight ago,*

several cases of Cholera occurred, eight of which proved fatal—it then ceased suddenly as it commenced. One man, from there, moved up to the Valley creek, near the line of East Bradford and East Caln, where he died. One other person also died immediately afterwards. A humane man, a Smith by trade, remained as nurse, while all the other workmen fled. Having shaved and decently laid out the second man who died, he blew his horn and called in some neighbors who aided to bury him. The contractor, after a day or two set fire to the shantees and burnt them down.

The disease extended no farther; the humane smith is hearty. All along the line we learn, it now is, and has been, through the summer.

The unnamed blacksmith appeared in an account fifty-seven years later in a piece for the May 3, 1889 *Village Record* written by local historian Sachse and subsequently transcribed in the PRR file on Duffy's Cut. It is a notice based in part on a conversation with a local man who appears to have had intimate knowledge of the events, noting that four anonymous Sisters of Charity from among the fourteen sisters working in Philadelphia city cholera hospitals were called to administer what aid that could be rendered, and Duffy's unnamed blacksmith (possibly Malachi Harris) also tended the ill and buried the dead. Sachse wrote that the when cholera struck the camp, some of the men fled and sought help in the community, "but so great was the fear of the surrounding population, that every house was closed against the fugitives, no one was found willing to give them food and shelter." Then, according to Sachse, "fear changed to panic, the fatal spot was avoided by all, with the single exception no one was left to minister to the wants of the sick or bury the dead." Sachse also mentioned that the blacksmith blew his horn for help, but no one came. The blacksmith, Sachse wrote, buried the dead one by one at a site later commemorated by a wooden fence (placed by railroader Patrick Doyle in 1873 and replaced in 1909 by a stone monument erected on orders from then PRR assistant supervisor Martin W. Clement).

At some point, according to Sachse, someone (perhaps Duffy) called for help from the diocese, and four Sisters of Charity were sent to help from among the fourteen nuns tending the sick in Philadelphia cholera hospitals. The coach carrying the nuns stopped about a half mile from the shanty at the Green Tree Inn, and the nuns were forced to walk into the valley. Despite their efforts, all fifty-seven men died, and when the sisters' work was completed, they were shunned on their way back to Philadelphia. No one would convey them back into Philadelphia by coach or even provide water or food. They walked the length of Lancaster Road eastward from

modern-day Malvern back into the city. Sachse reported that Duffy ordered the shanty to be burned.

The *Gazette* referred to one of the Duffy's Cut workers running westward from mile 59, fleeing from cholera in the valley. He fled along the unfinished line to another Irish immigrant workers' site at mile 48, perhaps to friends or relatives working under another Irish contractor, Peter Connor (died in 1832). Connor's P&C contract for mile 48, signed on May 18, 1831, included the same kind of work that Duffy's crew did at mile 59: grubbing and clearing the section; removal of sand, earth, clay and loam; removal of cemented gravel and hard pan; removal of embankment; removal of detached rock and slate rock; removal of solid/blast rock; and construction of cross drains. There were four property owners at mile 48 according to the contract signed with the P&C for fencing along the line: Henry Gallagher, Abner Baldwin, Margaret Lewis and William Torbert. Mile 48 is located at present-day Downingtown, eleven miles west of Duffy's Cut in Chester County. Later sources, including Pennypacker's *History of Downingtown* (1909), include a reference to a mass grave from mile 48 (at the site of present-day Northwood Cemetery, incorporated in 1871):

> *The old tradition that there was a cemetery at Northwood previous to the present one is incorrect. A number of persons, however, were buried there, especially the bodies of certain Irish laborers, who died of cholera during the epidemic of 1832. They were employed on the Pennsylvania Railroad and their homes were unknown. These graves lie in the eastern part of the cemetery, near the gully.*

There are interesting chronological convergences between events at mile 48 and mile 59. In 1832, both were the scene of a deadly cholera outbreak; at the time of the 1870s track expansion, it is likely that human skeletal remains were located at each place, with a wooden fence being placed to commemorate the deaths at mile 59 and a cemetery being made at mile 48. In 1909, during further track expansion, the wooden fence at mile 59 was replaced by a stone monument, and material on the event was compiled into the PRR file, while the story of the event at mile 48 was recorded in Pennypacker's history. Elsewhere along the line, however, recollections of the epidemic of 1832 became progressively dimmer by the passage of time in a century after the event.

The epidemic began to subside in the Delaware Valley in late September and moved progressively farther south along the Atlantic seaboard. The City

of Philadelphia paid the Sisters of Charity $100 on September 18 to pay for the sisters whose habits were ruined by their work in the almshouse. A citywide thanksgiving celebration was held on November 15 for deliverance from cholera, and a silver plate was approved as thanks to the physicians and sisters who had helped in the cholera hospitals. The sisters, however, declined the plate and asked that the money instead be sent to help the orphans asylums they administered and also the Female Free School on Prune Street. To most observers, the disease simply vanished as suddenly as it had arrived, taking with it between nine hundred and one thousand lives in the Delaware Valley.

MURDER

Obfuscation and changing the public record was done by railroad management following the deaths at Duffy's Cut because the story was bad news. It could prevent the easy recruitment of new, inexpensive Irish laborers in the future, and it potentially harmed the public perception of Chester County, where immigrants might fear that quarantines and nativist hostility could be awaiting them. The story was unpleasant also for the self-perception of the people of East Whiteland Township, who lived in proximity to the mass grave at mile 59. Changing the number of dead at Duffy's Cut from fifty-seven to "eight or nine" was done strictly for propaganda by the railroad, while the railroaders themselves always maintained the actual higher number of fifty-seven. It would have been just as easy for the railroad to maintain the smaller number of casualties in its internal records as well, but perhaps some kind of collective moral conscience made that impossible.

Sources on Duffy's Cut that once existed subsequently vanished from the historical record, such as the Ogden diary, mentioned in the PRR file on Duffy's Cut, and the October 3, 1832 *Village Record* newspaper, which contained an article on the event that was "corrected" by the November 7 piece. The only contemporary agency that seemingly could have pulled every copy of the October 3 issue from the record at the time appears to be the East Whiteland Horse Company. This organization was charged with retrieving stolen horses in the township, but it also would have operated in the capacity of a legal vigilante group, working in conjunction with the local judge, Cromwell Pearce (1772–1852), a former Chester County sheriff and

Barlow knife from skeleton 005, excavated at Duffy's Cut. *Watson Collection.*

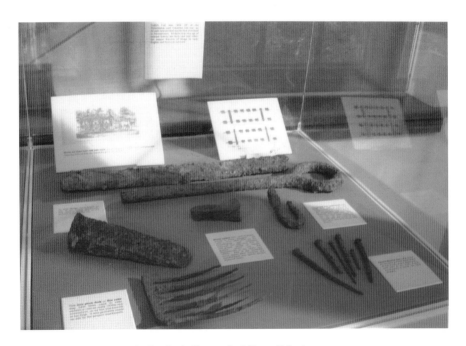

Duffy's Cut artifacts on display, including tools. *Watson Collection.*

officer in the U.S. Army in the War of 1812. Pearce lived about a half mile east of Duffy's Cut along King Street. No name would have been so despised and feared by Irish Catholics in the early nineteenth century than Cromwell, as Oliver Cromwell's policies two centuries earlier had cost Ireland a quarter of its population.

The East Whiteland Horse Company was dominated by the Pratt family, who owned the land at mile 59 and who signed an agreement with the railroad to construct a fence adjacent to the rail line to delineate their property. Horse companies operated throughout the United States during the nineteenth century, and the western versions are much better known in the literature. The question of whether horse companies could administer any punishment to suspected horse thieves was likely decided by local custom and local sensibilities as much as by the local judiciary. Its members naturally consisted of local farmers who had a need to protect their horses. A quarantine placed at mile 59 to contain cholera clearly would have been within the jurisdiction of the East Whiteland Horse Company, particularly so because the Pratt family owned the land.

Since cholera mortality rates in premodern cases were about 50 percent of the cases, it is statistically improbable that all the Irishmen at Duffy's Cut died of cholera. Quarantines of victims were common during the epidemic. The British Board of Health had established human quarantines in the United Kingdom in 1831, and in the epidemic in America, people were also quarantined in 1832. Instances of quarantines of infected workers along the

Skeleton 003 during excavation at Duffy's Cut. *Watson Collection.*

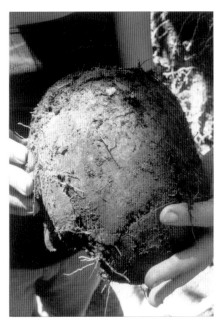

Skull of skeleton 003 during excavation at Duffy's Cut. *Watson Collection.*

Baltimore and Ohio Railroad and the Chesapeake and Ohio Canal were described in Maryland newspapers in 1832. In numerous instances, sick workers were reported to have been taken away from proximity to their healthy colleagues to a remote place in nature or into to a barn, to die alone without care. Even if care at the time consisted only of palliative measures, the psychological effect of care actually might help patients recover. Such actions of quarantine did not fit a legal definition of murder, but deliberate neglect caused uncounted numbers of deaths in the 1832 epidemic. The narrative of events at mile 59 points to the existence of a quarantine that went awry and resulted in more direct human intervention causing the death of the workers. Fear of cholera, merged with nativist hatred of immigrants, would provide more than enough of a motive for murder.

There were indeed examples of outright murder during the 1832 epidemic in the Delaware Valley. Infected victims and a man harboring them in Chester, Delaware County, were reported to have been murdered during the epidemic. Farther west in Chester County, however, around the time of the incident at Duffy's Cut, a terrible case of murder of an immigrant family suspected of having cholera was reported in local newspapers. The story, titled "Unparalleled Barbarity," seems to have made the rounds in several papers, including the *Village Record*, the *Chester County Democrat* and the *Thomsonian Recorder*. The *Recorder* included a preliminary note to the article stating the necessity of including the details of the story of "superstition, ignorance and cruelty."

The story entailed the arrival of an old man and his family in Chester County who were erroneously thought by their neighbors to be carrying cholera and who became victims of "murder and incendiarism, equaling in enormity…the most barbarous cruelties practiced among hostile savages." Neighbors first shunned the old man and his family and then drove them

from their home, so that they were "wandering about without shelter." A local mechanic took the family into his home, but panicky neighbors lynched them all:

> *His house…was surrounded in the dead of night by a mob, who rushed in, murdered the owner, the old man, and his family, and then fired the building, which was reduced to ashes. The writer of the account states that on the next day might be seen the "bones of the miserable victims blackened by the smoke of the mouldering ruins, lying exposed to the public gaze." It is understood that the ringleaders have been arrested.*

There is no surviving record of a trial and no mention of what became of the perpetrators. One week after the story appeared in the *Village Record*, a "correction" appeared similar to the subsequent "correction" of the Duffy's Cut story. In the case of the murder of the family suspected of having cholera, the rewrite implausibly stated that it had all been a parody of the fate of the Masons. A short time after this "correction," the editor of the *Village Record* abruptly quit his post and left the area.

The *Village Record* of June 9, 1829, which reported that Philip Duffy had commenced work on mile 60 with his "sturdy-looking band of the Sons of Erin," also included an ominous note about the need to avoid potential problems between laborers and local property owners a short distance from Duffy's Cut:

> *We are sorry to learn that upon some sections, too little attention has been paid to the rights and property of farmers, through whose land the rail road passes. It is complained that fences are too often left prostrate, to the destruction of valuable crops of grain, grass, &c. It is a matter of the first importance to preserve a good understanding between the people living adjacent to the route, and contractors and hands employed in the work. The disregard of this has been the fruitful source disorders and riots in some parts of the country.*

To the potential problems consisting of "disorders and riots," one might also include quarantines in Chester County.

THE PRR FILE

RAILROADERS AND OTHERS REMEMBER DUFFY'S CUT

MARTIN CLEMENT AND GEORGE SINNICKSON AND THE GENESIS OF THE PRR DUFFY'S CUT FILE

There were no efforts to memorialize the Irish laborers who died at Duffy's Cut while Philip Duffy was alive. Whether this was motivated by fear of Duffy or respect for him is not known. Duffy was certainly a formidable character. He was a man of influence within Irish Philadelphia. His reputation would have preceded him as a man who could assist recently arrived Irish immigrants when they settled in America. Duffy was also a man with powerful friends in both the railroad and politics, and for those desirous of working on the railroad, it would have been considered unwise to run afoul of him. Whatever the reason for the nearly four decades of public silence on the topic of Duffy's Cut, it is a fact that it was only after Duffy died that the Irish American railroading community felt free to openly remember the sacrifice of the laborers who lost their lives at mile 59 of the old P&C.

In 1873, two years after Duffy was dead and buried, Irish American railroaders gathered at the site that was known as Duffy's Cut to remember the story of the deaths that occurred there forty years earlier. Several local Irish-born railroaders, including James McCarron (1823–?) and Patrick Doyle (1849–1911), took the lead in organizing their coworkers in a public remembrance of what happened at mile 59. At McCarron's urging, Doyle

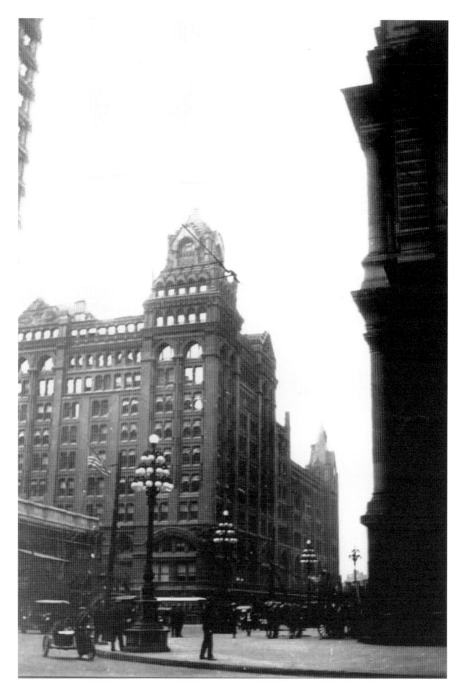

Broad Street Station, 1922. *Photo by Joseph F. Tripician. Watson Collection.*

made a speech to a gathered crowd of railroaders at the spot that they had learned was the site of the mass grave of Irish railroad laborers who had died in 1832. That public gathering of railroaders was the first effort to tell the story of what happened there. That gathering, though, was only the beginning of a movement within the Irish American railroading community that resulted in the erection of the first of several memorials at the site. It also resulted, within the first decade of the twentieth century, in the genesis of an effort on the part of the railroad to gather together those reflections and memories of what happened to the laborers who died at mile 59.

From 1873 onward, railroaders who worked along that mile of track between Malvern and Frazer passed on the tale of Duffy's Cut, and other local residents within that portion of Chester County added their own recollections. That body of knowledge proved to be indispensable to the transmission of the Duffy's Cut story within the PRR community. Thirty-seven years after that first effort to memorialize the dead at Duffy's Cut in 1873, several officials within the PRR recognized the significance of collecting as many of the railroader stories and local reminiscences as possible. These stories and reminiscences were eventually brought together, and the key to what actually happened to the Irish-born work crew who died at mile 59 was, in time, found in a secret railroad file, PRR file no. 004.01C, which was compiled and maintained by the PRR. The bottom of the cover page identifies that the file was maintained as an "Office File, Vice President in Charge of Operation, Philadelphia, PA."

The first page states that the document should never be let out of the office. From the moment the file was compiled to the merger of the PRR with the New York Central Railroad in 1968, the PRR Duffy's Cut file was maintained as a secret file that was not allowed out of the PRR offices.

This railroad file was created between the years 1909 and 1932 by the later PRR president Martin W. Clement and a colleague, George R. Sinnickson, when the two were railroad supervisors at Paoli, Pennsylvania. The PRR file consists of thirty-two pages, with twenty-two separate documents dating from 1889 to 1932. Within this file is a variety of sources, including letters and reminiscences from Irish American railroaders and related railroad memoranda, as well as several newspaper articles. In all, twenty-four individuals left their imprint on the PRR Duffy's Cut File. Twenty-two of these contributors were railroaders; two of those who contributed to the file were local authors whose reflections on Duffy's Cut were added to the file in 1909. One of these local authors, Julius Sachse, had written two earlier newspaper articles that were transcribed on PRR letterhead and added

to the file, while the other author, Reverend Alden Quimby, wrote a short newspaper piece in a local Chester County newspaper that was also added to the file by Clement. Even though the railroad file was kept from public view for fifty-nine years, until the merger of the PRR and the New York Central Railroad in 1968, the twenty-four individuals who variously contributed to the development of the PRR file helped to preserve the story of Duffy's Cut within the PRR leadership; thus, over time, those authors helped to ensure that the Irish laborers who died at Duffy's Cut were not forgotten.

MARTIN W. CLEMENT

The primary creator of the PRR Duffy's Cut file was Martin Withington Clement, eleventh president of the PRR, who was born in Sunbury, Pennsylvania. Clement's mother was Alice Virginia Withington (1855–1933), and his father was Major General Charles Maxwell Clement (1855–1934), a successful lawyer, officer in the Pennsylvania National Guard and president of the Central Railroad of Pennsylvania. Clement's forebears had been Quakers who had arrived in America in 1660 and settled on Staten Island. In time, the Clement family moved to New Jersey, where many members of the Clement family served as lawyers, judges and legislators. There are several historic homes still standing in the town of Haddonfield, New Jersey, that housed members of the Clement family. John Kay Clement (1820–1882), Martin's grandfather, eventually moved to Sunbury, Pennsylvania, where he practiced law. From 1871 to 1878, John K. served as both prosecutor and later as defender of members of the "Molly Maguires." John K. Clement both successfully prosecuted the first Molly Maguire who was convicted, Peter "the Bear" Dolan, and defended the last Molly Maguire to be tried, Peter McMannes.

Martin Clement graduated from Trinity College, Hartford, Connecticut, in 1901, majoring in civil engineering. While a student at Trinity, Clement played on the school football and basketball teams. Clement served as a trustee of Trinity College from 1930 to 1965, and he was awarded an honorary doctorate of human letters by the college in 1951.

Clement began working on the railroad in 1901 as a rodman, assisting in railroad surveys on the Union Railroad in New Jersey. He worked his way up through the ranks into executive leadership roles in the PRR, transitioning from transitman to track supervisor and division engineer; by 1933, he had

Martin W. Clement, circa 1940, Pennsylvania Railroad. *Watson Collection.*

become vice-president of the PRR. Clement became PRR president in 1935. He was fifty-three years old. Clement served the PRR as president until 1948. Upon his retirement, Clement continued to serve the PRR as chairman of the Board of Directors until 1951. He fully retired from the PRR board in 1957.

Standing over six feet tall, Clement was a commanding figure. His face graced the cover of the March 16, 1936 issue of *TIME* magazine. Clement was listed in *Who's Who* and in the Social Register, and in company with other railroad executives, he joined a number of prominent social and hereditary societies, including the Society of Colonial Wars, the Sons of the Revolution, the Society of the War of 1812, the Baronial Order of Runnymeade and the Colonial Society of Pennsylvania. He was also a member of a number of prominent clubs, including the Union League, the Rittenhouse Club, the Philadelphia Club, the Rabbit Club and the Merion Cricket Club, as well as the Gulph Mills Golf Club.

By the time Clement took over the reins of the PRR, his railroad had become "the standard railroad of the world." During Clement's tenure, the PRR remained the largest railroad system in the world. Clement developed the PRR in many significant ways, extending the electrification of the system and modernizing its passenger cars. Clement also led the PRR through World War II, as the railroad played an essential role in the American war effort, enabling the transport of war materiel and troops.

Clement received many visiting dignitaries on his presidential railroad car, including King George VI and Queen Elizabeth (the Queen Mother) and Lord Halifax, the British ambassador, as well as the Crown Prince of Sweden (and future king), Gustav VI Adolf, and his wife and the future queen, Lady Louise Mountbatten. American politicians who rode in Clement's presidential car included U.S. Secretary of State Cordell Hull, as well Hull's successor, Edward Stettinius, who became secretary of state in 1944.

At the peak of his career as president, Clement had an annual salary of $100,000. Under his leadership, the PRR increased its annual operating revenue from $368 million to more than $1 billion (as of 1944). Clement followed the precedent of previous PRR presidents and purchased a mansion along the Philadelphia Main Line. Clement's mansion was named Crefeld and was located in Rosemont. There he died on August 30, 1966, at the age of eighty-four. Clement had served as rector's warden and vestryman at the Episcopal Church of the Redeemer in Bryn Mawr, where he was buried at the church cemetery. His September 9, 1966 *Time* magazine obituary observed that Clement was "a happy blend of operating and financial man, which let him maintain the Pennsy's unbroken record of dividend payments throughout the Depression."

Clement has been described as a "driver," someone who led the men under him by the force of his character and the authority of his office. One anecdote related by Clement's longtime personal assistant, Joseph F. Tripician, described how Clement rode the rails in his presidential car after the horrendous St. Patrick's Day Flood of 1936 and surveyed the damage to the tracks and rolling stock of the PRR. Clement was said to have promoted and demoted railroaders instantly depending on his on-the-spot assessment of their ability or inability to deal with the logistics they faced in the midst of that crisis.

What is of prime importance in terms of Clement's role in the Duffy's Cut story is that, starting in 1909, while he served as PRR assistant supervisor at Paoli under Supervisor George R. Sinnickson, Clement began to collect information on what transpired at Duffy's Cut. Clement, along with Sinnickson, solicited information on the events at mile 59 from local railroaders and residents. Clement was the driving force behind the compilation of the PRR file, and he personally went so far as to advertise in local newspapers for any information on the subject. For most of its history, Clement maintained this file until he retired from the railroad.

Clement learned about Duffy's Cut from the family with whom he resided in 1909. While he worked as assistant supervisor in Paoli, Clement was then living in the home of George (1842–1921) and Bridget Donahue (1842–1911) in Frazer, Pennsylvania, now the site of Immaculata University. George had formerly been a railroader and later retired to work his farm. Bridget was the sister of former railroader Patrick Doyle, whose efforts in 1873 led to the erection of the first memorial at the site of Duffy's Cut. Both George and Bridget Donahue were born in Ireland, and they are buried at the cemetery of St. Agnes Catholic Church in West Chester, Pennsylvania,

where they had been members. George Donahue III, grandson of George and Bridget Donahue, related to the authors that he remembered Clement's sojourn with his family in Frazer and indicated that Clement wanted to commemorate the laborers who died at Duffy's Cut out of sympathy for their suffering and death. What is clear is that starting in 1909, Clement became the chief railroad chronicler of the Duffy's Cut saga.

The stamp of Clement's influence breathes throughout the PRR file, from beginning to end. The cover of the file dates to Clement's time as vice-president. The title of the file reads: "History of 'Duffy's Cut' Stone Enclosure East of Malvern, Pennsylvania, Which Marks the Burial Place of 57 Track Laborers Who Were Victims of the Cholera Epidemic of 1832." The various documents in the file present what Clement and the PRR believed about Duffy's Cut. Through his research, Clement came to the conclusion that fifty-seven track laborers had died at Duffy's Cut. This matches the number of fatalities listed in the 1833 Mitchell Letter, which indicated that a number as high as sixty men had died at mile 59. The number of the dead at Duffy's Cut was set officially by the PRR at fifty-seven. This number was likely set by Clement himself, on the basis of his reading of the sources. The stone enclosure that is referenced on the cover of the file was erected at Clement's instigation in 1909, replacing the original wooden octagonal fence that was first set in place in 1873.

On page eleven of the file, Clement noted the existence of a diary that shed light on the cholera outbreak in Chester County in August of 1832: "Miss Ogden says that her sister's diary shows entry in August 1832 men died of cholera at Frazer." Clement took this reference to "men" dying "of cholera at Frazer" to mean the deaths of the railroaders at Duffy's Cut. The "Miss Ogden" referred to was Elizabeth W. Ogden (1829–1913). Elizabeth was buried at the Great Valley Presbyterian Church Cemetery, where her parents and her two sisters who had preceded her were also buried. Miss Ogden's "sister" referred to by Clement was Mary Ogden (1815–1903), who was seventeen years old when cholera ravaged Chester County in 1832, leading not only to the deaths of some of the railroad laborers at Duffy's Cut but also to the death of her Irish-born father, William Ogden, who died of cholera in the same epidemic. Mary and Elizabeth lived their whole lives with another sister, Sarah Ogden (1820–1900), who was the first of the sisters to be buried at the Great Valley Presbyterian Church Cemetery. Sadly, the Ogden diary that Clement referenced in his file appears to be lost to history. No trace of the diary has been discovered after Elizabeth's death.

Pages twelve, thirteen and fourteen of the PRR file form a letter written to Clement from James Dixon (1844–1923), Irish-born railroader and immediate neighbor of the Donahue family in Frazer. This letter is dated May 11, 1909, and was written to Clement at Paoli. The letter makes clear that Clement had interviewed railroaders like Dixon who had worked along the tracks between Malvern and Frazer. Specifically, Clement had asked Dixon "about the graveyard west of Sugar Town [*sic*] Bridge." The "graveyard" that Clement was investigating was the octagonal wooden enclosure that had been erected by the Irish American railroaders in 1873 and therefore the presumed burial place in that immediate area. In his letter, Dixon stated that he had learned about the events at Duffy's Cut from "an old gentleman residing on Hoods Road" named Isaac Williams (1800–1870?) when he began working for the railroad in 1870. Dixon's letter was one of the sources used by Clement for setting the number of the dead who died at Duffy's Cut at fifty-seven.

On page twenty of the file, Clement also included his design for a plate that he intended having installed at the stone monument that he had erected in 1909: "57 Men are Buried Here. Died with the cholera During the Construction of the Road in 1832." On January 1, 1910, Clement wrote a note to George R. Sinnickson about his plans for the file that he was compiling, as well as for the erection of his memorial plate at Duffy's Cut (page twenty-three of the file):

> *Please hold this correspondence till the plate is erected. I have asked Colgan to make a sketch for me. After it arrives I will get G.E.M. to make a requisition for the plate. After the plate is erected these papers should be filed. MWC*

Clement later indicated that his plan of erecting a memorial sign at Duffy's Cut was turned down because the railroad did not want to spend the money to do so. In an August 9, 1917 letter found on pages twenty-one and twenty-two of the PRR file, Clement wrote to J. Herbert "Herb" Redding (1877–1930), a PRR divisional engineer and later general superintendent of the PRR. Clement's letter was written in response to an inquiry from Redding about the "monument on 'Sugartown Curve.'" This "monument" was Clement's stone wall. Clement was at that time superintendent of the New York, Philadelphia and Norfolk Railroad Company in Cape Charles, Virginia. In this letter, Clement outlined his recollection of the Duffy's Cut story, including the erection of the original octagonal wooden fence and the

building of his stone wall in 1909, as well his plans for the metal plate he wanted to place at Duffy's Cut. It appears that Clement's file was, for a time at least, in Herb Redding's office:

> *If you will search your files you will find a print of this plate and several newspaper clippings covering information, as I advertised in the West Chester newspapers for any definite information on this subject.*

It is clear from Clement's letter that there was an interest in the Duffy's Cut story that developed in 1917. Whether this interest came from railroaders working at the site, or for some other reason, is not known. Whatever the source of the interest in Duffy's Cut may have been in 1917, Herb Redding had gone for information to the man who created the file, Martin Clement. Clement concluded his letter by stating, "I have no book which covers the subject." As his file continued to be developed and redacted over the years, Clement would provide sufficient archival material for later researchers to piece together the details of the Duffy's Cut story.

GEORGE R. SINNICKSON

George Rosengarten Sinnickson was born in Philadelphia, the son of Charles P. Sinnickson (1844–1927) and Emma Sophia Rosengarten (1847–1911). The Sinnicksons were originally from Salem, New Jersey. Charles was an 1865 graduate of the University of Pennsylvania and a member of the University Zelosophic Literary Society. He was a successful lawyer in Philadelphia and became a member of the Philadelphia Club and the Racquet Club of Philadelphia, as well as the Sons of the Revolution. Emma was born in Philadelphia, the daughter of George D. Rosengarten and Emma Bennett, both born in Germany. George D. Rosengarten became an award-winning pharmaceutical manufacturer as well as a prominent member of the board of Mechanics National Bank in Philadelphia.

George R. Sinnickson received his given name and his surname from his maternal grandfather. He continued his family's Ivy League tradition and was educated at Princeton University, graduating in 1896 with a BS. Anticipating Sinnickson's career with the railroad, his graduation thesis was titled "The Pennsylvania Railway Bridge Crossing Luzerne and Tulip Streets, Philadelphia, PA." While at Princeton, he was a member of the Colonial

Club. Sinnickson followed his father and grandfather's example and joined the Philadelphia Club. According to his U.S. passport applications, Sinnickson was a little over five feet, eleven inches tall and had brown hair. In 1908, he married Mary Lippett in Rhode Island.

Trained as a civil engineer, Sinnickson worked on the railroad beginning in 1897 as a chainman on the Delaware and Raritan Canal, and then later that year, he became rodman on the Philadelphia and Erie Division. The following year, he went back as rodman to the Delaware and Raritan Canal. Sinnickson rose quickly through the ranks. In 1900, he became the assistant supervisor in the Amboy Division, and in 1901, he was transferred as assistant supervisor of the New York

George R. Sinnickson. *Watson Collection.*

Division. In 1903, he was made supervisor of the Tyrone Division, and in 1904, he moved on to become supervisor of the Monongahela Division. In 1905, he became supervisor in McKeesport, Pennsylvania.

By 1909, Sinnickson was supervisor at Paoli, and it was there that he learned the Duffy's Cut story, likely from his assistant supervisor, Martin Clement. Along with Clement, Sinnickson attempted to piece together what happened at Duffy's Cut in 1832 by inviting the reflections of local railroaders. The letters addressed to Sinnickson in the Duffy's Cut file bear witness to his interest in the story of the laborers who died at mile 59. During his sojourn in Paoli, along with a number of other local railroaders, Sinnickson became one of the charter members of the Paoli Fire Company.

Sinnickson continued his swift rise within the PRR. In 1911, he became divisional engineer in Williamsport, Pennsylvania, and in 1913, he moved to Reading, Pennsylvania, where he was appointed superintendent of the Schuylkill Division. In 1916, Sinnickson became superintendent of the Baltimore Division. While in Baltimore, he also served as superintendent of the Philadelphia, Baltimore and Washington Railroad, as well as the Baltimore and Sparrows Railroad. By 1920, Sinnickson was back in Philadelphia, and he was listed in the city directory as president of Acme

Agricultural Accessories in Philadelphia. While in Philadelphia, he and his family lived on the city's fashionable Rittenhouse Square.

Sinnickson eventually moved back to his family's ancestral hometown of Salem, New Jersey, where he and his family were member of St. John's Episcopal Church, in whose cemetery Sinnickson's parents are buried. Sinnickson died in Salem, but he was buried at the cemetery of the Episcopal Church of the Redeemer in Bryn Mawr, where his onetime colleague Martin Clement is also buried.

Sinnickson's significant role in the transmission of the Duffy's Cut story is evident in the three letters addressed to him and one written by him in the PRR file. These four letters provide significant detail about both the events that occurred at Duffy's Cut and how later Irish American railroaders commemorated their deaths. The first letter to Sinnickson appears on pages fifteen and sixteen of the PRR file and is from a local-born railroader named George Dougherty (1845–1924), whose parents were from Ireland. Dougherty's letter was written to Sinnickson on May 10, 1909, and came as a response to Sinnickson's inquiry concerning the "mound that is fenced at Duffy's bank." The name "Duffy's Bank" refers to what is also called "Duffy's Fill," the earthen railroad bridge built of fill taken from the gouging out of the earth at Duffy's Cut. Dougherty was able to inform Sinnickson of the work done in 1873 by McCarron and Doyle in erecting the first fence at the site of the mass grave. Dougherty suggested that Sinnickson contact James Dixon for more information, and most significantly, Dougherty indicated what he had learned from his father about the location of the mass grave. This letter would prove to be very important in helping to locate the first seven burials at Duffy's Cut in 2009 and 2010.

Immediately upon receiving Dougherty's letter, Sinnickson had Martin Clement contact James Dixon, while he himself made inquiries to two other railroad foremen: the Irish-born Thomas Furlong (1842–1917) and a Pennsylvania native of Irish descent, James Kerns. Sinnickson had written to Furlong on May 10, 1909, about the burial "mound west of Malvern." In his response, found on page seventeen of the PRR file, Furlong was able to inform Sinnickson about the erection of the original wooden fence at Duffy's Cut and how it was maintained over the years. He also offered what he had learned of the Dufy's Cut story from "old men" in the area when he worked there. Sinncikson had also written to James Kerns on May 10 and had made inquiry about the "mound" at the site of Duffy's Cut. Found on pages eighteen and nineteen of the file, Kerns wrote back to Sinnickson and indicated that the fence had been at the site since he had been "employed on

the road," and he offered what he learned about the story and who initiated the railroad commemoration of the place.

The final document bearing Sinnickson's name in the PRR file is a letter written by Sinnickson himself and bearing his own signature. The letter, dated December 3, 1909, from Paoli, was written to George H. Brown (1867–1938), divisional engineer in Harrisburg, Pennsylvania. In his letter, found on page twenty-five of the file, with a copy on page twenty-six, Sinnickson asked Brown to contact PRR superintendent John K. Johnston concerning "the burial plot on the south side of the right of way between Malvern and Frazer." Sinnickson stated that he had learned that while supervisor at Paoli, Mr. Johnston erected a fence around the mound built in commemoration of the laborers engaged in building the road who died on the work during a plague in 1832 or 1833.

Actually, J.K. Johnston had repaired the original wooden fence that had been erected at Duffy's Cut in 1873, and this work is what Sinnickson was referring to in his correspondence with George H. Brown. In his letter to Sinnickson, Thomas Furlong had stated that in 1896, then supervisor J.K. Johnston had the fence at Duffy's Cut enlarged. In his letter to George H. Brown, Sinnickson also corroborated Clement's stated desire to erect a memorial plaque at the Duffy's Cut site: "We want to put up a memorial plate and wish to have our information authentic." If this plate had been installed in 1909, this would have been the first public memorial to the laborers who died there. Sinnickson and Clement's desire was eventually fulfilled around the year 2000, when the first of two signs was hung at Duffy's Cut, and four years later, a Pennsylvania state historical marker was erected nearby. In 2017, a new sign was hung at the site by railroaders with fully accurate information, including naming the place "Duffy's Cut," listing the date and cause of the deaths at the site and listing the counties of origin of the workers who died there in 1832.

In addition to gathering available information from living railroaders who had worked in the area of Duffy's Cut, and thereby learning the basic elements of the Duffy's Cut story, Clement and Sinnickson learned about the earlier railroader commemorations at the site, beginning in 1873. What's more, the work of the two supervisors at Paoli in 1909 started a movement among their fellow railroaders to gather as much information as possible about the events at mile 59 in 1832. The thirty-four pages of the PRR's Duffy's Cut file are a chronicle not only of the events at Duffy's Cut but also of those railroaders who did not allow the deaths of the Irish laborers at mile 59 to be forgotten.

THE MEN IN THE PRR FILE

James McCarron

PRR foreman James McCarron and his wife, Margaretta (1825–?), were born in Ireland and settled in East Whiteland in Chester County, adjacent to and just south of the Duffy's Cut site. McCarron is significant to the Duffy's Cut story as being the one who initiated the work of organizing the very first railroader commemoration of the men who died there, as well as for erecting the first wooden memorial fence at the site.

The 1870 census listed McCarron as a naturalized American citizen who "works on the R. Road." He owned real estate worth $1,950, as well as a "personal estate" of $300. McCarron is mentioned three times in the PRR file as being the guiding force behind the first wooden fence erected at Duffy's Cut. The first letter that mentioned McCarron's work was a three-page letter from James Dixon to Martin Clement (pages twelve, thirteen and fourteen of the file). Dixon wrote about the work of a "James McKerns," whom Dixon stated was "Foreman at Frazer at what was at that time known as Garret's Siding." "McKerns" had a "repairman" working for him, Patrick Doyle, whom Dixon said was "the first to suggest placing a fence around their remains [of the Irish laborers buried there]." This "James McKerns" is actually James McCarron. Dixon offered significant detail on how the funds were raised for the erection of the wooden fence and set the date, 1873, as the year when the fence was first put in place.

The second reference to James McCarron's work of memorializing the dead at Duffy's Cut is found in the two-page letter dated May 10, 1909, from railroader George Dougherty to George Sinnickson (PRR file pages fifteen and sixteen). Dougherty wrote, "Referring to the mound that is fenced at Duffy's Bank was put up about 35 years ago by James McCarron who was foreman at that time and his men each one donating a small sum of money and erecting the fence on a holiday."

The third letter that details McCarron's work came from PRR foreman James Kerns. In his May 13, 1909 letter to Sinnickson (PRR file pages eighteen and nineteen), written from Caln, Kerns presented the basic facts of what happened at Duffy's Cut as he had learned them when he started working in the area. Writing of the graves of the dead Irishmen at Duffy's Cut, Kerns narrated that he had learned that "James McCarren [*sic*] who was foreman of that Sub. Div. about 30 years ago had the fence put around it."

A photograph of McCarron's original wooden fence is located in the photographic archive of the Chester County Archives in West Chester, Pennsylvania. This wooden fence was visible to passengers traveling on the railroad, but because there was no marker placed at the site, many people believed that the wooden fence that McCarron had erected was a memorial to the nearby 1777 Paoli Massacre. This railroader memorial to the Irishmen buried at Duffy's Cut was repaired a number of times, starting in the time of John McGraw (1816–1899), and it was eventually replaced by Martin Clement's stone wall in 1909.

Patrick Doyle

Born in County Wexford, Ireland, Patrick Doyle was the son of Martin Doyle and Henrietta (née Cavanaugh). He immigrated to America in 1862 and served in the United States Marine Corps. Doyle married twice. His first wife was Mary Hines (1852–circa 1880) from Bordentown, New Jersey, whose parents were from Ireland. Patrick and Mary had four daughters. In 1896, after Mary died, Doyle married Helen Lafferty (1864–1945), who was from Northern Ireland and with whom he had two sons and two daughters. Doyle worked as a repairman on the railroad near Duffy's Cut under James McCarron. McCarron had Doyle make a very significant speech along the tracks at the site of what they had learned was the mass grave of the Duffy's Cut workers.

Doyle's 1873 speech at Duffy's Cut was the very first public memorial to the railroaders who died there. Doyle's speech was mentioned twice in the PRR file. In James Dixon's May 11, 1909 letter to Martin Clement, Dixon mentioned Doyle by name: "Patrick Doyle…was the first to suggest placing a fence around their remains and made a speech to that effect. Every man present contributed 50 cts. and the fence was put up in 1873" (pages thirteen and fourteen). The May 10, 1909 letter of George Dougherty to George Sinnickson mentioned the significant speech that Doyle made: "I remember of hearing of one of his [McCarron's] men making a [*sic*] address on that occasion referring to the men who were buried who died with the cholera."

While it seems that both James McCarron and Patrick Doyle were equally involved in the movement to memorialize the dead at Duffy's Cut, Dixon specifically mentioned that it was Doyle's speech that particularly grabbed the attention of his fellow Irish American railroaders and encouraged their generous support of the project to erect a fence at the site. The importance

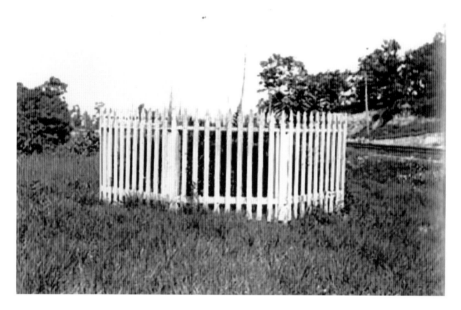

Patrick Doyle's wooden fence at Duffy's Cut (1872). *Chester County Historical Society.*

of Doyle's speech cannot be underestimated, as it epitomized the desire of railroaders after Duffy's death to remember the dead at mile 59.

Doyle continued to work for the PRR for about five years after his famous speech, and in 1878, he moved to the borough of Oxford in Chester County, where he conducted a lucrative business as a dealer in scrap metal. Doyle amassed enough money and property through his business dealings that he was able to assist his community in a number of ways. He was called the "Wanamaker of Myrtle Street" (after the entrepreneur and merchant John Wanamaker, the founder of Philadelphia's first department store), as well as the "scrap metal magnate." Doyle had a reputation for having a good sense of humor, as well as being a good orator. Typical of his advertisements is the following: "Mr. Doyle has such a vast variety of iron wreckage in his pile that relic gatherers looking for hinges from Noah's ark would be as likely to find them there as anywhere."

Doyle was known for philanthropy within the Oxford community. One of his obituaries read: "Mr. Doyle was philanthropic in many ways and several young men of the town owe their start in business to his financial encouragement." Doyle was a member of Sacred Heart Catholic Church in Oxford and a member of the Catholic Total Abstinence Union (an

American Catholic temperance society that had been founded in 1871). Doyle was a charter member of the Union Fire Company in Oxford, and he assisted in the erection of the town's fire hall. Doyle died on January 27, 1911, of "apoplexy" and was buried at Union Hill Cemetery in Kennett Square, Pennsylvania. Doyle's work of remembering the Duffy's Cut story was passed on through the family of his sister, Bridget (Doyle) Donahue, from whom Clement learned the story.

John McGraw

PRR supervisor at Paoli John McGraw was born in Ireland, as was his wife, Sarah McCaslin (1831–1913). By 1860, he was living in Downingtown, Pennsylvania, and working as a PRR foreman, and before 1870, he was promoted to supervisor. He continued to serve as a PRR supervisor in Chester County into the 1880s. In his letter to Martin Clement (PRR file page fourteen), James Dixon stated that sometime after 1873, McGraw had his assistant supervisor, a Mr. Gealy, make "inquiries" about the Duffy's Cut site. When "he heard the story," McGraw "had the fence repaired and painted." Dixon reported that from the time of McGraw onward, "the assistant supervisors have seen that it [the wooden fence at Duffy's Cut] is kept up and in good order." McGraw was a contemporary of the men who died at Duffy's Cut and was clearly taken with the story. His work of preserving the octagonal wooden fence at the site helped preserve the presumed traditional burial place of the men buried at Duffy's Cut, thus setting the stage for the building of the stone wall under Clement in 1909. McGraw was buried at St. Joseph's Cemetery in Downingtown.

James Dixon

James Dixon was born in Ireland to parents Edward Dixon and Mary Casey. Dixon arrived in America in 1866 and started work as a farmer in Willistown. Dixon's wife, Anastasia Furlong (1843–1906), was also born in Ireland, arriving in America in 1861. The couple settled in East Whiteland, Cheater County, and later in 1870, Dixon went to work for the PRR as a railroad laborer.

By 1880, when he became a naturalized American citizen, Dixon was working as a railroad repairman, eventually rising to foreman of track

repairs. In the 1900 census, the Dixons were living with their son, Richard (who was also a PRR foreman) and his family in East Whiteland. Their immediate neighbors were George Donahue and his wife, Bridget (Doyle). Bridget's brother was none other than Patrick Doyle—demonstrating a fascinating link within the community of those who remembered Duffy's Cut.

By 1910, Dixon had retired from the PRR and was listed in the census record as the widowed head of household, along with his widowed son, Richard, and five grandchildren. A year before his retirement, Dixon was still working as a foreman of repairs when he was contacted by Paoli assistant supervisor Martin Clement about "the graveyard west of Sugartown Bridge" (Duffy's Cut). In his May 11, 1909 three-page letter to Clement (PRR file pages twelve through fourteen), Dixon stated that he learned of Duffy's Cut from "Isaac Williams, an old gentleman on Hoods Road." According to Dixon, that conversation with Williams occurred in 1870, one year prior to the death of Philip Duffy. Dixon wrote that Williams "informed me when I first started to work on the railroad in 1870 that 57 men who helped to build the road in 1831 contracted yellow fever from some person who came in from the south and died, their remains being interred in that place."

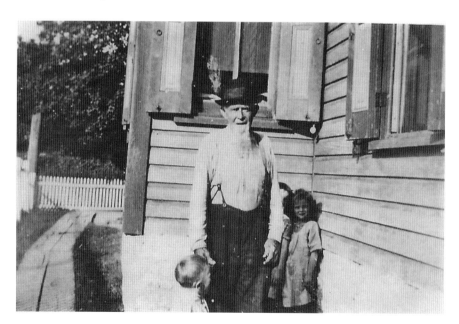

James Dixon. *Jo Ann Uricheck and Mike Uricheck.*

The exact year and cause of death of the men whom Williams reported to Dixon do not correspond with what is known of the 1832 cholera epidemic that devastated Chester County in the summer of 1832. Williams was seventy years old when he informed Dixon of the events at Duffy's Cut, and it is likely that some of the details of the story had dulled in his memory over time. Nonetheless, Williams accurately listed the number of the dead at Duffy's Cut at fifty-seven, which is the number eventually accepted by the PRR and which corresponds to the number of the dead in the 1833 Mitchell Letter, which listed a number as high as sixty. Williams also stated that the source of the outbreak of disease at Duffy's Cut came from "some person who came in from the south." This may indicate that the source of the cholera that devastated the shanty at Duffy's Cut was a laborer who fled north from the P&C's sister railroad, the Baltimore and Ohio Railroad, where many other Irish laborers were also dying in the 1832 cholera pandemic and were known to have run north in an effort to escape the disease.

In his letter, Dixon further reported to Clement the connection with Patrick Doyle's speech and the building of the first fence at the Duffy's Cut site. In addition to Dixon's letter to Clement, Dixon is also mentioned by name in George Dougherty's letter to Sinnickson as a source of information on the Duffy's Cut story and of the later 1870s railroader remembrance.

In retirement, Dixon joined the Pennsylvania Railroad Veterans Association. He and his family were members of St. Agnes Catholic Church in West Chester. In 1920, Dixon was living with his son-in-law and his family, along with two of his own children. Dixon died in Frazer and was memorialized with a High Mass at St. Patrick's Catholic Church in Malvern, within walking distance of Duffy's Cut, and was buried at St. Agnes Cemetery.

George Dougherty

George Doughty was born in the Chester County community of Steamboat (later Glen Loch). Dougherty's parents, John Dougherty and Mary Dailey, were both born in County Donegal, Ireland. Dougherty's wife, Mary (1856–1933), was also born in Chester County of Irish-born parents. Dougherty's father was born in 1809, making him a contemporary of most of the laborers who perished at Duffy's Cut. George Dougherty was born and raised and lived his entire life (outside of his service in North Carolina for the Union army during the Civil War) in Chester County. Apart from his time in the

Union Army Railroad Construction Corps, Dougherty worked for the Pennsylvania Railroad his entire life, eventually becoming a section foreman at Frazer, near Duffy's Cut. At the conclusion of the Civil War, he went back to the PRR, living variously in Tredyffrin and West Chester.

In his May 10, 1909 letter to George Sinnickson, Dougherty offered his insights into what he learned about Duffy's Cut, as well as how the Irish American railroaders began to memorialize that place. Dougherty also offered a very significant piece of information that helped locate the first bodies of the Irish laborers buried at Duffy's Cut. Dougherty wrote that "I do not think that they [McCarron and Doyle] knew where these bodies were buried. I heard my father say that they were buried where they were making the fill [meaning the earthen railroad bridge called Duffy's Bank or Duffy's Fill]."

As he lived in the area during the summer of 1832, Dougherty's father had accurately heard the story of where the bodies were buried at Duffy's Cut: under the original railroad fill from 1832. That was a crucial piece of information used to help locate the first seven graves at Duffy's Cut.

Upon his retirement from the railroad, Dougherty became an active member of the PRR Veterans Association. He was also active in his church, St. Agnes Catholic Church in West Chester, where he served as a charter member of the Knights of Columbus, and in the Holy Name Society. He was also a member of the Total Abstinence Brotherhood, a temperance society that had been founded in Ireland. When Dougherty died, a High Requiem Mass was held for him, with three priests officiating at his funeral. He was buried at St. Agnes Cemetery, West Chester.

Thomas Furlong

Thomas Furlong (1842–1917) was born in Ireland to Martin and Mary (née Doran) Furlong. He immigrated to the United States in 1867. His wife, Mary McIllheany (1849–1922), was also born in Ireland, arriving in America in 1870. Furlong progressed from railroad laborer to PRR section foreman. By the time he wrote his May 13, 1909 letter to Sinnickson, Furlong had retired. His letter detailed that he heard about Duffy's Cut from "old men" who told him of the men "buried there that died with collery [sic]." Furlong noted that "when the road was first building graveyards was scarce them days" and that this was why the men buried at Duffy's Cut were buried at that site near the tracks. Furlong furthermore

mentioned the names of PRR supervisors S.C. McComb (1860–1891) and J.K. Johnston (1860–1942), who repaired the Duffy's Cut fence over the years. Furlong was buried at St. Agnes Cemetery.

Samuel Craig McComb

Samuel McComb was born in New Jersey and lived for a number of years in Columbus, New Jersey. He was an 1879 graduate of Swarthmore College with a Bachelor of Science degree, and he earned his certification in civil engineering from Swarthmore in 1882. By 1884, he was serving as vice-president of the Swarthmore Alumni Association. McComb started working for the railroad, first in Wilmington, Delaware, and by 1880 in Reading, Pennsylvania, where he was listed in the Reading City Directory as a "civil engineer." By 1886, McComb was supervisor at Downingtown, Chester County, where he married Elizabeth F. Wells (1862–1947) at St. James Episcopal Church in Downingtown. During his sojourn in Chester County, McComb learned of the Duffy's Cut story and went to some effort to take care of the earlier railroad memorial. According to Thomas Furlong, "The foreman and his men kept a fence around this [the site of the mass grave] until S.C. McComb Supervisor took a hand in it and put the present fence up that is there now in 1886." McClomb was said to have "made it [the fence] smaller and partly round."

In 1890, McComb was living in Camden, New Jersey, and serving as assistant engineer on the West Jersey and Camden and Atlantic Railroad. He died at his home in Woodbury of heart failure and was first buried at Woodlands Cemetery in New Jersey, but his body was removed shortly thereafter to West Laurel Hill Cemetery, Bala Cynwyd, Pennsylvania.

John Kilgore Johnston

John Johnston was born in Greensburg, Pennsylvania, and was trained as a civil engineer. Johnston's paternal great-grandfather was from Fermanagh, Ireland. John married Martha Jones in 1887 and, by 1888, was working as a PRR assistant engineer in Altoona, Pennsylvania. By 1896, he was supervisor in Paoli, and while there, he learned about Duffy's Cut. According to Furlong, Johnston painted the fence. In 1909, George Sinnickson wrote a letter to Divisional Engineer George H. Brown of the Philadelphia Division:

Will you please ask Superintendent J.K. Johnston if he remembers any of the details regarding the burial plot on the south side of the right of way between Malvern and Frazer. While Supervisor at Paoli Mr. Johnston erected a fence around the mound built in commemoration of the laborers engaged in building the road.

On December 7, 1909, Johnston replied to Brown:

Referring to Mr. Sinnickson's inquiry, I have no knowledge of the small burial plot on the south side of our right of way, between Malvern and Frazer, other than traditional. I was informed when the fence was erected, that a number of laborers who were engaged in building the road during 1830 and 1833, had died...and had been buried there. Possibly some of the old residents about Downingtown, Malvern, or West Chester could give more information.

Apparently, Johnston did not simply paint the fence at Duffy's Cut. It seems that in 1896, Johnston put up a new fence to replace the original one erected in 1873. After he left Paoli, by 1900 Johnston was working as assistant engineer in Reading, and by 1901, he was assistant engineer in Harrisburg. By 1910, he was superintendent of the Tyrone Division of the PRR, where he served for many years. He died in Tyrone and was buried at Grandview Cemetery in Tyrone.

George Herbert Brown

George Brown was born in Renovo, Pennsylvania, to parents William Henry Brown and Sallie A. Rimmel. Trained as a civil engineer, Brown married Jane Howard in 1897. He settled into Radnor Township and worked as division engineer in the Philadelphia Division of PRR for several decades. Between December 3 and December 8, 1909, Brown served as a conduit for communication between George Sinnickson and J.K. Johnston regarding the "burial plot on South Side of the Right of Way between Malvern and Frazer" (PRR file pages twenty-four and twenty-five). Brown facilitated the gathering of information between the former and then current Paoli supervisors to assist in the stated goal of erecting a memorial plate at Duffy's Cut. Brown ended his career working as a civil engineer for a construction company. He died in Haverford, Pennsylvania, and was buried at Edgewood Cemetery in Pottstown, Pennsylvania.

Jacob Stoe

Jacob Stoe (1862–1940) was born in Germany to George J. Stoe and Freda Schnelbach. Trained as a stonemason, he immigrated to America in 1884 and became a naturalized citizen in 1890. Stoe married Margaret, and they eventually settled in Lancaster. Stoe worked for forty-two years as a stonemason and worked his way up to PRR stonemason foreman. He worked on a variety of projects for the railroad, including a railroad memorial for Martin Clement, while he was assistant supervisor at Paoli, which Clement called the "Standard of 1830"—that sat outside the supervisor's office in Paoli. In his August 9, 1917 letter to J. Herb Redding (1877–1930), Clement stated, "While I was Assistant Supervisor at Paoli this fence [the original wooden fence] was in poor condition. We were standard ditching and re-lining through here at the time and uncovered a lot of old track foundation stone, and I got Jacob Stoe, the foreman mason, to replace this wooden fence with a stone wall, now there."

Jacob Stoe's work still stands around what was believed to be the final resting place of the dead of Duffy's Cut. Stoe retired in 1932, and he died in Lancaster and was buried at Greenwood Cemetery in that community.

Reverend Alden W. Quimby

Reverend Alden Quimby was born in Chester County, Pennsylvania, and was active in the Methodist Church in Phoenixville. He was ordained as a Methodist minister and served as pastor of the Radnor Methodist Church. Quimby married Malinda Brower (1855–1939) in 1873. In 1896, Quimby became pastor of the Berwyn Methodist Church in Chester County, and he served that church until his death. While he was pastor in Berwyn, he lived in Easttown, Chester County, and there Quimby took an interest in astronomy, achieving some fame in that discipline, as well as in local history. In addition to authoring several books, Quimby contributed articles to astronomical and historical journals, including the *Pennsylvania-German*, and to local Chester County newspapers. Quimby was furthermore a proponent of the temperance movement.

Quimby's November 30, 1909 newspaper article in the *Daily Local News* in West Chester was added to the PRR file. The article, titled "That Small Burial Ground Near Malvern," offered Quimby's reflections on the Duffy's Cut story in response to Martin Clement's earlier inquiry:

Some ten years ago, being attracted to the odd enclosure, I visited it, photographed it, and prepared a sketch of it for a Sunday School magazine in New York State. All the data I could glean were furnished by an elderly man who was hoeing potatoes nearby. He said that during the cholera epidemic about 1833, sixteen laborers engaged in track laying died and were buried close to the roadbed. Many years later, when the course of the tracks was changed to avoid severe curves, the unmarked graves, unknown to the constructors, were covered by the new roadbed. Still later, some railroad folks, hearing the tradition of the burial, and fancying that a little mound near the tracks indicated the general tomb, sympathetically erected a fence about it. When this decayed the railroad company replaced it with a neat frame enclosure, which it has maintained in repair until this day.

While the elderly man's information on the number of the dead at Duffy's Cut and the year of their demise were incorrect, Quimby's newspaper reflections closely match the story of the railroader remembrances and the construction and the maintenance of the fence as recorded within the PRR file. He was buried at Radnor United Methodist Church Cemetery, Bryn Mawr.

Julius Friedrich Sachse

Julius Sachse was a jack-of-all-trades. He made a name for himself in Pennsylvania and beyond as a newspaper writer, historian and librarian. Sachse was educated in a local grammar school and the German Lutheran Academy in Philadelphia. As a boy, he spent summers in Chester County, where he developed an interest in history. During the Civil War, he served in the Maennerchor Rifle Company of the Philadelphia Home Guard. He married Emma Lang (1843–1922) in 1864 in Philadelphia.

Sachse was a skilled photographer. He had a national reputation as a renowned photographic historian, serving as the editor of the *American Journal of Photography* and as consultant for the *Ladies' Home Journal*. In an earlier career, Sachse was a merchant, helping with and then running his family's business in Philadelphia, F. Sachse and Son. By the 1880s, his business acumen allowed him the leisure to develop his other literary and historical interests. Sachse became the librarian and curator of the Museum of the Grand Masonic Lodge of Pennsylvania, located near city hall in Center City, Philadelphia. He also wrote many articles and books on Pennsylvania

secular and church history, including works treating the Lutheran Church as well as the German American pietists and the Ephrata Cloister community.

Sachse was a Lutheran, but for "reasons of convenience," he attended the Episcopal church for "many years before his death." He also had a special fondness for the Seventh Day Baptists, writing numerous articles in their periodical, the *Sabbath Recorder*. Nonetheless, Sachse was described as a "loyal Lutheran and a valued adviser in the Lutheran Church." He was generally lauded by many of his contemporaries for the breadth of his research and scholarship.

One of his obituaries made the bold claim that "[it] was upon his [Sachse's] motion that the Lutheran Church initiated the celebration, by all the Protestant churches in this country, in 1917, of the 400th anniversary of the revolt of Martin Luther, in 1517, against the Papal Power." While the notion that it was Julius Sachse who "initiated" the American Lutheran celebration of the anniversary of the Reformation is very much an overstatement of the facts of the matter, Sachse was nonetheless involved in the planning of aspects of that national Reformation celebration. He served on a committee with prominent American Lutheran clergy of the time who were charged with designing and issuing an official commemorative medal remembering the Reformation anniversary.

Sachse was a member of many learned and professional societies, including the American Philosophical Society, the American Historical Association, the International Congress of Orientalists, the Historical Society of Pennsylvania, the Pennsylvania German Society and the American Library Association. He was granted an LLD by Muhlenberg College.

In 1872, Sachse purchased sixty acres of historic property in Leopard, part of Easttown Township, Chester County, on which he built a grand home he called Sachsenstein. He served as a historical specialist for the editorial department of the *Philadelphia Public Ledger* newspaper and was a regular writer for the West Chester *Village Record* newspaper, the same paper in which the first account of the deaths of the railroad workers at Duffy's Cut appeared in 1832. It was there, in the pages of the *Village Record*, that Sachse penned two pieces on the events around the deaths of the Irish track laborers at mile 59.

Sachse's May 5, 1889 article, titled "The Legend about Duffy's Cut on the Pennsylvania Railroad between Malvern and Frazer," appeared in the *Village Record*. The account of the events that took place at Duffy's Cut that is presented in this article became a central piece of the accepted narrative of the Pennsylvania Railroad. Martin Clement included a

copy of Sachse's article, transcribed on three pages of PRR letterhead (pages six through eight). This was transcribed at Paoli on December 7, 1909. It was included with another article that Sachse wrote for the same newspaper in August 1889, titled "The Last Relic of the Pennsylvania Railroad Originally Called the Philadelphia and Columbia Railway," which was also transcribed on PRR letterhead (pages 9 and 10). This later article dealt with the remnants of the original 1832 track bed that were left in place at Duffy's Cut when the railroad tracks were moved a short distance north of the earlier line in the 1870s. Sachse used this later article to present some of the details of the building of mile 59, and he accurately wrote of Duffy's collaboration with James Smith prior to his work at Duffy's Cut. Sachse's two articles in the PRR file were used by the railroad as accurate records of the building of that mile of the railroad, and they both proved to be quite helpful in the work of locating and excavating the archaeological site and in the recovery of the remains of the murdered railroad laborers there.

In his article "The Legend about Duffy's Cut," Sachse based a portion of his narrative on an interview with an "elderly resident" who related to him a contemporary account of walking down the incomplete track bed in 1832, shortly after the last laborer was buried at Duffy's Cut. In his article, Sachse also included reflections that he gleaned from other locals who spoke of the area being shunned because of the mass grave, which Sachse accurately portrayed at the base of the original railroad fill. Sachse did his historical research, and he discovered that the laborers whom Duffy hired were recently arrived Irishmen; he described the shanty where the Irish laborers lived and where some of them died of cholera. Sachse's descriptions helped the Duffy's Cut Project team locate the remains of the Duffy's Cut shanty. Sachse also accurately presented the story of the burial of the dead laborers by the camp blacksmith.

Julius Sachse's account of the deaths of fifty-seven Irish railroad laborers brought the story back to the newspaper-reading public, and it eventually helped to solve the mystery of what happened at mile 59. Sachse died at his home in Philadelphia on November 15, 1919. He was buried with the participation of Lutheran and Episcopal clergy, and his grave at West Laurel Hill Cemetery lies near the Duffy's Cut Memorial Cross, where the bodies of five of the first six murdered laborers recovered at Duffy's Cut were laid to rest in March 2012.

Joseph Herbert Redding

Joseph Herb Redding was born in Philadelphia to Thomas A. Redding and Elizabeth L. Kennedy. Redding's father was born in England, and his maternal grandfather was from Northern Ireland. He was trained as a civil engineer and married Anna Hartman Roads (1880–1923) in 1902. He was a member of St. Paul Episcopal Church in Philadelphia, and upon his marriage, he joined his father-in-law's church, the Cumberland Street Methodist Church in Philadelphia. Redding started his railroad career as a clerk in Philadelphia and served variously as supervisor in Dravosburg, Pennsylvania; Sunbury, Pennsylvania; and Camden, New Jersey. By 1917, he was supervisor in Paoli. By 1920, Redding was division engineer in Altoona, rising to general superintendent of the PRR, with offices in Pittsburgh. Redding died in Pittsburgh and was buried at West Laurel Hill Cemetery.

Redding's role in the Duffy's Cut story dates from his time as supervisor in Paoli. While he was in Chester County in 1917, his interest was drawn to "the monument on 'Sugartown Curve'"—the stone monument that Clement built to replace the original wooden fence at Duffy's Cut. Clement's letter to "My dear 'Herb'" detailed the story as he had recorded it in his 1909 file. After relating the story of the fifty-seven men who died working at Duffy's Cut, Clement had offered particulars about the building and the later maintenance of the original wooden fence and his building of the stone wall. Clement then directed Redding to a number of railroad employees still in the area whom Clement had utilized in putting the story together—Jerry Fara, Charles Larkin, Ben Grow and "Doc" Baugh—as sources of further information on Duffy's Cut. What Redding did with this information is not recorded in the PRR file, but his interest in the story in 1917 allowed Clement to succinctly present his own research into the story.

George Earnest Mathias

George E. Mathias (1881–1963) was born in Ambler, Pennsylvania, to Allen Mathias and Catherine Moore. He married Jennie Collom (1885–1958) in 1908. He spent his career as a PRR clerk in Chester County, serving in Paoli and Downingtown. Mathias's role in the PRR story dates from his time as chief clerk to the supervisor in 1927. Mathias had

forwarded the PRR file to Royal M. Shunk (1882–1968), the PRR chief divisional correspondent for the PRR newspaper, the *Pennsylvania News*, for the purpose of writing an article on Duffy's Cut. Shunk's letter to Mathias, written when he returned the PRR Duffy's Cut file back to the supervisor's office in Downingtown, shows that the PRR file was actually maintained for nearly twenty years of its history in Chester County. Mathias died in West Goshen, and he was buried at the Episcopal Church of the Good Samaritan Cemetery in Paoli.

Felix Roy Gerard

Felix Gerard (1887–1947) was born in Blairsville, Pennsylvania, to parents Roy Gerard and Winifred S. Maurice, who were both born in England. Gerard married Rena Flenniken (1889–1953) in 1909. Trained as a civil engineer, Gerard moved quickly through the ranks of the PRR, becoming division superintendent in New York by 1930 before moving on to division superintendent in Harrisburg, Pennsylvania, by 1932. He had become PRR general superintendent in Chicago by 1940. Gerard's role in the Duffy's Cut story is found in his February 11, 1932 letter (PRR file unnumbered page two) to PRR supervisor Walter A. Trimble (1888–1955) in Downingtown, Pennsylvania, written from Harrisburg, Pennsylvania:

> *Will appreciate it is you will forward to me the file which Mr. Mathias has in his possession concerning the monument west of Malvern erected approximately 100 years ago in commemoration of the M.W.&S. employees who lost their lives in the plague. If you will forward it to me under personal cover, I will see that it is promptly returned to you.*
>
> *F.R. Gerard*
> *Superintendent*

On the occasion of the 100th anniversary of Duffy's Cut in 1932, there was clearly interest by PRR executives in learning more about the events that occurred there in 1832. The only reference to what happened to the file once it was forwarded from Downingtown to Harrisburg is a note found on the unnumbered page three of the PRR file: "Mr. Gerard, File herewith as per your memo and conversation. WAT." There is an additional note on this page that was dated March 12, 1932, that reads: "Noted with great interest.

Thanks. FRG." This communication between two railroaders in 1932 is a fascinating glimpse into how the PRR kept the centenary remembrance of Duffy's Cut a private, internal affair. Gerard was buried at Blairsville Cemetery, Blairsville, Pennsylvania.

Walter Adams Trimble

Walter Trimble was born in Birmingham, Pennsylvania, to John W. Trimble and Laura Green. Trimble's father was born in Ireland. Trimble married Josephine Seeds (1891–1981) in 1909. Trained as an engineer, he started working for the PRR as a clerk. Trimble served variously as supervisor in Downingtown, as division engineer in Altoona and as supervisor in Clearfield County, Pennsylvania. His death certificate listed him as a "professional engineer, Penna. R.R." Trimble died in New Castle, Pennsylvania, and was buried at Birmingham Cemetery in Birmingham, Pennsylvania.

Royal M. Shunk

Royal Shunk was born in Steelton, Pennsylvania, to Frank and Catherine Shunk. Early in his career with the railroad, Shunk worked as a clerk for the United States Railroad Administration in Harrisburg, Pennsylvania. By 1927, Shunk was serving as the chief division correspondent of the *Pennsylvania News* in Harrisburg, and it was in that capacity that his name entered the Duffy's Cut story. In 1927, Shunk had borrowed the PRR Duffy's Cut file to write an article "relative to the stone enclosure, east of Malvern, which marks the burial place of 57 of our track laborers who were victims of the cholera epidemic of 1832." As he returned the file, Shunk wrote a letter detailing his use of the file (PRR file page two). He mentioned to Mathias that he had "prepared an article about it for our *Pennsylvania News*, sending it in in time for the next issue—May 15th." Shunk wanted to include a photo of the stone wall

Royal M. Shunk. *Daniel Shunk.*

with his article. He stated that "I think the story of sufficient interest to hold the attention of many readers, and a picture would make it still more interesting." Shunk promised to send Gerard a copy of the article "if and when it is published" if Gerard "may wish to file it with these papers" (the PRR file). Shunk curiously noted that "[n]ow that the matter is stirred up again, there is no telling when somebody else will want to have a look at the file." Shunk's article for the *Pennsylvania News* was never published. In fact, instead of an article on Duffy's Cut in the May 15 edition, the newspaper had articles on the fear of Communist infiltration in the railroad unions.

Even though his article on Duffy's Cut was suppressed, Shunk continued to write for the railroad. In the early 1940s, he was working as the news editor for the Engineers' Society of Pennsylvania. Shunk attended St. John's Lutheran Church in Steelton, and when he died, he was buried at Shoops Cemetery, in Harrisburg.

OTHER RAILROADERS

In his 1917 letter to J. Herb Redding, Clement listed several other sources of information on Duffy's Cut: "Jerry Farra, the night track walker on Charles Larkin's section, and Ben Grow, your blacksmith foreman, and 'Doc.' Baugh, the Company surgeon, can all give you some information." Even though these individuals are merely mentioned by Clement, they clearly helped him glean some information on the Duffy's Cut story. Charles Larkin (1867– 1927) was born in Downingtown of Irish-born parents Charles Larkin and Catherine McMann. He ended his career a track foreman and was buried at St. Joseph's Cemetery in Downingtown. Ben Grow (1870–1925) was born in Pennsylvania to William Grow and Rebecca Patterson. Grow spent much of his life in Willistown, near Duffy's Cut, and became a PRR blacksmith foreman. He was buried in the Great Valley Presbyterian Cemetery. Anthony Wayne "Doc" Baugh (1867–1938) was born in Paoli to James Baugh and Edith Taylor. He was educated at the Medical College of the University of Pennsylvania. He established his practice in Paoli but also served as a Pennsylvania Railroad surgeon. He was known as a student of local history and co-founded the Tredyffrin Easttown History Club. His knowledge of local history helped Clement in 1909 as he sought information on the events at Duffy's Cut. He retired in 1938, just months before he died, and was buried at the Great Valley Presbyterian Cemetery.

Joseph Francis Tripician

Joseph Francis Tripician (1898–1977) was born in Naso, Sicily, to Nicholas Tripiciano and Josephina Fiocco. Tripician's name was originally "Tripiciano" and was Americanized by the family after they came to the United States through Ellis Island in 1902. Raised near Altoona in the central Pennsylvania town of Dysart, Tripician graduated high school and was then put to work by his father cutting stone for railroad bridges in central Pennsylvania. Tripician had other plans for his career. In August 1916, he left stonecutting behind and began working for the Pennsylvania Railroad as a clerk-stenographer in the Office of the Train Manager in Altoona. Tripician married Mary Markley (1900–1987) of Bellwood, Pennsylvania, in 1920.

Quickly rising through the ranks of the railroad in less than four years, Tripician was secretary to PRR vice-president J.J. Turner in Pittsburgh. In July 1930, he was made secretary to PRR vice-president Elisha Lee in Philadelphia. In May 1935, Tripician was promoted to secretary to the president of the PRR, Martin W. Clement. That promotion enabled Tripician to travel with Clement on the PRR presidential railroad car throughout the United States and meet world leaders and other dignitaries. Significantly, that promotion also brought Tripician into the transmission of the Duffy's Cut story. As Clement's secretary, Tripician was present on many occasions when Clement shared his file with other railroad executives. As he

Joseph F. Tripician, circa 1940s. *Watson Collection.*

did not want the file to get out of the office, Clement would only allow those he gave permission to view the file to do so in his office.

In his work at the PRR, Tripician had occasion to write a number of papers and articles both on the history and on the management of the PRR. Tripician wrote several significant histories of the early days of the railroad in America, including his paper "The Role Played by the Pennsylvania Railroad in the Main Line Area of Philadelphia," as well as his "History and Development of the Pennsylvania Railroad."

Tripician rose to become PRR manager of wage and salary administration (1956–61), and ultimately he became director of personnel administration for the PRR (1961–63). Upon his retirement, he worked in local politics in suburban Philadelphia, serving as Narberth Borough Council president and as chair of the Board for the Assessment and Revision of Taxes for Montgomery County, Pennsylvania.

Tripician's direct role in the transmission of the Duffy's Cut story came in 1968 with the merger of the PRR and New York Central Railroad. Due to his association with Clement, his longtime role in railroad management and his work on railroad history, Tripician was given the PRR Duffy's Cut file. Tripician did not merely preserve the PRR file—from his years of working with Martin Clement and his familiarity with the Duffy's Cut file, he also redacted the file, adding page numbers to the historic order of the documents and ensuring that the file was maintained as Clement had created it. Tripician also corrected a few dates in the file that were incorrectly added over the years.

Through his own historical research, Tripician knew that many stories from the early days of the railroad had been lost forever because they had never been transcribed. He knew the historical value of the archive that had been bequeathed to him by the railroad. Tripician understood that while events like those that transpired at mile 59 were not unique, the PRR file itself was very much unique. Thus, Tripician helped to preserve the story of Duffy's Cut and make sure that it was not lost to history. As an immigrant laborer himself who had succeeded and risen through the ranks at the railroad, Tripician had an appreciation of the plight of the Irish railroaders who had died at Duffy's Cut. As a railroader himself, he wanted to remember those who died building that mile-long stretch of the railroad. He told the story of the Irishmen who died at Duffy's Cut to his grandsons (the authors), which, in time, led to the discovery of the mass grave at the mile 59 in 2009.

Tripician died on January 14, 1977, at Lankenau Hospital in Wynnewood, Pennsylvania, and his funeral was held at Holy Trinity Lutheran Church in

Joseph F. Tripician, circa 1960s. *Watson Collection.*

Narberth, Pennsylvania, where he had been a very active member for many years. He is buried at Logan Valley Cemetery in Bellwood, Pennsylvania. Through his preservation of the Duffy's Cut story and the PRR file, as well as his passing on of the story to his grandsons, Tripician provided the essential clues that led to the resolution of this Irish American murder mystery.

RECOVERY AT DUFFY'S CUT

The Duffy's Cut story survived for more than a century in local folklore, dimly remembered by locals who embellished the narrative in various ways and by railroaders who more specifically recalled that fifty-seven Irish immigrants had died at the site. The Duffy's Cut Project was formed in 2002 following the rediscovery of the PRR file. When the PRR collapsed, in its new incarnation as the Penn Central, following its merger with the New York Central Railroad, the memorabilia and the records of the PRR were put up for auction by Freeman's at Thirtieth Street Station in March 1972. The auction material contained numerous bundles of miscellaneous documents from throughout the history of the PRR, as well as from the P&C and the Allegheny Portage Railroad. However, the PRR file on Duffy's Cut was removed from the company vault prior to the auction by Martin Clement's former executive assistant and late director of personnel for the PRR, Joseph F. Tripician.

One of Tripician's grandson's, Lutheran pastor and archivist J. Francis Watson, inherited the file and shared it in 2002 with his brother, Immaculata University history professor William E. Watson. The brothers established a research team consisting also of adjunct professor John H. Ahtes (1962–2010) and student and later adjunct professor Earl H. Schandelmeier to undertake archival and archaeological research about the story. The Immaculata team, with assistance from the Chester County Emerald Society, obtained a Pennsylvania state historical marker in March 2004 and placed it at the intersection of King Road and Sugartown Road in Willistown, near Malvern, that August.

RAILROAD RELICS, ARTIFACTS.
RARE and HISTORIC DOCUMENTS
comprising
THE ENTIRE MEMORABILIA
of the
PENNSYLVANIA RAILROAD MUSEUM

will be sold at
ABSOLUTELY UNRESTRICTED PUBLIC SALE
by order of
THE TRUSTEES OF THE
PENN CENTRAL RAILROAD
on
March 20th, 21st, and 22nd, 1972
commencing at 10 A.M. each day
the sale will be conducted in
THE SOUTH CONCOURSE AT 30th ST. STATION
PHILADELPHIA, PENNSYLVANIA

under the management of

Freeman's Auction catalogue for Pennsylvania Railroad artifacts, 1972. *Watson Collection.*

The team received permission from the private property homeowners to start an excavation in January 2004 at the site where the remnants of the original fill were located. Permission to excavate came from East Whiteland Township in May 2004 and from the commonwealth in August 2004. The Emerald Society assisted in obtaining the additional permission for the excavation from the county district attorney and coroner. Local volunteer archaeologists, Immaculata students, with members of the Emerald Society, composed the bulk of the original excavation team. Numerous railroad artifacts and personal effects were excavated from 2004 to 2012, with additional assistance provided by the Battlefield Restoration and Archaeological Volunteer Organization and Greater Philadelphia Search and Rescue.

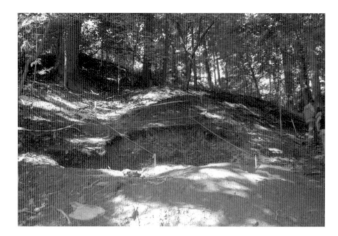

Left: Fill excavation at Duffy's Cut, circa 2011. *Watson Collection.*

Below: Buttons and other artifacts excavated at Duffy's Cut on display at Immaculata University. *Watson Collection.*

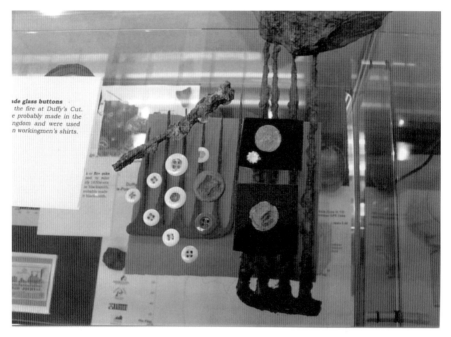

Duffy's Cut is located near the intersection of King and Sugartown Roads, where the modern-day municipalities of Willistown, East Whiteland and Malvern border one another and where the 2004 state historical marker is located. Duffy's Cut technically includes both the "cut" and the "fill," although the archaeologically significant area is where the workers' shanty was located, in the southern valley adjacent to the old railroad fill. The original fill still exists in part only in the eastern end of the valley. The shanty

area, where the bulk of the artifacts were recovered, is about thirty feet south of the old fill line. The south valley is bordered in the east by a plateau where the 1909 stone monument and an Amtrak sign are located, built up by subsequent layers of later fill; in the west by the 1831 stone culvert built to protect the Valley Creek for local farmers as it flows under the railroad fill; in the south by the Valley Creek itself, whose springs are an eighth of a mile southeast of the shanty and which flows northward and eventually reaches Valley Forge; and in the north by the original railroad fill below the modern track line. The burial sites of the workers are on land divided between private property owned by local homeowners (where the original excavations revealed seven graves) and Amtrak property (where a large subsurface anomaly suggests the location of many of the remaining graves).

The Workers' Shanty

The first artifacts located in 2004 were a heavily rusted cooking pot and ladle found near a source of a spring, buried with remnants of charcoal visible below it, an object seemingly buried in haste. The Duffy's Cut excavation team located the remains of the railroaders' lean-to shanty housing area in 2005, within a thirty- by thirty-foot ashen burned field. Ash was found uniformly in this area at a depth of three to four inches below the surface. The burned field was located about thirty feet south of the surviving 1832 railroad fill. A substantial number of artifacts were located in the shanty area. These included seven heavily rusted forks and knives, fifteen glass buttons (fourteen white and one dark blue) and several dozen old clay pipes, some with Irish emblems on them. Many of the pipe stems were long, indicating that they were simply discarded rather than having the stems broken off after use by multiple individuals. Several dozen glass and pottery shards, more than forty hand-cut nails (perhaps used in construction of lean-to housing in the shanty) and a chest hasp were excavated. Other excavated items found closer to the railroad fill include a shovel blade and handle; the head of a rake-like implement; a hook and looped iron implement, which would have been used in combination to lower the stone sleepers into place; an attachment used for a canopy on an early railroad car from the horsecar era; an 1860s brake wheel; an early 1830s piece of Morris and Essex strap rail track; and eight experimental stone spikes used in the earliest days of the rail line (the last, located some

twenty-five feet west of the burned field). The pottery dates from the 1830s through the 1870s, the latter of which period corresponds to the time of Patrick Doyle's work crew.

Several objects showed evidence of the fire reported by Sachse, including several pipe stems with a melted metal (probably pewter) on them and a hand-cut nail with a glass button melted onto it. The ash in the burned field was produced by the fire reported by Sachse. The density of the ash within the valley floor varied from an inch and a half at the northwest edge of the burned field to a half inch at the southeast edge. Some 89 percent of artifacts retrieved at the entire Duffy's Cut site were recovered in the ash of the burned field (see diagrams).

In November 2005, several archaeological discoveries linked the excavated 1832 railroaders' shanty with the city of Derry when a clay pipe stem marked "Derry" was excavated by the Immaculata University Duffy's Cut dig crew. It was excavated near a clay pipe bowl with an *Erin go bragh* flag and the words "Flag of Ireland" marked on the front, along with shamrocks, and on the reverse was a round tower with shamrocks. Another clay pipe bowl with a Brian Boru harp and several shamrocks

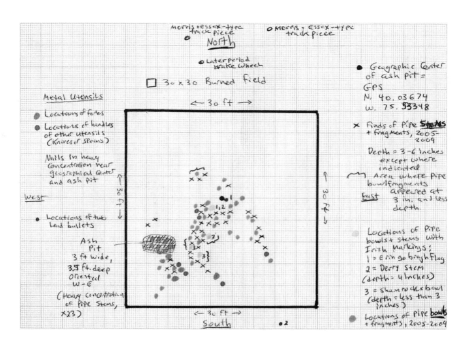

Map of archaeological finds in the burned field at Duffy's Cut. *Watson Collection.*

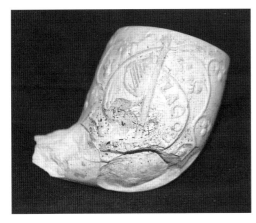

Left: *Erin go bragh* flag emblem pipe bowl excavated at Duffy's Cut. *Watson Collection.*

Below: Derry pipe stem excavated at Duffy's Cut. *Watson Collection.*

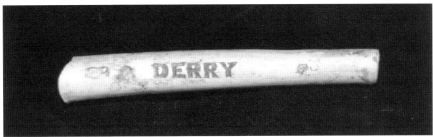

was also located nearby. The Derry stem was one of several dozen pipe stems excavated at the site, from 2004 to 2012, but it is the only stem found that was marked with a city name on it. The 1832 railroad crew lived and worked in the valley. The 1870s local railroad work crew working on track expansion resided in Garrett's Siding, near Fraser, and not in the valley.

Examples of 1830s railroad artifacts excavated at the site include two pieces of imported strap rail and stone spikes, each used for a discrete period of time in the early days of the railroad. Many railroading artifacts were identified by John Hankey of the B&O Railroad Museum and Kurt Bell of the Railroad Museum of Pennsylvania. These items were placed on display in a museum in Immaculata's Gabriele Library. The *Erin go bragh* flag pipe bowl with the words "Flag of Ireland," shamrocks and a round tower on the reverse is perhaps one of the oldest examples of Irish nationalism found in North America. The museum housing the artifacts was opened at Immaculata University's Gabriele Library in August 2010.

Skeletal Remains, Genealogy and Reinterment

The team obtained all necessary permissions from the county district attorney and coroner for the handling of human remains. The objective was to locate not only the shanty but also the graves of the men, with the intent to rebury the workers properly at West Laurel Hill Cemetery in Bala Cynwyd, Pennsylvania, where grave space was donated by the cemetery directors. The team obtained assistance from the University of Pennsylvania (geologist Tim Bechtel, physical anthropologist Janet Monge and archaeologist Samantha Cox), from forensic dentist Matt Patterson and from Chester County deputy coroner and forensic dentist Norman Goodman.

Trains still pass Duffy's Cut and cross the valley by means of the railroad fill that was started by the Irishmen under Duffy in 1832. This fill stretches 300 feet across the small valley, and it is now about 125 feet from bottom to top. Tim Bechtel explored the 300-foot railroad fill to discern the artificial, man-made area from natural hillside. This was within the 1832 fill area, which was at a lower level than the later fill but was still apparent in the eastern end of the valley. The 1832 fill projects southward into the valley from the later stages of fill construction from the 1870s and the first decade of the twentieth century. The 1832 fill is about one-third the height of the modern-day fill. The 1832 fill disappears below the modern-day fill, about halfway across the valley to the west, on the other side of a deep ravine. Bechtel was able to discern that the 1832 fill was constructed by backfilling the soil and rocks excavated from the "cut" made up top to make the tracks as straight and level as possible, with the loose soil and rocks being dumped from east to west, toward the culvert at the western end of the valley

Specifically, Bechtel examined the findings of the Pennsylvania Society for the Promotion of Internal Improvements in 1826 to understand how the fill was created. The society sent architect William Strickland to the United Kingdom in 1825 to observe the construction of rail lines in Lancashire, Leeds and Newcastle. Upon his return, Strickland advocated the use of "stone sleepers…on solid earth embankments." Bechtel wrote of the technique of fill construction:

> *Lack of mechanization, and the cost and danger of black powder, meant that all but the hardest rock was cut by hand using pick and shovel. Cuts consisted of a shallow "gullet," where workers filled wheelbarrows which were dumped into "sets" of (often six) horse-drawn wagons on*

Duffy's Cut excavation team, 2009. *Watson Collection.*

the "second lift." Wagons were hauled along temporary wooden tracks, and separated near the working face onto three "teaming roads," where they were hand-pushed against bumpers that tipped their loads onto the advancing embankment. Material fell to "angle of repose," requiring little grading to achieve.

Examining the construction techniques and then the embankment material at Duffy's Cut enabled Bechtel to narrow down the probable area where the human remains were buried. The details in the railroad file from the George Dougherty letter, that the men "were buried where they were making the fill," were correctly interpreted by Bechtel and the Duffy's Cut team to mean that the men were buried within the fill rather than up top where the fill came from.

Bechtel used electrical resistivity and ground-penetrating radar to search for the probable location of a human grave within the 1832 fill. He searched for a kind of subsurface anomaly called a "stopping void" within the man-made fill, based in part on the details of the burials in the PRR Duffy's Cut file, which included the detail that "the men were buried where they were making the fill." A stopping void is a geological feature in which a solid object buried in the ground has dissolved over time, collapsing to the bottom and leaving layers of uneven soil above the collapsed object (the skeleton), a void. Bechtel had located graves from stopping voids at American battle sites in the past.

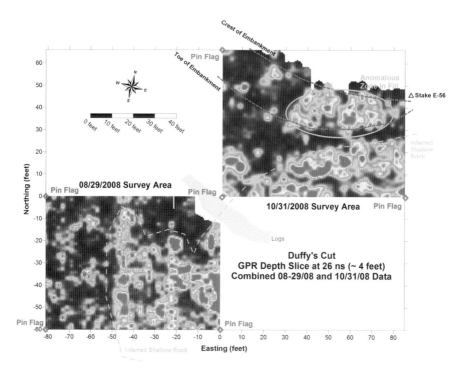

Tim Bechtel's GPR image of fill, 2008. *Tim Bechtel.*

Bechtel found a stopping void anomaly within the 1832 fill via resistivity in December 2008. The stopping void was located one meter below the surface of the fill, between twelve inches and eighteen inches below the ground level where the fill meets the valley floor. He put the coordinates on a map at the beginning of March 2009, and on March 20, the Immaculata dig crew located the initial set of remains (sk001). The forensic analysis by Janet Monge and Samantha Cox revealed that the remains of sk001 were those of a heavily muscled male, about five feet, four inches tall and aged about eighteen years at his death. He had once had a bad ear infection that left scarring, and he had experienced substantial perimortem (time of death) violence on his skull. A pants clasp and a shoe buckle were found with him. Matthew Patterson X-rayed the skull and proved the man had an M-1 agenesis, a rare dental anomaly in which the top-right front molar never came in.

Portions of coffin wood were found around the skeleton, and 141 coffin nails were found around the remains. The orientation of the skeleton was head in the west and feet in the east, following the standard long practiced in Catholic burials.

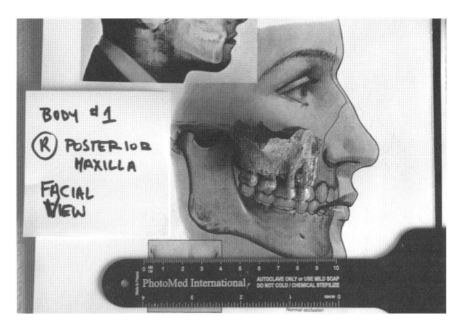

Matt Patterson's placement of skeleton 001 (John Ruddy) jaw fragment on facial chart, 2009. *Matt Patterson.*

Matt Patterson's jaw fragment X-ray showing M-1 agenesis, 2009. *Matt Patterson.*

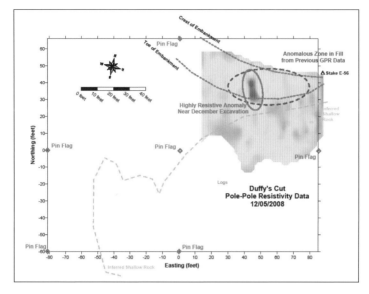

Tim Bechtel's GPR image of skeleton 001 (John Ruddy), 2008. *Tim Bechtel.*

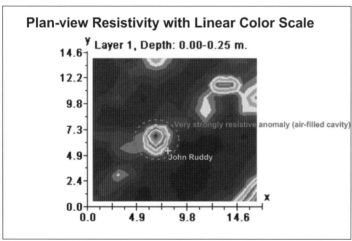

Tim Bechtel's GPR image showing location of other skeletons, 2009. *Tim Bechtel.*

Bechtel located another highly resistive area in a survey in late July in proximity to a double-trunked 80-foot-tall tulip poplar. This was a larger anomaly, located 4.5 feet northwest of sk001, and proved to be a series of stopping voids, as well as the location of four other burials. These were in proximity to one another, also about 1 to 1.5 feet under the ground level, about 3 feet into the fill. Samantha Cox supervised the excavation and located three graves on August 10–11, 2009.

Sk002 consisted of the top half of an adult male skeleton, oriented west–east as sk001, which measured 29.134 inches long by 12.992 inches wide.

The skull also showed signs of extreme perimortem violence to the right rear of the cranium. The neck, spine, left side of the rib cage and the left shoulder and humerus were all excavated. The excavation also revealed coffin remnants, with measurements as follows: north board, 29.134 inches long; west board, 14.567 inches long; and south board, 7.874 inches long, including fifty-four nails. The eastern portion of the coffin board vanished, along with the upper left side and bottom half of the skeleton, probably due to the periodic heavy flow of water along the base of the fill during the nineteenth century.

Sk003 consisted of only a portion of the lower left leg to the foot, measuring 10.63 inches, as well as a stain of other portions of the skeleton and the outline of a coffin but no surviving nails. The skeleton would have measured 5 feet, 4 inches. Sk004 presented only the stain conforming to the outline of a coffin, measuring 5 feet, 4.5 inches in length, 29 inches wide. It is probable that the same periodic flow of water that is believed to have caused a portion of sk002 to vanish also caused most of sk003 to vanish and all of sk004. Yet another grave was located when a coffin line of sk005 was found in mid-August amid the roots of the tulip poplar and then a portion of a tibia was excavated, but no further excavation could be attempted until the tree was removed.

In the first week of July 2010, two more sets of adult human remains were located on a line lying four feet west of the tulip poplar. Sk006 was buried in the fill slightly interior to, and east of, sk007. These also were located along the base of the fill, where fill meets the valley floor, and about one foot below ground level. Sk006 was excavated on August 4. This excavation revealed an adult male, oriented west–east, who measured six feet, one inch in height and whose right arm was missing, perhaps also due to the flow of water after burial.

The skull received a great deal of perimortem violence, including an axe blow to the right side of the head and a small-caliber, low-velocity bullet fired at close range directly into the top of the cranium from above. The bullet was still lodged in the bottom of the skull. The coffin measured 42.6 inches long, with both north–south boards present, and 29 inches remained of the western (top) board.

The bottom half of the coffin line was missing, but a total of fifty-one coffin nails were excavated from the top half of the coffin. A CT scan and X-ray were taken of the cranium, and lead swipe was located by Monge within the cranium, which is evidence of the bullet passing through the skull.

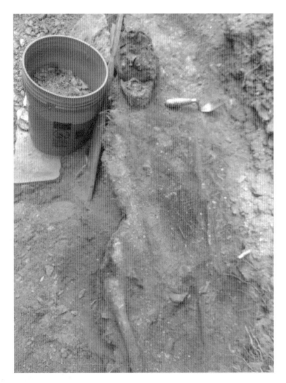

Left: Excavation of skeleton 006 at Duffy's Cut, 2010. *Watson Collection.*

Below: Skull of skeleton 006, showing axe blow and bullet hole. *Watson Collection.*

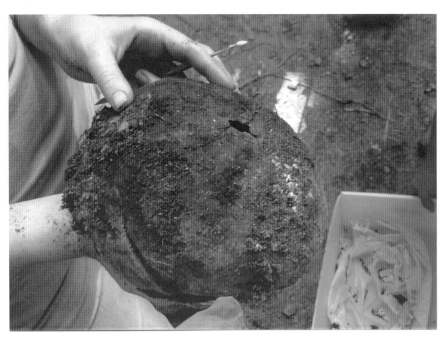

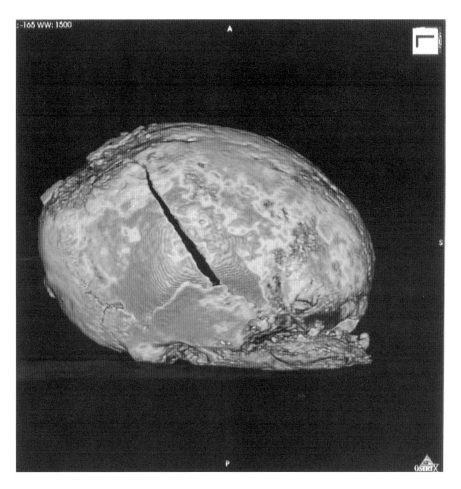

Janet Monge's CT scan of skull of skeleton 006, 2010. *Janet Monge.*

Sk007 was excavated on August 5. This excavation revealed another burial oriented west–east and a coffin line measuring five feet, five inches, with most of the western, northern and eastern boards present. The southern boards, along with the right arm and eight foot, were absent; 110 coffin nails were excavated from this grave. The individual in the coffin would have been five feet, three inches in height. Forensic analysis of the palate and the pelvis by Janet Monge and Samantha Cox revealed that this skeleton was female.

The tulip poplar was removed in two stages, in the spring and summer of 2011. This skeleton was oriented west–east, but his right side was intact, and excavation lasted from August 8, 2011, to February 20, 2012. A femur

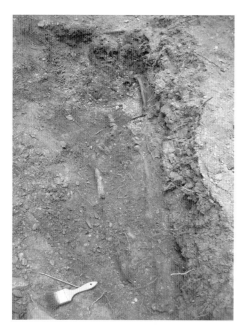

Excavation of skeleton 007 at Duffy's Cut, 2010. *Watson Collection.*

was excavated on August 19, along with a four-inch-long barlow knife along what would be the skeleton's right hip, as well as two pewter buttons that might have been from a haversack. Much of the skeleton was entwined in the still-existing roots of the stump. The excavation would proceed along an unconventional plan because the roots had cut through the skeleton and twisted it. The destruction could not be negated even if the stump were removed, which it eventually was, in early February 2012. Portions of the coffin and bones were removed from the roots for the next several weeks. The longest portion of coffin line was along the northern edge, measuring 1.3 feet long, but a total of 107 coffin nails and a hinge were retrieved throughout the excavation. The skull was retrieved in pieces, but Deputy Coroner Norm Goodman said that more of the teeth had been recovered from this excavation because the tree's root ball had effectively encased the skull. Some thirteen other bones, from the legs, vertebrae and collar bone, were excavated in this unconventional endeavor. In addition, a bullet fragment was found with the remains.

Forensic analysis revealed that each of the skulls showed evidence of blunt-force trauma. These burials had supposedly been from a group that had died of cholera, yet the physical evidence pointed to murder. Sk006 was shot at close range. A bullet was found with sk005. Several small-caliber, low-velocity bullets had previously been excavated in the shanty. Given the blunt-force trauma on the skulls and the bullet in the cranium of sk006, Janet Monge told CNN that "if they had cholera, that's not what killed them." In an interview with Bette Brown of the *Irish Examiner* in 2014, Monge further stated:

> *I would have to say that it was actually a massacre....* [T]*hey all showed signs essentially of wounds. The preponderance of evidence is that they met*

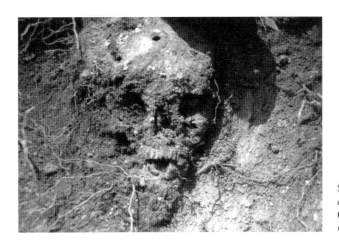

Skull of skeleton 007 excavated at Duffy's Cut, 2010. *Watson Collection.*

a violent death. We have evidence of blunt force trauma, evidence of sharp force trauma and we even have evidence of bullet holes.

The burial of railroaders who died on the work site within the railroad fill became a common custom among railroaders throughout the United States. The burial of the workers at Duffy's Cut may be the oldest known examples of the practice. The fill was completed in 1832–34. No one could have been buried in the fill before that time because the fill did not yet exist. Similarly, no one could have been buried in the fill when it served as part of an active rail line. There was thus a narrow time frame of only two years when individuals could have been buried in the fill at Duffy's Cut. No other burials have been recorded at the site after the railroad's opening.

Standard genealogical protocols were used on the 160 individuals on the *John Stamp* passenger list, matching the names against census and tax records, and while many names can be traced after arrival, nineteen names on the passenger list absolutely disappeared from the record after arrival. These are presumed to be some of the fifty-seven Duffy's Cut victims, given the PRR file's note on the specific period when the crew arrived; the record of the one ship in that period coming directly from Ireland to Philadelphia; the fact that it had a substantial number of laborers on board; the fact that it sailed from Derry (Londonderry for Protestant Irish); and presence of the only pipe stem or other artifact from any city, suggesting that the 1832 work crew sailed from Derry.

Since the *John Stamp* passenger list contained only home counties and not hometowns of many of the Duffy's Cut work crew, other sources might provide a key, although the lacunae in the native Irish sources are large.

However, *Griffith's Valuation* of 1857 includes a good many of the surnames of the nineteen names of the Duffy's Cut workers who disappeared in 1832 within the Donegal baronies, some twenty-five years after the deaths of the men in Pennsylvania, suggesting points of origins for some of the workers. Ruddy appears in Inishowen W and E, Kilmacrenan, Banagh, Boylagh and Tirhugh. Doherty appears in Inishowen W and E, Kilmacrenan, Raphoe N and S, Banagh, Boylagh and Tirhugh. McCahill appears in Inishowen E, Raphoe S, Banagh, Boylagh and Tirhugh. Quigley appears in Inishowen W and E, Kilmacrenan, Raphoe N and S, Boylagh and Tirhugh. McIlheaney appears in Inishowen W and E, Kilmacrenan, Raphoe N and S, Boylagh and Tirhugh. Devine appears in Inishowen E, Raphoe N and S, Boylagh and Tirhugh. These are all possible locations of the point of origin of the Donegal-born Duffy's Cut workers. Similar work remains to be done on the Tyrone and Derry names. DNA extraction from the remains might help with more specific identification if the extracted data can be placed into a worldwide database.

All but one of the workers on the passenger list came from the Province of Ulster (one was from nearby Leitrim). Almost half of the workers came from Donegal; the second-largest contingent came from Tyrone, then Derry (not given as Londonderry) and one from Leitrim (in Connaught). As already noted, their average age was twenty-two. Some came together, and a few came with a relative—one came with a sister. Most of them had few possessions—contained in a chest, a box or a bundle—while some had nothing at all other than their clothing. The laborers would have had experience working in a farm setting on manual labor projects like fence making, ditch digging and horse teaming, and such workers were already being used on construction projects in the United Kingdom, such as railroad and canal construction.

The unique characteristics of sk001 and sk007 made possible a tentative linking of those two sets of remains with names on the *John Stamp* passenger list from counties Donegal and Tyrone. Sk001's young age (eighteen) and his M1 agenesis (right top front molar missing from birth, a congenital anomaly) proved intriguing. An eighteen-year-old named John Ruddy of Donegal was among the nineteen missing names from the *John Stamp*. Ruddy was passenger no. 4 on the list, and he came with only a box containing his possessions. His remains had been the initial skeleton located in March 2009. When word reached the Irish media that remains had been found, it caused a sensation, in particular when it became known that it may have been an eighteen-year-old named Ruddy who was missing his right top front molar.

Ruddys in Donegal contacted the Duffy's Cut research team to explain that the family has a high preponderance of M1 agenesis, even though it is rare in the general population.

Sk007, on the other hand, was a female approximately thirty years of age. There were two female names among the nineteen missing from the *John Stamp*: nineteen-year-old Elizabeth Devine, of Donegal, who traveled with her brother, William Devine (one of the laborers), and her infant son, John (born out of wedlock, as she was listed as a "spinster"), and twenty-nine-year-old Catherine Burns, of Tyrone, who was a widow and was traveling with her seventy-year-old father-in-law, John Burns, who was also listed as a laborer. Janet Monge determined that the remains were those of the twenty-nine-year-old female upon examination of the pelvis and palate.

The reburial of the remains from the first seven graves began on March 9, 2012, at West Laurel Hill Cemetery in Bala Cynwyd, Pennsylvania, when five sets of remains were buried. Members of the Immaculata student excavation team served as pallbearers, conscious that their ages were on average the same as those of the individuals they were carrying to their resting place. Immaculata

Irish ambassador Michael Collins and his wife, Marie, viewing Duffy's Cut artifacts at Immaculata University with Earl Schandelmeier, Frank Watson and William Watson, 2011. *Watson Collection.*

University paid for the Celtic cross and stone ledger, both carved in Ireland from Kilkenny limestone. A representative of the Irish Embassy was present at the ceremony (Ambassador Michael Collins, having personally visited the site of the graves twice). Members of the Irish county societies, the Ancient Order of Hibernians, the Friendly Sons of St. Patrick and various other Irish American organizations were present among the several hundreds attending the ceremony. The West Laurel Hill cross and ledger are often visited by Irish tourists to the Delaware Valley.

The skeleton of sk001, aka John Ruddy, was buried at the cemetery of Holy Family Church in Ardara, Donegal, on March 2, 2013, in a plot provided by Vince Gallagher of the Commodore Barry Club. Bones of Sk007, aka Catherine Burns, were buried in St. Patrick's Church in Clonoe, Tyrone, on July 19, 2015, in a plot arranged by Brian McCaul of the Tyrone Society. These burials attracted large numbers of visitors and participants from other parts of Ireland and even from the United States, and they were extensively covered in the Irish and American press. Donegal historian Sean Beattie attended both ceremonies, and Ulster Folk Park director Patrick Fitzgerald attended the reburial of Catherine Burns.

The Duffy's Cut team learned just prior to the Ruddy reburial that members of the "Families of the Disappeared" would be attendance—in particular Anne Morgan, sister of Seamus Ruddy, who had vanished in Northern Ireland's Troubles—and that American governmental officials had suggested to the group to employ the techniques that the Duffy's Cut team had employed to locate the first seven burials in their efforts. In 2017, Morgan related the following:

Hi Frank,

Thanks for writing to me. 32 years was a very long time but I never gave up hope. I prayed continually for his return and now my prayers are answered. Being with you and your brother Bill in Ardara and giving John Ruddy a burial meant so much to me. It spurred me on. Duffy's Cut has helped to find 7 people here as in 2005 we were able to set up a Forensic team to help with the searches. I had been told about Duffy's Cut by Mitchel Reiss who was a Special Advisor in N. Ireland for George Bush who was the U.S. President at the time. So a big thank you to you for all your work in Duffy's Cut. Keep up the good work.

Anne

Procession for Duffy's Cut burials, West Laurel Hill Cemetery, 2012. *Watson Collection.*

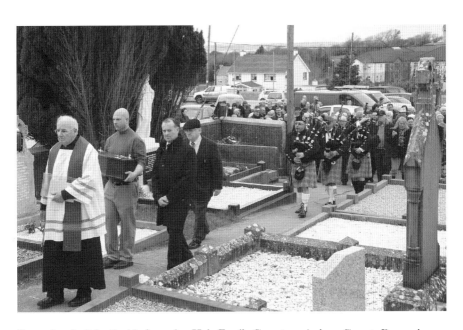

Procession for John Ruddy funeral at Holy Family Cemetery, Ardara, County Donegal, Ireland, in March 2013. *Photo by John McConnell.*

The parish of St. Patrick's in Clonoe held a wake and *feis* for Catherine Burns in the Washingbay Centre on the Friday before her reburial in the cemetery. Two of the Duffy's Cut victims, perhaps the only two whose names could be associated with a particular set of remains, were finally returned home, and a sense of long-delayed justice pervaded both of the ceremonies in 2013 and 2015.

The archaeological excavation at Duffy's Cut enabled the full recovery of the Duffy's Cut story and took the tale from the realm of folklore into history and science by means of the physical evidence. The search for the remaining fifty workers continues. A GPR and electrical resistivity survey by Tim Bechtel at the stone monument obtained in 2011 indicated a large stopping void about fifty feet by seventy feet in diameter some sixty feet south of the tracks, down near the original level of the valley, beneath about twenty-five feet of fill. Negotiations with Amtrak in 2012–15 eventually resulted in a contract to excavate core samples at the stone monument as a prelude to an archaeological dig. The first core samples were taken on the northern edge of the anomaly in October 2015, and the remainder of the work is yet to be done by the stone monument. GPR survey work was done above the first

Feis at wake for Catherine Burns at Washingbay Centre, Clonoe, County Tyrone, Northern Ireland, with St. Patrick's Church parish members and Father Benedict Fee, July 2015. *Brian Quinn and Clonoe Gallery.*

Procession for Catherine Burns funeral, St. Patrick's Cemetery, Clonoe, County Tyrone, Northern Ireland, 2015. *Brian Quinn and Clonoe Gallery.*

Bagpipe procession for Catherine Burns funeral at St. Patrick's Church, Clonoe, County Tyrone, Northern Ireland, July 2015. *Brian Quinn and Clonoe Gallery.*

Above: Procession for Catherine Burns funeral, St. Patricks Church, Clonoe, County Tyrone, Northern Ireland, July 2015. *Brian Quinn and Clonoe Gallery.*

Left: Core sampling led by Joe Devoy at Duffy's Cut stone monument, October 2015. *Watson Collection.*

graves on the 1832 fill in early June 2017, and a cluster of eight anomalies was found at the bottom of the fill, upslope and another fifteen feet farther north than the first graves excavated. This area remains to be excavated. DNA work on the remains is currently being negotiated as well.

Two other mass graves of Irish workers in Chester County await the full attentions of the Duffy's Cut team: one a railroaders' mass grave in Downingtown (connected to the circumstances at Duffy's Cut) and another a canal workers' mass grave in Spring City. Collectively, the dead at these sites will dramatically raise the number of casualties in the 1832 epidemic in Pennsylvania. If the rest of the remains at Duffy's Cut, and those at the other two sites, show signs of perimortem violence, then these might indeed be proof of the worst mass murders in the history of Pennsylvania.

COMMEMORATION OF DUFFY'S CUT

The government of the Republic of Ireland expressed its interest in supporting the Duffy's Cut Project starting in 2006. Among those expressing support include President Michael Higgins; Prime Minister Enda Kenny; Deputy Prime Ministers Michael McDowell and Joan Burton; Minister of the Diaspora Jimmy Deenihan; Ambassador Michael Collins; Consuls General Tim O'Connor, Barbara Jones and Ciaran Madden; and Deputy Consuls Peter Ryan and Anna McGillicuddy. Sinn Fein officials have also expressed their support, including former party VP and MP Pat Doherty and Mid-Ulster mayor Linda Dillon.

The Duffy's Cut Project Inc. was established in 2004 as a 501(c)(3) nonprofit for the purposes of mobilizing the resources necessary for the ongoing archival and archaeological work and to help spread the story in hundreds of public talks to the Irish American community, to civic groups and to railroading and community historical societies. It has also helped to establish public history displays at locations important to the story.

PUBLIC HISTORY

Duffy's Cut is a story that has resonated in Ireland and in the Irish American community and has spawned music, art and literature. There are several sites in Pennsylvania and in Ireland where the Duffy's Cut

Duffy's Cut team with Irish president Michael Higgins at New York University, New York City, October 2015. *Left to right*: Frank Watson, Tom Conner, President Higgins and William Watson. *Watson Collection.*

Duffy's Cut team with Irish prime minister Enda Kenny at Aronimink Country Club, Newtown Square, Pennsylvania, March 2017. *Tom Keenan.*

incident is commemorated. The Pennsylvania state historical marker for Duffy's Cut at King Road and Sugartown Road in Willistown, near Malvern, was placed by the Duffy's Cut team on August 18, 2004. Paid for by the Chester County Emerald Society, it reads as follows:

> *Nearby is the mass grave of fifty-seven Irish immigrant workers, who died in August, 1832, of cholera. They had recently arrived in the United States and were employed by a contractor, named Duffy, for the Philadelphia and Columbia Railroad. Prejudice against Irish Catholics contributed to the denial of care to the workers. Their illness and death typified the hazards faced by many 19th century immigrant industrial workers.*

The Pennsylvania Historical and Museum Commission marker was first dedicated in a ceremony at nearby Immaculata University on the previous June 18, in which the marker was blessed and sprinkled with holy water. The marker was placed at the nearest intersection to the site of the mass grave, although the grave and work site are both in East Whiteland Township.

There is a standing Duffy's Cut Museum housing most of the artifacts excavated at the site, located in the Gabriele Library of Immaculata University. Four cases display the artifacts from the workers and from the early railroad. One case houses the clay pipes, including the two Irish emblem pipe bowls, the Derry stem and other pipe bowls (some with other designs, including one with an American flag on it) and pipe stems. There are also three pipe stems and one bowl fragment displayed with melted pewter that matches the story of the fire reported in the Julius Sachse account of the

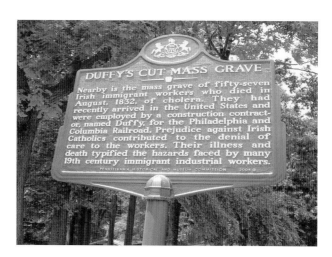

Duffy's Cut Historical Marker, 2004. *Watson Collection.*

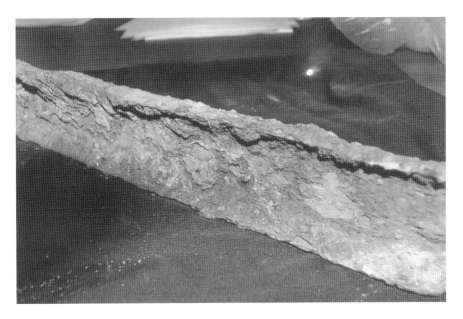

Morris and Essex-type strap rail found at Duffy's Cut. *Watson Collection.*

events. ("The contractor no sooner heard that all were dead than he sent word to the heroic blacksmith to set fire to all the buildings and utensils on the ground which was done.")

Another case includes early railroad items found on the 1832 fill or in proximity to it: six rare, experimental stone spikes found at the site; a sample of the equally rare cast-iron strap rail; two iron pitchforks or fire rakes; an iron hook and looped iron implement for placing the stone sleepers along the original line; an iron shovel blade and iron handle; and an iron wedge used for chipping the sleepers. This case also includes examples of the coffin nails, contrasting some from sk001 (John Ruddy) and sk005 (the man under the tree).

One case includes personal items from the workers, such as the pants clasp of sk001/John Ruddy; the barlow knife and pewter buttons from sk005; and ten glass buttons found in the shanty area, along with the nail with a melted glass button fused to it, also demonstrating the fire described in the Sachse account of the events. The fourth case includes the first artifacts excavated at the site, the cooking pot and ladle; the lid of a potbellied stove with a piece of coal fused to it; and many pieces of pottery and glass found at the site. The museum's guest book indicates a steady stream of tourists from throughout the United States and from Ireland.

The limestone cross for the Duffy's Cut burials at West Laurel Hill Cemetery in Bala Cynwyd, Pennsylvania, includes the following words:

> *Here lie the remains of some of the 57 Irish railroad workers who died of violence and cholera while building the Philadelphia and Columbia Railroad in East Whiteland, Penn.*
>
> *August 1832.*
> *Duffy's Cut 57*

The cross was carved in Kilkenny limestone by Johnnie Rowe of Stradbally, County Laoise, and finished at Abby Rose Incorporated of Yardville, New Jersey, by William Farrell in the fashion of the early medieval Celtic crosses of Ireland. The front includes a map of Ireland, painted green. Several illustrations are carved into the sides of the stone, including a painted map of Ireland with its four provinces delineated and marked with their traditional heraldic emblems and a black silhouette illustration of a bark, the kind of sailing vessel that brought the work crew to America. The limestone ledger at the grave includes names of twenty individuals from the ship *John Stamp* whom the research team is reasonably certain died at Duffy's Cut:

- George Doherty, County Donegal
- John Ruddy, County Donegal
- William Putetill, County Donegal
- William Devine, County Donegal
- Elizabeth Devine and son John, County Donegal
- James Deveney, County Tyrone
- Daniel McCahill, County Donegal
- Bernie McGarty, County Donegal
- David Patchell, County Donegal
- Robert Skelton, County Donegal
- Patrick McAnamy, County Tyrone
- Bernard McIlheaney, County Donegal
- George Quigley, County Donegal
- Samuel Forbes, County Tyrone
- John McGlone, County Derry
- John McClanon, County Derry
- John Burns, County Tyrone
- Catherine Burns, County Tyrone

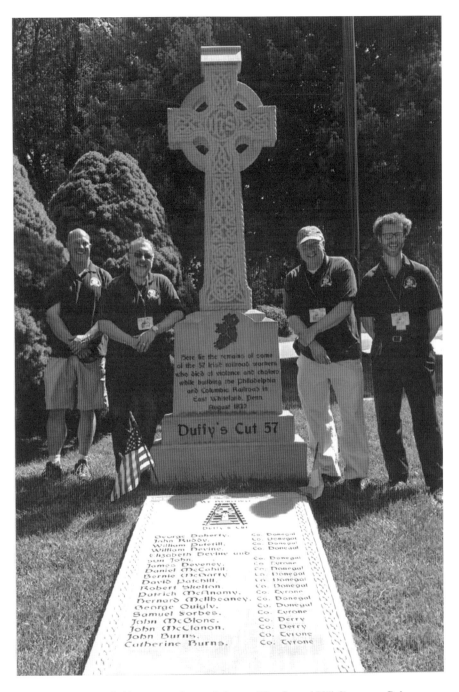

Duffy's Cut team at Celtic cross and stone ledger at West Laurel Hill Cemetery, Bala Cynwyd, Pennsylvania, July 2016. *Left to right*: Earl Schandelmeier, Frank Watson, William Watson and Joseph Conte. *Watson Collection.*

The names are placed in relation to where their names appear on the 160-person *John Stamp* ship list. At the top of the ledger appears a logo created by the Chester County Emerald Society, with a Celtic cross on top of railroad tracks and the words "We Remember Duffy's Cut."

The Donegal Association of Philadelphia holds an annual commemoration at the cross at the Sunday afternoon closest to the anniversary of the reburials. The coffins for the reburials at West Laurel Hill were constructed by cemetery caretaker Bill Doran, himself an Irish immigrant, who also lowered the coffins into the vault at the 2012 ceremony.

The grave of John Ruddy is located in the Gallagher family plot at Holy Family Cemetery in Ardara, Donegal. The black stone marker for Ruddy, designed and constructed by the Shovlin Funeral Home in Ardara, has gold lettering that states the following:

> *In Loving Memory of*
> *John Ruddy*
> *Born, Donegal, Ireland, 1814*
> *Died, Duffy's Cut, Pennsylvania, 1832*
> *Grave Donated by the Gallagher Family*
> *Of Loughros Point, Ardara*

The flags of the United States and Ireland are painted around the heraldic crest of County Donegal. The coffin for John Ruddy was also made by Bill Doran of West Laurel Hill Cemetery in Pennsylvania.

The grave of Catherine Burns at St. Patrick's Church in Clonoe, Coalisland, Tyrone, in Northern Ireland, was donated by the parish and Canon Benedict Fee. Her marker is a wooden cross beneath the large stone community cross, and the plaque on the wooden cross reads as follows:

> *Catherine Burns 1832*
> *Duffy's Cut USA*
> *Interred 19*[th] *July 2015*
> *Rest in Peace*
> *Patsy Taggart Funeral Directors, Coalisland*

The coffin for Catherine Burns was made by Patsy Taggart Funeral Directors as well.

The Pennsylvania Railroad had rejected the plea of Martin Clement in 1909 to place a plaque on the stone monument. An inaccurate sign

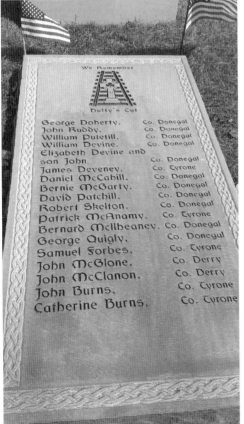

Above: Duffy's Cut team with Philadelphia mayor James Kenney at West Laurel Hill Cemetery Duffy's Cut annual memorial ceremony, Bala Cynwyd, Pennsylvania, March 2016. *Photo by David Scott.*

Left: Stone ledger with names of Duffy's Cut victims at West Laurel Hill Cemetery, Bala Cynwyd, Pennsylvania. *Watson Collection.*

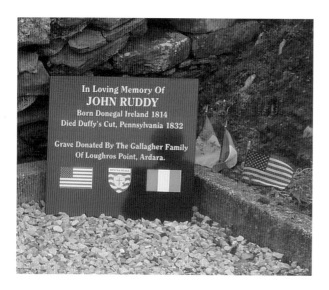

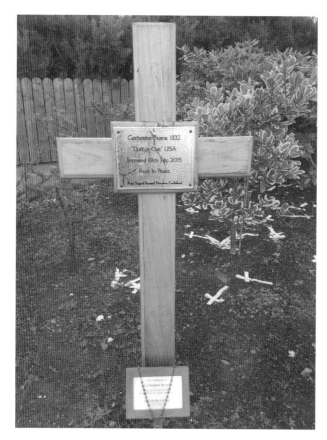

Top: Tombstone of John Ruddy in Gallagher plot in Holy Family Cemetery, Ardara, Donegal. *Vince Gallagher.*

Bottom: Cross for Catherine Burns at St. Patrick's Cemetery, Clonoe, County Tyrone, Northern Ireland, 2015. *Watson Collection.*

was placed over the stone monument by locals in 2000 that included the incorrect year (1834) and disease (black diphtheria), in addition to having no mention of the site as "Duffy's Cut." The East Whiteland Historical Commission met with the Duffy's Cut team and the International Brotherhood of Electrical Workers (IBEW) members of Amtrak (Pearse Kerr, Hugh Campbell and Dennis Henry) in July 2016 to discuss the changing of the wording on the sign, and the commission agreed to allow the team to remove the sign and correct it. The IBEW members enlisted the Ancient Order of Hibernians to have the sign repainted with correct verbiage. The new sign was replaced above the stone monument on September 9, 2017, with the following wording:

> *Burial Plot of*
> *Irish*
> *Railroad Workers*
> *At This Site, Known as Duffy's Cut*
> *Fifty Seven Irish Immigrant Railroad Workers*
> *From the Counties of*
> *Donegal, Tyrone, Derry, and Leitrim*
> *Died of Cholera and Murder*
> *In the Summer of 1832*

The iconography of the Amtrak sign borrowed something from the first sign, with two Celtic crosses on either side of the text and use of a Victorian-looking border, but the color scheme was changed from the red and gold of

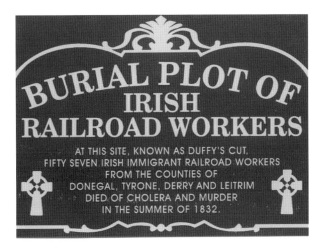

Amtrak historical marker for Duffy's Cut at the site of the stone monument from IBEW members and the AOH, with Frank Watson and William Watson. *Watson Collection.*

the Pennsylvania Railroad to the green and gold of the Irish flag. The sign faces the tracks of eastbound Amtrak and Septa trains, as did the previous sign. Subdued solar-powered lighting was installed so that the sign can be seen at night from the tracks.

MEDIA AND POPULAR CULTURE

Hundreds of news pieces have appeared in the first fifteen years from when the Duffy's Cut Project began—in newspapers, magazines and on television and radio—all of which collectively reflect the national and international interest in the tragedy and efforts to bring justice to the Duffy's Cut victims. Articles have appeared in a variety of journals written by project team members, and aspects of the story have been cited in a number of books, both scholarly and popular, on Irish and Irish American history, cholera, the railroad, the history of Catholicism, true crime and even the paranormal. The research team published *The Ghosts of Duffy's Cut* with Praeger Publishers in 2006. BBC, RTE, NPR, PBS, CNN, CBC, PCN, the Smithsonian and CBS, among other media outlets, produced television and radio segments on Duffy's Cut, including an hour-long segment of NPR's *Radio Times with Marty Moss-Coane* that aired on September 14, 2009.

The first of several documentaries appeared in 2006, produced by Tile Films of Dublin, called *The Ghosts of Duffy's Cut*, which appeared in Ireland on RTE and in the United States on the Smithsonian Network. The book and documentary of the same title appeared within weeks of each other in the summer of 2006. Nominated for an Irish film award, *The Ghosts of Duffy's Cut* was the highest-viewed documentary in Irish history up to that time. A screening of the documentary at Tellus 360 in Lancaster, Pennsylvania, on March 15, 2012, included the live performance of a Duffy's Cut song by Tyrone singer and musician Mickey Coleman, and event sponsor Irish-born entrepreneur and builder Joe Devoy raised funds for the dig to continue. On March 23, Devoy arranged a meeting with the Friends of Ireland Committee in the U.S. House of Representatives in Washington, D.C. Devoy and the Watsons sought to obtain the support of the Friends of Ireland for the continued excavation on Amtrak property. Such support was forthcoming, and representatives of Amtrak were receptive to the plan for the resumed excavations. The showing of the Tile documentary in Lancaster had led to the continuation of the excavation.

Joe Devoy and Duffy's Cut tulip poplar that grew over four graves. The tree will be made into musical instruments called "57 Brand." *Watson Collection.*

Devoy had also removed the large tree that had grown on top of the remains of four of the Duffy's Cut victims the previous February. He planned to use the wood from the tree for musical instruments to be called "57 Brand."

The Travel Channel filmed a segment of *Mysteries at the Museum* on Duffy's Cut in early 2012, featuring the Duffy's Cut Museum at Immaculata and discussed the skeletons, airing on May 1, 2012 (episode no. 215). Tile Films, meanwhile, had returned to Duffy's Cut in 2009, after the first human remains were located, and filmed on and off for the next four years as the excavations occurred and the reburials occurred at West Laurel Hill and Holy Family in Donegal. This new documentary, entitled *Death on the Railroad*, was made for RTE and for the national PBS series *Secrets of the Dead*. It premiered in the United States on national PBS channels on May 8, 2013. The Farrells—father Dave and sons Keith and Colin, all producers and directors at Tile—stated that the Duffy's Cut story was the longest-running project they had ever worked on.

The Irish government flew Dave and Colin Farrell to Philadelphia to participate in a screening and discussion of the documentary and the state of the excavation at the Ibrahim Theater of the International House at the University of Pennsylvania on March 20, 2014. The screening and discussion was the idea of Irish deputy consul general Peter Ryan. He and Irish Immigration Center director Siobhan Lyons sought to mobilize the Philadelphia-area Irish community behind Duffy's Cut.

Two important results came from this second public screening of a Duffy's Cut documentary. First, a successful fundraiser was organized for the nonprofit at the Twentieth Century Club in Lansdowne, Pennsylvania, on July 15, 2014, organized by Lyons, Irish Network–Philadelphia president Bethanne Killian (a Duffy's Cut Project board member) and Donegal Association president Kathy McGee Burns (also a board member). Any fees

Symposium program cover for "Duffy's Cut and the Arts," at Immaculata University, October 2014. *Watson Collection.*

incurred by the excavation work could be now be paid by the nonprofit. The second outcome was a symposium at Immaculata called "Duffy's Cut and the Arts," held on October 11, 2014.

Organized by Bethanne Killian, the symposium's panels explored the music, art and literature that had been created in the Irish American community based on the Duffy's Cut story. The participants included musicians Marian Makins and Gabriel Donahue; Pat Kenneally (whose Duffy's Cut song had won a state prize in folk music); Rosaleen McGill and Vince Gallagher; authors Kristen Walker and Kelly Clark, who were working on Duffy's Cut novels; and individuals in the media, such as veteran CBS TV reporter Walt Hunter (a Duffy's Cut board member), former vice-president of Warner Bros. Bill Daly and actor Pat McDade (a Duffy's Cut board member). Perhaps the biggest result of the symposium was the release of a Duffy's Cut tribute CD containing much of the Duffy's Cut music called *Songs of Duffy's Cut*, produced by Bethanne Killian.

The first song about Duffy's Cut, "Sacred Ground," written by Irish American artist Michael Boyce, appeared in 2006 by the Philadelphia-area American Irish rock band Blackthorn on the album *Push and Pull*. A song was commissioned from Irish artists Wally Page and Tony Boylan by Tile Films called "Duffy's Cut" for the 2006 documentary *The Ghosts of Duffy's Cut*. It appeared on Page's 2008 album *Live at the Hatch*, and his lyrics were performed by famed Irish balladeer Christy Moore for his 2009 album *Listen*. Philadelphia Irish American folk singer Marian Makins and Irish singer-musician Gabriel Donahue performed a different-tempo version of the Page song for the 2013 album *Ceili Drive: The Music of Irish Philadelphia*. The widely known Boston-area "Celtic punk" band Dropkick Murphys produced a high-energy rock song about Duffy's Cut called "The Hardest Mile" for its 2011 album *Going Out in Style*.

A number of songs appeared around the period of the Duffy's Cut reburials. The Kilmaine Saints, a Celtic rock band from central Pennsylvania, produced a song called "57" for its 2012 album *Drunken Redemption*. The Mickey Finns, a Celtic rock band from New York City, produced "The Ballad of Duffy's Cut" for its 2012 album *Prayers and Idle Chatter*. Orange County, California–based punk/rock band the American Wake produced a song called "The 57" for its 2012 album *Another Round*. Massachusetts folk singer Pat Kenneally won the sixth annual Pennsylvania Heritage Song Writers' Competition in 2013 for her song "Duffy's Cut" (distinct from the Wally Page lyrics and melody). The song appeared on the 2013 Cooper and Kenneally album *Off Our Rockers*. Tyrone-born Irish balladeer Mickey Coleman's song entitled "Duffy's Cut" (also distinct from the Page lyrics) was produced with Joe Devoy for Coleman's 2013 album *Last Glance*. Galway balladeer Jon Bulman produced a 2014 a capella single called "Beneath the Earth at Duffy's Cut." The Pennsylvania punk/rock band Birmingham Six produced "Here at Duffy's Cut" for its 2014 album *Move On*. California Americana balladeer Rick Shelley produced "Dead Horse Hollow" on his 2017 album *Hope Wrapped in Razor Wire*.

The Alfred Publishing Company published Bob Phillips's school music composition entitled "The Legend of Duffy's Cut" in 2009, which has been performed throughout the United States by school bands and orchestras in grades three through eight. The Philadelphia-area Irish dance school Cara-McDade produced a Duffy's Cut dance in 2009, with which it won several competitions, including a second place for Philadelphia Rose of Tralee performers in the Rose Petal and Rosebud level in the North American Irish Dance Championship in Montreal, Canada, in 2014. Jennifer Bellor composed a twenty-minute opera for the Kennedy Center for the Performing Arts in Washington, D.C., for the American Opera Initiative called *Duffy's Cut*, which was performed on November 13, 2013.

Irish author Paul Lynch wrote a novel based on Duffy's Cut in 2013 called *Red Sky in Morning*, which was published by Little, Brown, and which includes the characters Philip Duffy and John Ruddy. Starting in Ireland, the novel's focal point shifts to Duffy's Cut and the murders at mile 59 but eventually takes the story to California. Tony Conaway's short story "Incident at Duffy's Cut" appeared *Unclaimed Baggage: Voices from the Main Line Writers Group*, edited by Ann Stolinsky and Littner and published by White Lightning Publishing in 2013. Marita Krivda Poxon produced a series of ghost stories along with the Watson brothers in 2012 at the Commodore Barry Irish Club in Philadelphia on October 28, 2012, and

published by Book Country as *Ghosts of Duffy's Cut: Tales of Cholera and Death* in 2014.

Artwork has also been produced on the subject of Duffy's Cut. Jonathan Valania's article "Murder in the Time of Cholera" in *Philadelphia Weekly* (August 17, 2010) included an illustration of skeletons in the railroad fill with a train going over the top by artist Tim Durning, a graduate of the University of the Arts in Philadelphia. Samuel Hughes's article "Bones Beneath the Tracks" in the *Pennsylvania Gazette* of November/December 2010 included a cover collage painting of a train going over a skull that was growing out of the

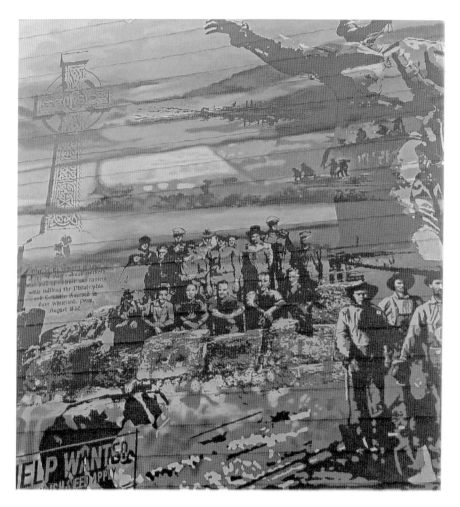

Eric Okdeh's Duffy's Cut mural at Marty Magee's Pub, Prospect Park, Pennsylvania. *Joe Magee.*

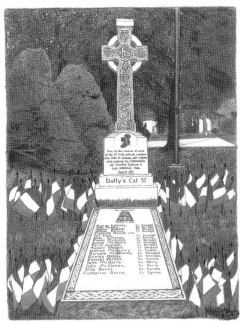

Duffy's Cut Celtic Cross Memorial
"Our Day Will Come"

Pamela Murphy illustration of Duffy's Cut Celtic cross and stone ledger at West Laurel Hill, Bala Cynwyd, Pennsylvania, 2016. *Pamela Murphy.*

roots of a tree, produced by artist David Hollenbach, a Society of Illustrators silver medalist. In 2015, muralist Eric Okdeh completed a mural of Irish and Irish American historical themes at Marty Magees Pub on Lincoln Avenue in Prospect Park, Pennsylvania, reminiscent of the murals in Belfast and Derry in Northern Ireland. Okdeh, a graduate of Temple University's Tyler School of Art, was commissioned by pub owner Joe Magee to depict images of the Troubles in Derry, the Molly Maguires in Pennsylvania, Commodore John Barry and several scenes of Duffy's Cut.

Pittsburgh artist Pamela Murphy produced a series of paintings about Duffy's Cut in 2016–17, focusing on the 1909 stone monument, the cooking pot and ladle (the first artifacts from the excavation) and the West Laurel Hill Celtic cross and ledger, to be followed by paintings of other scenes, produced as prints to raise funds for the nonprofit.

Duffy's Cut was a featured segment of Sam Katz's *Urban Trinity* documentary (History Making Productions) about the history of Catholicism in Philadelphia that aired on ABC TV on September 22, 2015, the timeframe of the visit of Pope Francis I to Philadelphia during the World Meeting of Families. Artist Fred Danziger, an instructor at the Art Institute

Duffy's Cut sign for NEH
Summer Teachers' Institute
at Immaculata University,
July 2016. *Immaculata
University.*

of Philadelphia, produced a series of paintings for *Urban Trinity*, six of which depicted Duffy's Cut scenes. They were exhibited at the Rodger LaPelle Galleries in Philadelphia in October–November 2017 and at Gabriele Library of Immaculata University in January–February 2018. The subject of the geological surveys and radar at Duffy's Cut served as the basis of a segment of the Science Channel series *Secrets of the Underground* entitled "America's Buried Massacre," which aired on February 28, 2017. Irish-American Films (Shawn Swords and Roger Cameron Bruce) produced a feature-length documentary about Duffy's Cut entitled *The Cut: The Journey of the Men and Women of Duffy's Cut* in 2017 that aired on Philadelphia-area cable TV channels throughout the year.

In July 2016, a National Endowment for the Humanities summer teachers' institute was held at Immaculata University for secondary teachers to facilitate getting the Duffy's Cut narrative into the high school curriculum. Twenty-nine teachers from across the country produced lesson plans for classroom use incorporating the story into immigration and industrial history, archaeology, geology, biology and English.

The themes associated with the Duffy's Cut narrative have inspired such a variety of artistic responses because of the universal appeal of those themes, and it is likely that they will continue to do so as long as modernization, immigration and intercommunal violence continue to arouse the interest of creative individuals.

CONCLUDING ASSUMPTIONS

The Duffy's Cut historical team has made several specific assumptions based on the available documentary and physical evidence. These refer to Philip Duffy, the railroading crew, the East Whiteland neighbors and the question of murder at the site.

Philip Duffy was probably from Ulster, and his family was likely involved in the 1798 United Irishmen revolt and hence fled to America at that time. Swiftly becoming a purveyor of his countrymen for various Pennsylvania railroading construction projects, Duffy had contacts in Donegal who advertised his P&C contracts, including the 1832 contract for mile 59, throughout Ulster. He was a man of paradoxes. Some of his peers would have recognized his personal ambition for what it was; others would have admired him for being the personal conduit for so many disenfranchised Catholic laborers to make their way to the New World. A man who held indentures for some of his countrymen, he was nevertheless a living advertisement of how an Irishman might rise above his lowly status and become a part of the establishment. While the industrial leaders of the day believed that Irishmen were the perfect cannon fodder of the Industrial Revolution—strong, hardworking and inexpensive—Duffy also amassed his wealth on this very premise. While the incident at mile 59 would not help his labor recruitment efforts, Duffy continued to obtain contracts with various railroads through the remainder of his days.

The workers answering Duffy's call were young, desperately poor men, mostly in their early twenties and uniformly Catholic, and many were Gaelic

speakers. Their only opportunity to work to date was for absentee British landlords picking potatoes, and thus far, they had been deliberately kept out of a money economy by the sectarian economic status quo of the Protestant Ascendancy. Prior to their arrival, they would have been unaware that a remarkably similar sectarian situation existed in America as in Ulster, yet unlike Ulster, the American Industrial Revolution was more than willing to use them up in internal improvement projects like the P&C. A nativist sentiment existed in Pennsylvania in 1832, witnessed in the Orange-Green Riot of 1831 and in the anti-immigrant stories in Chester County circulating during the 1832 cholera epidemic. While American industrial managers valued inexpensive, expendable Irish labor, native-born manual laborers resented the influx of cheaper competitors from Ireland. Nativist resentment fed the quarantines of immigrant laborers that characterized some of the responses to the arrival cholera in communities where internal improvements occurred in the 1830s.

Nativist sentiment also led to the murder of the first laborers at Duffy's Cut, when cholera broke out in the railroaders' camp at mile 59. It is likely that the first seven workers—who were healthy—broke out of a quarantine established by the Horse Company at mile 59 and were rounded up and murdered off site by blunt-force trauma and gunfire. Forensic analysis of the skeletal remains in 2009–12 provided substantial evidence that the first workers died from violence, not cholera. It is likely that some workers did indeed die of cholera, but it's equally likely that other workers died from violence as well.

The bodies of the murdered workers were brought back into the valley in coffins sealed with between eighty and one hundred nails and buried in the fill by their fellow workers, who did not know that their comrades had been murdered. Burial in the fill became a standard practice for railroaders who died during construction in the future throughout the United States. Duffy's Cut is the first known case of the practice. The East Whiteland Horse Company did much to hide the specific details of the murders, including confiscating every copy of the October 3, 1832 *Village Record*, which allegedly told the full story, and then put forward the false details in the November 7, 1832 "correction" piece, including the smaller number of deaths and no mention of murder. The subsequent murder of other immigrants in Chester County suspected of having cholera attests to the level of nativist sentiment as much as to the pervasive fear of an unknown disease.

Duffy's Cut most certainly was the site of mass murder, whether only the first seven were killed or all fifty-seven. If all fifty-seven were killed, it would

make Duffy's Cut the site of the worst mass murder in Pennsylvania history. It is likely that other sites in Chester County, Pennsylvania, contain mass graves of Irish laborers who died during the 1832 cholera epidemic, at P&C railroad mile 48 in Downingtown and at a Pennsylvania Canal worksite in Spring City. It is likely that some of those workers were also killed in response to the epidemic. Perhaps twenty thousand Irish immigrant laborers died in industrial projects on railroads and canals throughout the eastern portion of the United States in the 1820s and 1830s, from the Erie Canal to the New Orleans Canal. It is estimated that eight thousand Irish immigrants died building the New Orleans Canal alone. The deaths at Duffy's Cut therefore fit a pattern of abuse and neglect of Irish immigrants throughout the United States during the Industrial Revolution. The fifty-seven Irish victims at Duffy's Cut died building something of great consequence, and trains still pass over the place where they worked and died building Pennsylvania's pioneering railroad.

ACCOUNT OF THE DUFFY'S CUT INCIDENT BY JULIAN SACHSE, 1889

This detailed account of the Duffy's Cut incident was written in 1889 by Julian Sachse for the *Village Record* newspaper and was reproduced in 1909 for the Pennsylvania Railroad File on Duffy's Cut by Martin W. Clement.

In the month of August the much dreaded cholera suddenly made its appearance among the laborers, many were stricken causing great consternation, and with the improper attention and the lack of proper remedies, the scourge could not but rage with terrible effect.

Most of the workmen fled from the infected shanty at once, but so great was the fear of the surrounding population, that every house was closed against the fugitives, no one was found willing to give them food and shelter. When it was known that a case had resulted fatally, fear changed to panic, the fatal spot was avoided all, with the single exception no one was left to minister to the wants of the sick or bury the dead.

This exception was the blacksmith of the contractor, who had his shop near the shanty. This Hero, who's [sic] name is unfortunately lost to history, is said to have been an American, born and bred in Chester County, and when all fled he alone remained and ministered to the sick, and when the scourge claimed its first victim, he blew his dinner horn for assistance, none coming, he laid the man out as decently as he could, dug a grave singlehanded where the enclosure is now, then returned and dragged the corpse over to the opposite side of the ravine and buried it.

At the outbreak of the epidemic word had been sent to the City of the sad state of affairs. In response the church authorities at once sent out several Sisters of Charity to attend to the sick and dying in the shanty in the ravine.

An eye witness yet remembers the sensation caused by the arrival of the stage at the Green Tree with its precious freight. This was as near the infected spot as the driver could be induced to go. How these four brave women, clad in the habit of their order, in the hot blazing August sun started cheerfully to walk up the turnpike, carrying large parcels of supplies and medicines, was a sight not to be forgotten even after this long elapse of years.

On the arrival of these angels of mercy at the shanty they found all the sick with the exception of the brave blacksmith, who at first tried to dissuade them from their mission, but was soon convinced that the new arrivals had come to stay and do their duty fearless of the result to themselves. However, notwithstanding their merciful efforts all the victims fell a victim to the scourge. No sooner did one succumb to the fell destroyer than the brave smith would arrange him as best he could, place the body on the sled and drag it across the ravine and bury it beside the others; where as soon as he knew that all would die he dug a ditch to receive them.

The day after the last man died the four Sisters of mercy attempted to return to the City, but so great was the fear of contagion that they could get neither shelter nor conveyance, and tradition tells us that although jaded and worn out as they were by their vigils and duty to the dying laborers, they were forced to walk all the way to the City, twenty miles, according to the milestones, but to these four weak females, frail in body but strong in spirit, it seemed more like two hundred. It is stated that at the sight of their habit doors would be closed and all assistance refused to these persons, who had themselves risked their own lives to save that of their unknown fellowmen.

The tradition further says that although the day was burning hot and the poor creatures almost famished they could not even get a drop of water, until they arrived at the Spring House Tavern below the sixteenth milestone, where the cooling spring crosses the turnpike, and where they could not be prevented from slaking their burning thirst, they finally arrived at the City long after the shades of night had fallen starved and famished, but undismayed and ready to start again on their errands of mercy wherever called.

The contractor no sooner heard that all were dead than he sent word to the heroic blacksmith to set fire to all the buildings and utensils on the ground which was done.

Appendix B

DUFFY'S PHILADELPHIA AND COLUMBIA MILE 60 CONTRACT, *VILLAGE RECORD*, JUNE 9, 1829

F ollowing is an account of rising tensions between Irish railroad workers and the local population at contract mile 60, located just east of Duffy's Cut.

Mr. Philip Duffy is now prosecuting his Herculian [sic] task with a sturdy looking band of the sons of Erin....When the item of damages is taken into consideration, it is perhaps a fortunate circumstance, that where the greatest amount of ground to be broken, it is either woodland or thin soil, of comparatively small value. We are sorry to learn, that upon some sections, too little attention has been paid to the rights and property of farmers, through whose land the railroad passes. It is complained that fences are too often left prostrate, to the destruction of valuable crops of grain, grass, &cc. It is a matter of the first importance to preserve a good understanding between the people living adjacent to the route, and the contractors and hands employed in the work. The disregard of this has been the fruitful source of disorders and riots in some parts of the country—but which, we earnestly hope, may not occur in this section of the section of the state.

BIBLIOGRAPHY

Historical Context

Avery, John G. *The Cholera Years: An Account of the Cholera Outbreaks in Our Ports, Towns, and Villages.* Hampshire, UK: Beech Books, 2001.

Bechtel, Timothy. "The Engineering Geology of Duffy's Cut." Published online. Annual Conference of the Eastern American Studies Association, LaSalle University, Philadelphia, March 28, 2014. https://www.researchgate.net/publication/263579838_The_Engineering_Geology_of_the_1832_Duffy's_Cut_Railroad_Embankment_Malvern_PA.

Billington, Ray Allen. *The Protestant Crusade: A Study of the Origins of American Nativism.* New York: Macmillan Company, 1938.

Bondeson, Jan. *Buried Alive: The Terrifying History of Our Most Primal Fear.* New York: W.W. Norton, 2001.

Brody, Susannah. *Remembering Chester County: Stories from Valley Forge to Coatesville.* Charleston, SC: The History Press, 2010.

Burstein, Andrew. *The Passions of Andrew Jackson.* New York: Knopf, 2003.

Campbell, John H. *History of the Friendly Sons of St. Patrick and of the Hibernian Society for the Relief of Emigrants from Ireland, March 17, 1771–March 17, 1892.* Philadelphia, PA: Hibernian Society, 1892.

Catholic Directory/Laity's Directory. N.p., 1833.

Cator, Reverend Charles A.M. *The Cholera Morbus: A Visitation of Divine Providence.* London: Baldwin and Cradock, 1832.

Chambers, J.S. *The Conquest of Cholera: America's Greatest Scourge.* New York: Macmillan, 1938.

Chariton, Faith. "1832 Cholera Outbreak in Philadelphia and Duffy's Cut." *Catholic Historical Research Center of the Archdiocese of Philadelphia* (September 15, 2010). http://www.pahrc.net/1832-cholera-outbreak-in-philadelphia-and-duffys-cut.

"The Cholera in Philadelphia." Archives of the Daughters of Charity, De Paul Provincial House, Albany, New York. Record Group 11-01, Box 1, Folder 03-02, Item no. 1. The Sisters of Charity subsequently changed the name of the order to the Daughters of Charity.

Church, Samuel Harden. *America's First Railroad*. Philadelphia: Pennsylvania Railroad, 1925.

Churella, Albert. *The Pennsylvania Railroad*. Vol. 1, *Building an Empire, 1846–1917*. Philadelphia: University of Pennsylvania Press, 2012.

Clark, Dennis. *Erin's Heirs: Irish Bonds of Community*. Lexington: University Press of Kentucky, 1991.

———. *The Irish in Philadelphia: Ten Generations of Urban Experience*. Philadelphia, PA: Temple University Press, 1973.

Connelly, James F., ed. *The History of the Archdiocese of Philadelphia*. Philadelphia, PA: Archdiocese of Philadelphia, 1976.

Coogan, Tim Pat. *The Famine Plot: England's Role in Ireland's Greatest Tragedy*. New York: St. Martin's Press, 2012.

Coverdale and Colpitts. *Officers of the Pennsylvania Railroad Company and Operated Lines, 1846–1946*. New York: self-published, 1947.

Cox, Samantha L. "Duffy's Cut: A Brief Report of the Bioarchaeological Findings from a Massacre of Irish Immigrant Railroad Laborers from 1832." *American Journal of Physical Anthropology* 153 (2014).

Cupper, Dan, ed. *The Pennsylvania Railroad: Its Place in History, 1846–1996—A Brief History and Research Guide*. Wayne: Pennsylvania Railroad Technical and Historical Society, 1996.

Curtis, L. Perry, Jr. *Apes and Angels: The Irishman in Victorian Caricature*. Washington, D.C.: Smithsonian Institution Press, 1971.

Daughen, Joseph R., and Peter Binzen. *The Wreck of the Penn Central*. Boston: Little, Brown, and Company, 1971.

Dilts, James D. *The Great Road: The Building of the Baltimore and Ohio—The Nation's First Railroad, 1828–1853*. Stanford, CA: Stanford University Press, 1993.

Extension Magazine. "Our Sisters in Two Crises of Medical History" (January 1919). In Archives of the Daughters of Charity, De Paul Provincial House, Albany, New York.

Feldberg, Michael. *The Philadelphia Riots of 1844: A Study in Ethnic Conflict*. Westport, CT: Greenwood Press, 1975.

Forster, T. *Origins, Symptoms, and Treatment of Cholera Morbus*. 2nd ed. London: Keating and Brown, 1831.

Foster, R.F. *Modern Ireland: 1600–1972*. London: Allen Lane, 1988.

Franchot, Jenny. *Roads to Rome: The Antebellum Protestant Encounter with Catholicism*. Berkeley: University of California Press, 1994.

Franscell, Ron. *The Crime Buffs Guide to Outlaw Pennsylvania*. Guilford, CT: Morris Book Publishing, 2013.

Gallman, J. Matthew. *Receiving Erin's Children: Philadelphia, Liverpool, and the Irish Famine Migration, 1845–1855*. Chapel Hill: University of North Carolina Press, 2000.

Garratt, Colin, and Max Wade-Matthews. *Illustrated Book of Steam and Rail*. New York, Barnes and Noble Books, 2003.

Goodrich, Carter. *Canals and American Economic Development*. New York, 1961.

Gordon, Sarah H. *Passage to Union: How Railroads Transformed American Life, 1829–1929*. Chicago: Ivan R. Dee, 1997.

Gordon, Thomas F. *A Gazetteer of the State of Pennsylvania*. Philadelphia, PA: T. Belknap, 1832.

Griffin, Martin I.J. "The Sisters of Charity and the Cholera in Baltimore and Philadelphia, 1832." *American Catholic Historical Researches*. Vol. 14. Philadelphia, PA: Griffin, 1897.

———. "St. Joseph's Orphan's Asylum, Philadelphia." *American Catholic Historical Researches*. Vol. 14 Philadelphia, PA: Griffin, 1897.

Hage, Hother. *Report Relative to the Survey of a Rail Road from Chambersburg to Pittsburg, and a Survey of the Raystown Branch of the Juniata River, with Estimates of the Cost of the Work*. Harrisburg, PA, 1839.

Heathcote, Charles William. *History of Chester County, Pennsylvania*. West Chester, PA, 1926.

Hedge, Egbert. *Sketch of a Railway, Judiciously Constructed Between Desirable Points*. New York: Egbert Hedge, Railroad Journal Office, 1841.

Hoeber, Francis W. "Drama in the Courtroom, Theater in the Streets: Philadelphia's Irish Riot of 1831." *Pennsylvania Magazine of History and Biography* 125, no. 3 (July 2001): 191–232.

Ignatiev, Noel. *How the Irish Became White*. New York: Routledge, 1995.

Johnson, Greg. "Putting a Mystery to Rest." *Penn Current* (March 15, 2012). https://penncurrent.upenn.edu/2012-03-15/features/putting-mystery-rest.

Jones, Jim. *Railroads of West Chester*. West Chester, PA: Taggart Publishing, 2006.

Kenny, Kevin. *The American Irish: A History*. Essex, UK: Pearson Education Limited, 2000.

Kirlin, Joseph L.J. *Catholicity in Philadelphia*. Philadelphia, PA: John McVey, 1909.

Knobel, Dale T. *Paddy and the Republic: Ethnicity and Nationality in Antebellum America*. Middletown, CT: Wesleyan University Press, 1986.

Kraut, Alan M. *Silent Travelers: Germs, Genes, and the "Immigrant Menace."* New York: Basic Books, 1994.

Lewis, Richard A. *Edwin Chadwick and the Public Health Movement, 1832–1854*. London: Longmans, 1952.

Leyburn, James G. *The Scotch-Irish: A Social History*. Chapel Hill: University of North Carolina Press, 1962.

Licht, Walter. *Working for the Railroad*. Princeton, NJ: Princeton University Press, 1983.

Light, Dale E. *Rome and the New Republic: Conflict and Community in Philadelphia Catholicism between the Revolution and the Civil War*. Notre Dame, IN: University of Notre Dame Press, 1996.

Longmate, Norman. *King Cholera: The Biography of a Disease*. London: Hamish Hamilton, 1966.

McGuinness, Margaret M. *Called to Serve: A History of Nuns in America*. New York: New York University Press, 2013.

Messer, David W. *Triumph II: Philadelphia to Harrisburg, 1828–1998*. Baltimore, MD: Barnard, Roberts and Company, 1999.

BIBLIOGRAPHY

Mid-Ulster Mail. "Clay Pipe Making." Ardboe Heritage, November 17, 1928. http://ardboeheritage.com/articles/clay-pipe-making.

Miller, Kerby A. *Emigrants and Exiles: Ireland and the Irish Exodus to North America.* Oxford: Oxford University Press, 1985.

Mokyr, Joel. *Why Ireland Starved: A Quantitative and Analytical History of the Irish Economy, 1800–1850.* London: George Allen and Unwin, 1985.

Moses, Norton H., ed. *Lynching and Vigilantism in the United States: An Annotated Bibliography.* Westport, CT: Greenwood Press, 1997.

Nash, Gary B., and Jean R. Soderlund. *Freedom by Degrees: Emancipation in Pennsylvania and Its Aftermath.* New York: Oxford University Press, 1991.

Nesbitt, Mark, and Patty A. Wilson. *Cursed in Pennsylvania: Stories of the Damned in the Keystone State.* Guilford, CT: Globe Pequot, 2016.

"Noble Work in Caring for Destitute Patients in the Almshouse Here during the Cholera Epidemic of 1832." Undated, printed source of unknown provenance in Archives of the Daughters of Charity, De Paul Provincial House, Albany, New York.

Nolan, Hugh J. *The Most Reverend Francis Patrick Kenrick, Third Bishop of Philadelphia, 1830–1851.* Philadelphia, PA: American Catholic Historical Society, 1948.

O'Neel, Brian. *150 North American Martyrs You Should Know.* Cincinnati, OH: Servant Books, 2014.

Phillips, Lance. *Yonder Comes the Train: The Story of the Iron Horse and Some of the Roads It Traveled.* New York: A.S. Barnes and Company, 1965.

Polder, Bart J., Martin A. Van't Hof, Frans P.G.M. Van der Linden and Anne M. Kuijpers-Jagtman. "A Meta-Analysis of the Prevalence of Dental Agenesis of Permanent Teeth." *Community of Dentistry and Oral Epidemiology* 32 (2004): 217–26.

Poxon, Marita Krivda. *Irish Philadelphia.* Charleston, SC: Arcadia Publishing, 2012.

Quimby, Alden W. "That Small Burial Ground Near Malvern." *Daily Local News,* November 30, 1909.

Ranelagh, John O'Beirne. *A Short History of Ireland.* 3rd ed. Cambridge, UK: Cambridge University Press, 2012.

Remini, Robert V. *Andrew Jackson.* New York: Harper Perennial, 1999.

Roberts, Solomon W. *Reminiscences of the First Railroad Over the Allegheny Mountain.* Philadelphia: Pennsylvania Railroad Company, 1878.

Rosenberg, Charles E. *The Cholera Years: The United States in 1832, 1849, and 1866.* Chicago: University of Chicago Press, 1987.

Sachse, Julian F. "The Last Relic of the Pennsylvania Railroad Originally Called the Philadelphia and Columbia Railway." Pennsylvania Railroad File no. 004.01C, "History of Duffy's Cut Stone Enclosure."

Schiffer, Margaret B. *Chester County, Pennsylvania Inventories, 1684–1850.* Exton, PA: Schiffer Publishing, Ltd., 1974.

Shah, Sonia. *Pandemic: Tracking Contagions, from Cholera to Ebola and Beyond.* New York: Sarah Crichton Books, 2016.

Sipes, William B. *The Pennsylvania Railroad: Its Origin, Construction, and Connections.* Philadelphia: Pennsylvania Railroad, 1875.

"The Statutes at Large of Pennsylvania, Harrisburg, PA, 1911, Laws Passed Session, 1832–1833." http://www.rootsweb.com/~usgenweb/pa/pafiles.htm.

Tauxe, Robert V. "Cholera." *Bacterial Infections of Humans.* Edited by Alfred S. Evans and Philip S. Brachman. 3rd ed. New York: Plenum Medical Book Company, 1998.

Tise, Larry E. *The American Counter Revolution: A Retreat from Liberty, 1783–1800.* Mechanicsburg PA: Stackpole Books, 1998.

Trautwine, John C., Jr. *The Philadelphia and Columbia Railroad of 1834.* Philadelphia, PA: City History Society of Philadelphia, 1925.

Treese, Lorett. *Railroads of Pennsylvania.* 2nd ed. Mechanicsburg, PA: Stackpole Books, 2013.

Tripician, Joseph F. "Idiosyncrasies of People in High Places." Unpublished paper, Narberth, PA, July 1970.

———. "The Role Played by the Pennsylvania Railroad in the 'Main Line' Area of Philadelphia." Unpublished paper, Narberth, PA, August 2, 1960.

Trollope, Frances. *Domestic Manners of the Americans.* Edited by John Lauritz Larson. St. James, NY: Brandywine Press, 1993.

University of Pennsylvania Museum of Archaeology and Anthropology. "Dead Men of Duffy's Cut." https://www.penn.museum/research/projects-researchers/physical-anthropology-section/144-dead-men-of-duffy-s-cut.

Von Gertsner, Franz Anton Ritter. *Early American Railroads, 1842–3.* Edited by Frederick C. Gamst, translated by David J. Diephouse and John C. Decker. Stanford, CA: Stanford University Press, 1997.

Watkins, J. Elfreth. "History of the Pennsylvania Railroad Company, 1848–1896." Unpublished galley proof, Philadelphia, PA, 1899.

Watson, J. Francis. "Duffy's Cut Burial in Ireland." *The Keystone* 46, no. 3 (2013): 41, 44.

———. "Duffy's Cut Update." *The Keystone* 45, no. 1 (2012): 11–12.

———. "George Dougherty: A Section Foreman Looks at Duffy's Cut." *The Keystone* 43, no. 1 (2010): 81–82.

———. "Philip Duffy and Duffy's Cut Among the Irish-American Railroading Community." *Seanchas Ard Mhacha* (Journal of the Armagh Diocesan Historical Society) 26, no. 1 (2016): 151–67.

———. "Remembering Duffy's Cut 57." *The Keystone* 45, no. 2 (2012): 24–26.

———. "Update: Murder at Duffy's Cut." *The Keystone* 43, no. 4 (2010): 32–33.

———. "Who Was the Real Philip Duffy?" *Railroad History* 214 (Spring–Summer 2016): 82–89.

Watson, William E. "Duffy's Cut." *The Encyclopedia of Greater Philadelphia* (2015). http://philadelphiaencyclopedia.org/archive/duffys-cut.

———. "Duffy's Cut—Main Burial Spot Cannot Be Excavated." *Irish Edition*, December 2011.

———. "First Human Remains Recovered at Duffy's Cut." *The Keystone* 42, no. 3 (Autumn 2009): 43–44.

———. "History and Memory at Duffy's Cut." *Railroad History*, no. 211 (Fall/Winter 2014): 76–87.

———. "The Irish and Ireland." *The Encyclopedia of Greater Philadelphia.* N.p., 2017. http://philadelphiaencyclopedia.org/archive/irish-the-and-ireland.

———. "Remarks at Retirement Luncheon for Joseph F. Tripician." *The Keystone* 33, no. 5 (Autumn 2000): 47–51.

———. "The Sisters of Charity, the 1832 Cholera Epidemic in Philadelphia and Duffy's Cut." *U.S. Catholic Historian* 27, no. 4 (Fall 2009): 1–16.

Watson, William E., and Eugene J. Halus, eds. *Irish Americans: The History and Culture of a People*. Santa Barbara, CA: ABC-Clio Publishers, 2015.

Watson, William E., and J. Francis Watson, John H. Ahtes and Earl H. Schandelmeier. *The Ghosts of Duffy's Cut: The Irish Who Died Building America's Most Dangerous Stretch of Railroad*. Westport, CT: Praeger Publishers, 2006.

Way, Peter, *Common Labour: Workers and the Digging of the North American Canals, 1780–1860*. Cambridge, UK: Cambridge University Press, 1993.

Wilson, David A. *United Irishmen, United States: Immigrant Radicals in the Early Republic*. Ithaca, NY: Cornell University Press, 1998.

Wilson, J. Gilmore. *A Brief History of East Whiteland Township*. Frazer, PA: Frazer Press, 1965.

Wilson, William Hasell. *The Columbia-Philadelphia Railroad and Its Successor*. York, PA, 1985. Originally entitled *Reminiscences of a Railroad Engineer* in 1896.

Year Book for Nineteen Twenty-Three in Aid of All Saints Chapel. Philadelphia General Hospital. Philadelphia, PA, 1923.

1832 Newspapers Consulted

American Railroad Journal.
American Republican.
The Belfast Newsletter.
Catholic Intelligencer.
Chester County Democrat.
Daily Local News.
The Friend.
Mercantile Advertiser.
National Gazette and Literary Register.
Niles Weekly Register.
Oxford Press.
Philadelphia Gazette and Daily Advertiser.
Village Record.

Reporting on the Duffy's Cut Project

Baker, Zack. "Irish Woman Murdered Nearly 200 Years Ago in Philadelphia Reburied in Northern Ireland." *NBC News*, July 27, 2015. https://www.nbcphiladelphia.com/news/local/Irish-Woman-Murdered-Nearly-200-Years-Ago-in-Philadelphia-Reburied-in-Northern-Ireland-316142001.html.

Barry, Dan. "With Shovels and Science, a Grim Story Is Told." *New York Times*, March 25, 2013. http://www.nytimes.com/2013/03/25/us/secrets-of-duffys-cut-yield-to-shovel-and-science.html?pagewanted=all&_r=0.

Barter, Pavel. "Duffy's Cut Secrets Unearthed." *Sunday Times*, July 9, 2017. https://www.thetimes.co.uk/edition/ireland/duffys-cut-secrets-unearthed-zvtlsdj3v.

BBC News. "Duffy's Cut: Catherine Burns Is Buried in Clonoe." July 19, 2015. http://www.bbc.com/news/uk-northern-ireland-33586042.

Brett, Sarah. "Mystery of Duffy's Cut Railroad Deaths in Philadelphia." *BBC News*, August 31, 2010. http://www.bbc.co.uk/northernireland/radiofoyle/features/features_duffys_31aug10.shtml.

Browne, Bette. "Blood on the Tracks." *Irish Examiner*, May 19, 2014. http://www.irishexaminer.com/lifestyle/features/blood-on-the-tracks-were-50-irish-immigrants-murdered-in-philadelphia-in-1832-268069.html.

Burns, Kathy McGee. "Duffy's Cut Heroes." *Irish Edition*, October 2014.

Bushe, Andrew. "End of the Line." *Sunday Mirror*, June 20, 2004.

Callahan, Jim. "Beer and Brew to Raise Funds for Duffy's Cut: Organizers Want to Place Memorial Near 1832 Mass Grave for Immigrants." *Daily Local News*, February 14, 2011.

———. "Burial in Ireland Planned for Duffy's Cut Victim." *Main Line Suburban Life*, February 20, 2013. http://www.mainlinemedianews.com/mainlinesuburbanlife/news/burial-in-ireland-planned-for-duffy-s-cut-victim/article_25f5916f-d855-5a1a-acf4-80ae343d0806.html.

———. "A Cut Above Duffy's—Research into Fate of Irish Rail Workers Requires an Aerial Approach to Grave." *Daily Local News*, July 17, 2011.

———. "New Findings at Duffy's Cut Provide Age-Old Clues." *Daily Local News*, August 23, 2010.

———. "Professors Seek Account of Duffy's Cut Deaths." *Daily Local News*, March 18, 2010.

Carswell, Simon. "Deaths Reveal a Hidden History of Labour and the Story of Irish America." *Irish Times*, March 15, 2014. http://www.irishtimes.com/news/world/us/deaths-reveal-a-hidden-history-of-labour-and-the-story-of-irish-america-1.1725814.

DeNicola, Linda. "Project Seeks Answers to Immigrants' Deaths." *The Independent*, August 11, 2004. http://independent.gmnews.com/news/2004/0811/Front_Page/026.htm.

Derry Now. "Campaigners on Behalf of US Irish Immigrants Praise Dery Women's Project." December 13, 2016. https://www.derrynow.com/news/campaigners-on-behalf-of-us-irish-immigrants-praise-dery-womens-project/133663.

Drew Magazine. "The Nameless" (Spring 2007). http://www.drew.edu/magazine/default.aspx?id=12501.

Farrar, Carolyn. "A Tragic, 180-Year-Old Mystery." *Donegal Democrat*, February 13, 2013.

Fincham, Kelly, and Lauren Carroll. "More Bodies Discovered at Irish Mass Grave in Duffy's Cut." *Irish Central*, August 3, 2009. http://www.irishcentral.com/roots/More-bodies-discovered-at-Irishmass-grave-in-Duffys-Cut.html.

Gladden, Michele. "Relentless Search for What Remains." *Asbury Park Press*, March 30, 2009. http://www.app.com/apps/pbcs.dll/article?AID=200990330001.

Glastky, Genevieve. "Site of Worst Mass Murder in Pa. History?" *Philadelphia Daily News*, July 14, 2017.

———. "Telling the True Tale." *Philadelphia Inquirer*, July 15, 2017.

Glenza, Jessica. "Reburial of Woman in Native Ireland Highlights 183-Year-Old Mystery." *The Guardian*, July 19, 2015. http://www.theguardian.com/us-news/2015/jul/19/reburial-woman-ireland-murder-mystery-duffy-s-cut.

Grilli, Alexis. "Unexplained Events Fuel Interest in Duffy's Cut." *Suburban Advertiser*, April 7, 2005.

Hayes, Cathy. "Mass Murder Now Suspected of Irishmen at Duffy's Cut." *Irish Central*, August 17, 2010. http://www.irishcentral.com/news/100872699.html.

Hickey, Kate. "Dig at Duffy's Cut to Recover 50 Irish Cholera and Murder Victims Resumes." *Irish Central*, June 10, 2017. https://www.irishcentral.com/roots/history/dig-at-duffy-s-cut-to-recover-50-irish-cholera-and-murder-victims-resumes#.WTvme2tz6ds.facebook.

———. "Duffy's Cut Archaeologists Search for Descendants of Murdered John Ruddy: Seeking Information on the Ruddy Family Who Share a Rare Genetic Trait." *Irish Central*, December 11, 2011. http://www.irishcentral.com/news/Duffys-Cut-archaeologists-search-for-descendants-of-murdered-JohnRuddy-135237548.html#ixzz1xhi4uucw.

———. "Duffy's Cut Murder Victim's Remains Brought Home to Donegal After 180 Years." *Irish Central*, February 8, 2013. https://www.irishcentral.com/news/duffys-cut-murder-victims-remains-brought-home-to-donegal-after-180-years-190357551-237563951.

———. "Further Testing Underway at Duffy's Cut Mass Grave of 57 Murdered Irish." *Irish Central*, October 8, 2015. https://www.irishcentral.com/news/further-testing-underway-at-duffys-cut-mass-grave-of-57-murdered-irish.

Holmes, Kristin E. "Bones May Be from 19th Century Grave Site." *Philadelphia Inquirer*, March 25, 2009. http://www.philly.com/philly/news/local/20090325_Bones_may_be_from_19th-century_gravesite.html.

———. "Irish Railworkers' Grave in East Whiteland Too Close to Tracks to Excavate." *Philadelphia Inquirer*, November 8, 2011.

———. "Long-Forgotten Dead of Duffy's Cut Get Proper Rites." *Philadelphia Inquirer*, March 10, 2012.

———. "19th-Century Chesco Crime." *Philadelphia Inquirer*, August 19, 2010.

———. "Sorrow at Duffy's Cut." *Philadelphia Inquirer*, November 8, 2011.

Hughes, Samuel. "Bones Beneath the Tracks." *Pennsylvania Gazette* (November/December 2010): 34–43. http://www.upenn.edu/gazette/1110/feature1_1.html.

Hunter, Walt. "Exclusive: New Search Begins for Secret Main Line Grave Holding Irish Rail Workers." KYW-3 TV, October 5, 2015. http://philadelphia.cbslocal.com/2015/10/05/exclusive-new-search-begins-for-secret-main-line-grave-holding-irish-rail-workers.

————. KYW CBS-3 TV. Stories of Walt Hunter spanning fourteen years can be found at the Duffy's Cut Project website: http://duffyscut.immaculata.edu/Pages/exclusive.html.

Hwang, Helen. "Mystery, a Mass Grave and 'Ghosts.'" *Philadelphia Inquirer*, March 8, 2007.

Inish Times. "Left for a New Life, Dead within Weeks." June 13, 2007. http://www.inishtimes.com/2007/06/13/left-for-a-new-life-dead-within-weeks.

Irish Central. "Experts Close to Making New Find at Duffy's Cut." June 29, 2010. http://www.irishcentral.com/roots/Experts-close-to-making-new-find-at-Duffys-Cut-97376529.html.

Irish Film and Television Network. "'Duffy's Cut' to Premiere at Stranger than Fiction." September 29, 2006. http://www.iftn.ie/search/?act1=record&aid=73&rid=4279936&sr=1&only=1&force=1&tpl=archnews.

Kelly, Antionette. "Newly Unearthed Remains at Duffy's Cut Offer New Information on Irish Laborers—New Info on Murdered Irish Railroad Workers Is Uncovered." *Irish Central*, October 17, 2011. http://www.irishcentral.com/roots/Newly-unearthed-remains-at-Duffys-Cut-offer-new-information-onIrish-laborers-131945108.html#ixzz1xhk0u6bQ.

Kelly, Daniel. "Centuries-Old Mass Grave of Irish Laborers Probed in Pennsylvania." Reuters, March 9, 2014. http://www.reuters.com/article/2014/03/09/us-usa-pennsylvania-irish-idUSBREA2809420140309.

Kristie, Dan. "Researchers Treating 1832 Gravesite Like a Crime Scene." *Daily Local News*, March 25, 2009.

Langan, Sheila. "Irish Woman Murdered at Duffy's Cut in 1832 Begins Journey Home." *Irish Central*, May 9, 2015. https://www.irishcentral.com/roots/history/journey-home-begins-at-last-for-irish-woman-murdered-at-duffys-cut-in-1832.

————. "Irish Woman Murdered 183 Years Ago at Duffy's Cut Will Be Reinterred in Ireland." *Irish Central*, March 4, 2015. https://www.irishcentral.com/roots/irish-woman-murdered-183-years-ago-at-duffys-cut-will-be-reinterred-in-ireland.

Loftus, Peter. "The Mystery of Duffy's Cut." *Wall Street Journal*, April 14, 2011. http://online.wsj.com/article/SB1000142405274870446130457621657222297 94408.html?mod=ITP_pageone_1.

Lohr, David. AOL.com "Pennsylvania Ghost Story Leads to Murder Mystery." August 25, 2010. http://www.aolnews.com/nation/article/duffys-cut-mass-grave-in-pennsylvania-did-irish-immigrants-die-of-cholera-or-were-they-murdered/19606498.

Love, Robert. "Irish Blood on the Tracks." *Scope* 1, no. 5 (November, 2008): 44–48.

Lowe, Benjamin. "Fragments May Be Bones from Workers' Grave." *Philadelphia Inquirer*, Friday, May 13, 2005.

————. "2 Scholars Cast Doubt on Mass Rail Workers' Grave." *Philadelphia Inquirer*, March 9, 2004.

Matheson, Kathy. "19th-Century PA Immigrant Reburied in Ireland." AP wire, February 28, 2013. https://www.cnsnews.com/news/article/19th-century-pa-immigrant-reburied-ireland.

————. "PA Researchers Unable to Unearth Irish Mass Grave." AP wire, October 30, 2011. http://archive.boston.com/news/nation/articles/2011/10/30/pa_researchers_unable_to_unearth_irish_mass_grave.

McClements, Freya. "Secrets of Mass Grave Revealed." *BBC News*, March 24, 2009. http://news.bbc.co.uk/2/hi/uk_news/northern_ireland/foyle_and_west/7961564.stm.

McRorie, Jessica. "Artifacts May Be Awakening Spirits." *Daily Local News*, March 21, 2005.

————. "Duffy's Cut Research Continues." *Daily Local News*, May 3, 2004.

————. "57 Men Who Died at Duffy's Cut Honored." *Daily Local News*, June 20, 2004.

————. "New Artifacts Unearthed at Duffy's Cut." *Daily Local News*, November 15, 2004.

————. "Officials Search for Mass Grave." *Daily Local News*, February 8, 2004.

Midgette, Anne. "Washington National Opera Gives Young Writers a Chance to Emerge." *Washington Post*, November 14, 2013. https://www.washingtonpost.com/entertainment/music/washington-national-opera-gives-young-writers-a-chance-to-emerge/2013/11/14/ce73eb46-4d77-11e3-9890-a1e0997fb0c0_story.html?utm_term=.b3783bb829b1.

Moss-Coane, Marty. "Duffy's Cut: An Early Irish-American Tragedy." *Radio Times with Marty Moss-Coane*, National Public Radio. Aired September 14, 2009. http://whyy.org/cms/radiotimes/2009/09/14/duffys-cut-an-early-irish-american-tragedy.

Mullan, Adrian. "DNA Search for Families of Tragic Tyrone Men." *Tyrone Herald*, August 27, 2007.

O'Carroll, Daniel. "New Murder Victims Found at Duffy's Cut." *Irish Central*, July 20, 2010. http://www.irishcentral.com/news/Two-more-skulls-found-at-Duffys-Cut-98814919.html.

O'Driscoll, Seán. "Bodies of Murdered Irish Rail Workers to Be Exhumed in US." *Irish Times*, July 12, 2004.

————. "Irish Firm Offers Funeral Help." *Irish Voice*, July 2004.

————. "Mystery Deaths of 19th-Century Irish Rail Workers." *Irish Voice*, July 2004.

Oglesby, Amanda. "Brothers Return Bones to Ireland." *Asbury Park Press*, June 2, 2015. http://www.app.com/story/news/local/jackson-lakewood/manchester/2015/06/02/brothers-return-bones-ireland/28380677.

O'Hanlon, Ray. "Crime Scene." *Irish Echo*, September 15, 2010.

————. "D-Day at Duffy's Cut." *Irish Echo*, August 8, 2007.

————. "Digging for Truth: Excavation Could Determine Fate of Irish Rail Workers." *Irish Echo*, August 11, 2004.

————. "Duffy's Cut Victim Catherine Laid to Rest." *Irish Echo*, July 29, 2015.

————. "Going Home." *Irish Echo*, May 13, 2015.

————. "It Was Murder." *Irish Echo*, August 18, 2010.

————. "Journey Home: Full Circle as John Ruddy's Remains Back in Ireland." *Irish Echo*, February 13, 2013.

————. "Last Man: Duffy's Cut Dig Closes in on Last Grave." *Irish Echo*, August 31, 2011.

———. "Philadelphia Dig Uncovers Evidence of Irish Workers." *Irish Echo*, October 20, 2004.

———. "Philly Find Could Be Vital Clue." *Irish Echo*, May 25, 2005.

———. "Remains Dig Could Be Inches from Success." *Irish Echo*, November 30, 2005.

———. "Sacred Duty." *Irish Echo*, April 1, 2009.

———. "She's a Lady: Two Names Being Linked to Latest Duffy's Cut Discovery." *Irish Echo*, April 20, 2011.

———. "This Time, the Pipe Is Being Called." *Irish Echo*, October 19, 2916. http://irishecho.com/2016/10/derrys-tower-wants-pa-pipe.

———. "Work Begins at Duffy's Cut Mass Grave." *Irish Echo*, October 8, 2015. http://irishecho.com/2015/10/work-begins-on-duffys-cut-mass-grave.

———. "Work Resumes at Duffy's Cut." *Irish Echo*, June 14, 2017. http://irishecho.com/2017/06/work-resumes-at-duffys-cut.

O'Kelly, Declan. "PA Mass Grave of Sick Irish Railroad Workers May Be Murder Scene." *Irish Central*, August 19, 2009. http://www.irishcentral.com/news/Pa-mass-grave-of-sick-Irish-railroad-workers-may-be-murder-scene--.html.

O'Shea, Kerry. "Murder in a Time of Cholera Remembered as Duffy's Cut Irish Victims Finally Reburied." *Irish Central*, March 10, 2012. http://www.irishcentral.com/news/Murder-in-a-time-of-cholera-remembered-as-Duffys-Cut-Irish-victims-finallyreburied-142179803.html#ixzz1xhhQJxaL.

Philip, Abby. "Unearthing a Deadly Secret: Were 57 Irish Workers Murdered in 1832 Pennsylvania?" *Washington Post*, October 8, 2015. http://www.washingtonpost.com/news/morning-mix/wp/2015/10/8/unearthing-a-deadly-secret-were-57-irish-workers-murdered-in-1832-Pennsylvania/?tid=sm_fb.

Pirro, J.F. "Lost and Found." *Main Line Today*, May 2010. http://www.mainlinetoday.com/Main-Line-Today/May-2010/Lost-and-Found.

Poxon, Marita Krivda. "Duffy's Cut Upcoming 2014 Events." *Irish Edition*, March 2014.

———. "Duffy's Cut Update." *Irish Edition*, September 2015.

———. "Watson Brothers Bring Catherine Burns Home for Burial in Clonoe, Co. Tyrone." *Irish Edition*, July 2015.

Puglionesi, Lois. "Duffy's Cut Is on Track for Historic Designation." *Delaware County Daily Times*, June 14, 2004.

———. "Ghosts Beneath the Rails." *Irish America Magazine* (June/July 2004).

———. "The Ghosts of Duffy's Cut." *Delaware County Daily Times*, August 10, 2003.

———. "Researchers Continue Dig for Irish Workers' Remains." *Delaware County Daily Times*, Saturday, May 28, 2005.

———. "Tracking History." *Times Herald*, August 25, 2003. http://www.aoh61.com/history/Tracking_History.htm.

Raz, Guy. "Fates of Irish Workers Sealed in Mass Grave." NPR, *All Things Considered*, May 23, 2010. http://www.npr.org/templates/story/story.php?storyId=127074433.

Rettew, Bill. "Irish Whys." *Daily Local News*, June 17, 2017. http://www.dailylocal.com/article/DL/20170610/NEWS/170619999.

Ross, Cindy. "Duffy's Cut: The Lancaster Connection." *Lancaster County* (March 2013).

———. "The Mystery of Duffy's Cut." *Pennsylvania Magazine* (March/April 2013).

RTE News. "Woman Buried in Co Tyrone After 183 Years in Duffy's Cut." July 20, 2015. http://m.rte.ie/news/2015/0719/715818-duffys-cut.

Rutter, Jon. "Bones of Dead Men Tell Tales at Duffy's Cut." *Lancaster Online*, November 8, 2017. http://lancasteronline.com/news/bones-of-dead-men-tell-tales-at-duffy-s-cut/article_db5877f5-088b-5267-8f5c-52cc21c0b4da.html.

———. "Local Dentist, Using Skeletal Remains, Dental X-Rays, Helping to Give Some Belated Respect to 19th Century Railroad Worker—Trying to Unravel Duffy's Cut Mystery." *Intelligencer Journal*, March 2, 2013.

Sessinger, Lou. "Irish Laborers Found an Early Grave Together." *Intelligencer*, May 6, 2004.

Skwiat, Matthew. "Excavation of Duffy's Cut Continues." *Irish America*, June/July 2014, 18.

Snow, Mary. *Wolf Blitzer's "Situation Room."* CNN, 2010. http://www.cnn.com/video/?/video/crime/2010/08/21/snow.csi.1832.cnn.

Sullivan, Mary. "Revisiting the Ghosts of Duffy's Cut." *History Ireland* 21, no. 3 (May/June 2013): 6–7.

Sweeney, Eamon. "End of the Road for American Brothers." *Derry Journal*, July 17, 2015.

———. "Grisly Find in Philadelphia." *Londonderry Sentinel*, April 1, 2009. http://www.londonderrysentinel.co.uk/news/Grisly-find-in-USA.5130445.jp.

———. "The Londonderry Sentinel and the Philadelphia Railway Mystery." *Londonderry Sentinel*, August 29, 2007.

———. "New Evidence Uncovered at 'Duffy's Cut.'" *Londonderry Sentinel*, May 20, 2009. http://www.londonderrysentinel.co.uk/news/New-evidence-uncovered-at-39Duffy39s.5284572.jp.

———. "Remains of Immigrants Found in Philadelphia." *Londonderry Sentinel*, March 24, 2009. http://www.londonderrysentinel.co.uk/news/Remains-of-immigrants-found-in.5103551.jp.

Telegraph. "US Historians Launch New Search for Remains of Irish Migrants." October 6, 2015. http://www.telegraph.co.uk/news/worldnews/northamerica/usa/11915918/US-historians-launch-new-search-for-remains-of-Irish-migrants.html.

Tucker, Abigail. "Ireland's Forgotten Sons." *Smithsonian* 41, no. 1 (April 2010): 14–18. http://www.smithsonianmag.com/ist/?next=/history/irelands-forgotten-sons-recovered-two-centuries-later-9194680.

Valania, Jonathan. "Murder in the Time of Cholera." *Philadelphia Weekly*, August 18, 2010.

Via, Noelle. "173-Year-Old Main Line Mystery." *Main Line Life*, June 1–7, 2005.

Weir, Claire. "Mass Grave May House Immigrants." *Belfast Telegraph*, August 22, 2007. http://www.belfasttelegraph.co.uk/northwest-edition/daily/article2884216.ece.

Whyte, Barry J. "Duffy's Cut Victim to Be Given a New Face." *Irish Central*, September 25, 2010. http://www.irishcentral.com/news/Duffys-Cut-victim-to-be-given-a-face-103779529.html.

Wylie, Catherine. "County Tyrone Woman Laid to Rest 183 Years After Murder." *Irish News*, July 20, 2015. http://www.irishnews.com/news/2015/07/19/news/remains-of-catherine-burns-buried-in-clonoe-197701.

———. "Remains of Woman Murdered 183 Years Ago Brought Home." *Irish Times*, July 20, 2015. http://www.irishtimes.com/news/ireland/irish-news/remains-of-woman-murdered-183-years-ago-brought-home-1.2290182.

INDEX

G

Gabriele Library, Immaculata University 109, 130, 144

Gallagher, Vince, Irish American community leader 122, 140

Garrett and Eastwick, locomotive company 22

Gerard, Felix R., American railroader 98

Goodman, Norman, Chester County deputy coroner 110, 118

Granite Railroad, Massachusetts 16

Greater Philadelphia Search and Rescue 105

Great Hunger, the 9, 17, 32, 36

Great Valley, Chester County, Pennsylvania 18, 42, 63, 78, 100

Green Hawk, locomotive 22

Green Tree Inn, Malvern, Pennsylvania 22, 63, 65, 150

Griffith's Valuation, publication 120

Grow, Benjamin, American railroader 97, 100

Gunkle's Mill (also Kunkle's Mill), Chester County, Pennsylvania 63

Gunnar's Run Improvement Association, Philadelphia, Pennsylvania 34

H

Hankey, John, Irish American railroad historian 109

Harlan, Richard, American physician, Philadelphia 58

Harrisburg, Pennsylvania 18, 30, 32, 83, 92, 98, 99, 100

Harris, Malachi, American blacksmith, Chester County, Pennsylvania 65

Hedge, Egbert, American railroad historian 22

Henry, Dennis, Irish American railroader 137

Higgins, Michael, Irish politician 128

Hollenbach, David, American artist 143

Hollidaysburg Borough, Pennsylvania 19

Holy Family Church, Ardara, Donegal, Ireland 122, 134, 139

Holy Trinity Lutheran Church, Narberth, Pennsylvania 102

Honesdale Borough, Pennsylvania 16

Hughes, Samuel, Irish American author 142

Hunter, Walter, Irish American journalist 140

Hurley, Michael, Irish American Catholic priest 62

I

Immaculata University, Pennsylvania 77, 104, 108, 112, 121, 122, 130, 139, 144

Inclined Plane, Philadelphia, Pennsylvania 19, 35

Inishowen Barony, Donegal, Ireland 120

International Brotherhood of Electrical Workers (IBEW), American union 137

Intersection Borough, Malvern, Chester County, Pennsylvania 19, 22, 63, 104, 106

J

Jackson, Andrew, American politician 17

Jackson, Samuel, American physician, Philadelphia 58

John Stamp, ship 39, 49, 50, 51, 119, 120, 121, 132, 134

Johnston, John K., Irish American railroader 83, 91

N

O

P

Village Record, newspaper, Chester County, Pennsylvania 42, 64, 65, 67, 70, 71, 95, 146, 149

W

Walker, Kristen, American author 140
Walker, Lewis, Quaker chronicler 59
Washingbay Centre, Clonoe, County Tyrone, Northern Ireland 124
Washington, D.C. 138, 141
Watson, J. Francis, Duffy's Cut Project member 104
Watson, William E., Duffy's Cut Project member 104
Watt, James, British/Scottish engineer 15
West Chester Borough, Chester County, Pennsylvania 19, 28, 64, 77, 80
West Chester Railroad 19
West Goshen Township, Chester County, Pennsylvania 98
West Jersey and Camden and Atlantic Railroad 91
West Laurel Hill Cemetery, Bala Cynwyd, Montgomery County, Pennsylvania 91, 96, 97, 110, 121, 132, 134
Whig Party 32
White Horse Tavern, Chester County, Pennsylvania 42, 63
Williams, Isaac, Chester County resident 79, 88
Willistown Township, Chester County 12, 28, 87, 100, 104, 106, 130
Wilson, John A., American railroad engineer 18
Wilson, William Hassell, American railroad engineer and historian 18
Wolfe Tone, Theobald, Irish revolutionary 8
Wolf, George, American politician 23

Y

Young Ireland, reform movement 9
Young, John, Irish ship captain 50, 51

ABOUT THE AUTHORS

The Watsons are the founders of the Duffy's Cut Project. William E. Watson received his PhD in history from the University of Pennsylvania and is a professor of history at Immaculata University in Pennsylvania. J. Francis Watson received his PhD in historical theology from Drew University and is a Lutheran clergyman, ecclesiastical archivist and historian in New Jersey.

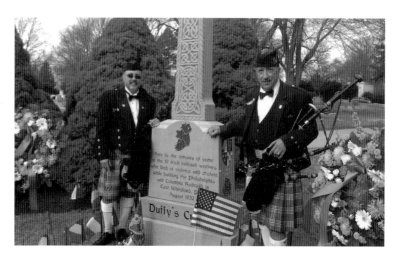